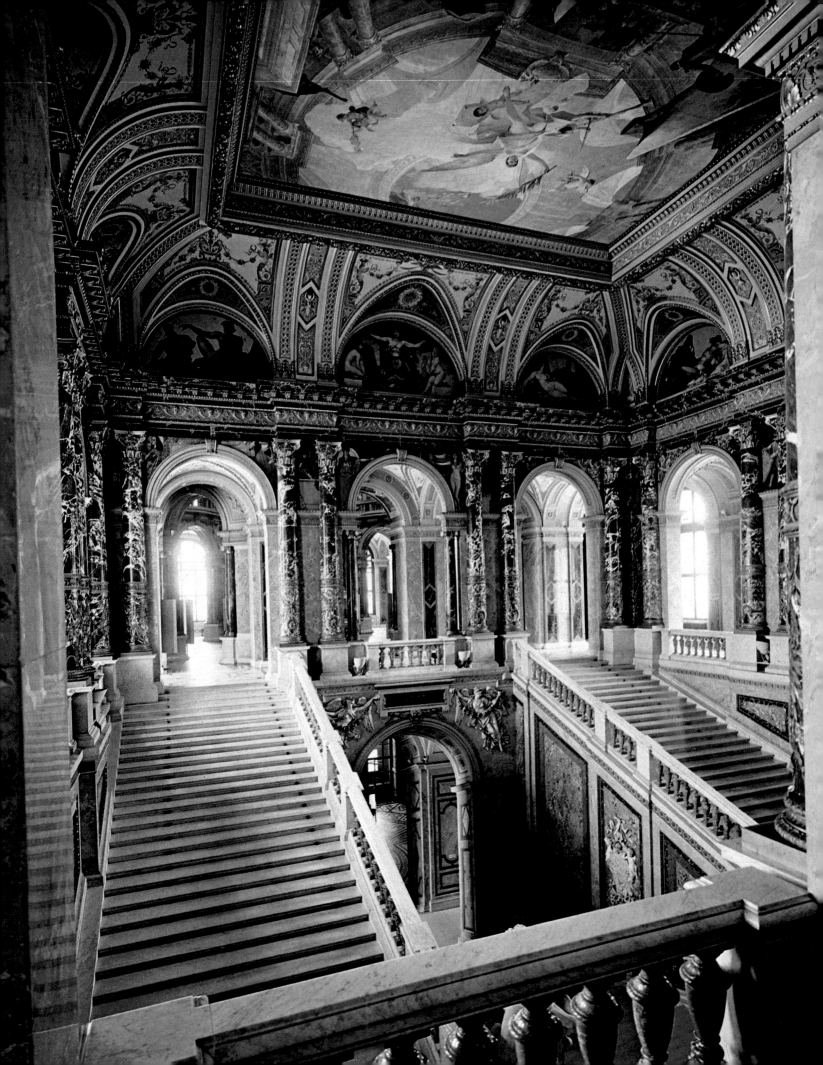

ART HISTORY MUSEUM

VIENNA PICTURE GALLERY

Newsweek/GREAT MUSEUMS OF THE WORLD

NEW YORK, N.Y.

GREAT MUSEUMS OF THE WORLD

Editorial Director—Carlo Ludovico Ragghianti
Assistant—Giuliana Nannicini
Translation and Editing—Editors of ARTNEWS

ART HISTORY MUSEUM
VIENNA PICTURE GALLERY

Texts by:

Giorgio T. Faggin
Günther Heinz
Raffaele Monti
Anna Pallucchini
Rodolfo Pallucchini

Design:

Fiorenzo Giorgi

Published by:

NEWSWEEK, INC.
& ARNOLDO MONDADORI EDITORE

Library of Congress Catalog Card No. 69-19064

© 1969—Arnoldo Mondadori Editore—CEAM—Milan

© 1969—Photographs Copyright by Kodansha Ltd.—Tokyo

INTRODUCTION

FRIDERIKE KLAUNER

Director of the Picture Gallery of the Art History Museum

The operation of this great Viennese museum, especially the picture gallery of some one thousand paintings, has ceased to be a routine matter during the past several decades because of a growing number of problems. For one, the relationship between the public and the museum is undergoing profound changes. This does not mean that the painting of the past — our main concern here — has lost its appeal. The contrary is shown by the great number of visitors to the galleries and the public's interest in the internal problems of the museum. To give even an approximate idea (more would not be possible here) of the changing relations between public and museum, it is necessary to go back in time and observe past developments in order to understand the present situation.

To state the terms of the question: on one side there is the collection; on the other, the observer. The collector — assuming that he is one and is not a curator — more and more takes on the role of observer, a particularly critical observer generally with a specific orientation in taste. In this orientation, the artist himself carries no weight.

The Picture Gallery of the Kunsthistorisches, or Art History, Museum is one of the few long-established art galleries with an international range. And, like all great collections, it has its own history of progressive change in the organization of its heritage.

By the second half of the 16th century the Emperor Rudolph II (1552–1612) had already collected, at his residence in Prague, an inestimable group of works, including masterpieces by Dürer, Correggio, etc. Following the taste of the time, he displayed in his so-called *Kunstkammer,* or Art Chamber, curiosities and "marvels" of nature as well as paintings and other objects. The imperial connoisseur surrounded himself with these treasures for his own delight. His clear preference for certain painters and subjects was determined, at least in part, by his own personality. The persistence with which he pursued the subjects he wished to possess had something obsessive about it. Of course, a huge collection, and a very famous one as in this case, served to increase the prestige of a Renaissance prince. Yet it was not only

for this reason that Rudolph surrounded himself with art. The collection was there for his own exclusive pleasure. Naturally this did not keep him from often showing his treasures to privileged visitors.

The true creator of the Vienna gallery, however, was the Archduke Leopold William (1614–62), brother of the Emperor Ferdinand III and governor of the Catholic Netherlands. He was one of the most splendid art lovers of the Baroque period, and the pictures that he managed to amass — despite the difficult political situation around the middle of the 17th century — was one of the most illustrious of its time in breadth and quality. He had his agents buy the best pieces to be found in Italy, Germany and of course the Low Countries. Sometimes he acquired whole collections, like the magnificent group of 16th-cenutry Venetian paintings that originally belonged to Bartolomeo della Nave and which later came into the possession of the Duke of Hamilton in England and was subsequently sold at auction.

When Leopold William resigned as governor in 1656 and moved to Vienna, he took his collection with him and installed it in the part of the Hofburg, or imperial castle, known as the Stallburg. This gallery, which was already quite famous, was eventually inherited by Leopold William's nephew, the Emperor Leopold I. Leopold William's concept of collecting was different from that of his great predecessor, Rudolph II. It was based on broader and to a certain extent more objective criteria. He attached great importance to making a collection of the painting of his country, that is, of the Southern Netherlands, from van Eyck — the "Giotto of the Low Countries" — to the Archduke's contemporaries. And he followed the same principle in collecting Italian painting. His major criterion thus was no longer his private pleasure, but rather the desire to assemble a complete review of the best paintings produced up to his time. His personal predilections, accordingly, are not shown as clearly as are those of Rudolph II. On the other hand, the fact that his collection does not include 17th-century Dutch painting — then at its peak — is due to the contemporary political, social and economic situation.

10 Leopold William's relationship to his picture gallery — which included

1,400 works — was the typical one of a prince and art lover in the Baroque age; the possession of such a gallery was a requisite of his rank. Even if it was not acquired only for this reason, but also out of a real love of art, the gallery of pictures nevertheless confirmed an aristocrat's social status. An awareness of the social values of art patronage caused not only the high aristocracy but also the average nobility and prelates, as well as rich convents and monasteries, to build collections during the same period.

This approach to collecting was even more pronounced in the early 18th century. The Archduke Leopold William's gallery was merged with part of the old imperial possessions, and under the Emperor Charles VI (1685–1740) it was installed in the Stallburg according to entirely new standards. Three luxuriously produced illustrated inventories (1723, 1730 and 1733) are lasting records of this installation. Although he had no personal interest in art, Charles VI saw to it that the works he had inherited were arranged in a most splendid way. In accordance with the Baroque taste for the total effect, the paintings covered the walls from ceiling to dado and were hung without any regard to styles or other affinities. The general effect was sumptuous, and no single picture was expected to hold the eye. A symbol of the Emperor's power and magnanimity, this was not a gallery intended for public visitors.

Fifty years later, under the Emperor Joseph II (1741–90), grandson of Charles VI and son of Maria Theresa, there was another radical change in the conception of the gallery. Two factors, the philosophy of the Enlightenment and the ebbing of artistic energies in the age of Neo-Classicism, were at the root of this change. The aristocracy and the Church, which had been the main patrons of the arts, gradually lost their primacy and middle-class patronage increased. At the same time a new style, the first art movement to see itself in historic perspective, was born in the wake of a wave of theoretical writings: Neo-Classicism.

Joseph II, a follower of the Enlightenment and sophisticated to its theories and opinions, sought, almost excessively, to put them into practice. He dis-

mantled the imperial picture gallery and had the works moved to the larger Belvedere palace (former residence of Prince Eugene of Savoy). Here the works were arranged according to the new system. Similar schools of painting were hung together in chronological order to provide a historical review. The first catalogue to appear after this rearrangement, by Christian von Mechel, clearly states the intention to offer "the history of art in visual terms." The collection was seen more as a means "of instruction than for passing enjoyment." Mechel describes the gallery as like "a well-furnished library in which anyone who wishes to learn will find works of every kind and every period," and he goes on to say that the collection not only includes perfect examples but also works that contrast with one another. By observation and comparison, which are the only ways to attain knowledge, one may become a true connoisseur.

The most notable fact connected with the new arrangement was the opening of the gallery to the public, which took place in 1781, or twelve years earlier than the Louvre. For the first time, the highest examples of art (outside of the churches) became readily available. Today it is difficult to imagine how much this meant. Everything was still the private property of the imperial family, and the middle-class visitors to the gallery were in fact guests of an illustrious host. Nevertheless, new values were gradually acquired by larger sections of the public.

In the long reign of Francis Joseph (1848–1916) the Picture Gallery came to reflect the gradual development of art studies as a new field. Toward the end of the 19th century, the directors of the Picture Gallery, who earlier had always been painters, were historians. By the Emperor's express wish the imperial collections were organized for scholars and for research. Corresponding to the internal reorganization, a new building was designed for the imperial collection. After some one hundred years at the Belvedere, the works were moved to the new museum, inaugurated in 1891. Opposite the Art History Museum a companion building for the Museum of Natural History was constructed. This disposition is like a distant echo of Rudolph II's *Kunst-*

kammer with its combination of art and natural objects. In elaborateness and splendor of style the buildings are a symbol of the imperial power of a dynasty that understood the value of art but that was now nearing its collapse.

With the end of World War I, the first Austrian Republic (1918–1938) arose. Now the property of the Republic, the art collections were also the property of the people. The higher positions at the museum were no longer filled by aristocrats, and the gallery became an educational means serving the entire population.

Developments in art history, a new, larger public and new ways of looking at pictures inspired by modern art called for a new arrangement, and in the 1930s the paintings were again rearranged. Along with specialization in art history and the increased emphasis on outstanding individual artists, there was a notable simplification in methods of display. A considerable number of pictures was removed from view, and at the same time some of the less important artists were gradually forgotten. The over-all effect of a large number of pictures had lost its importance as the attention of scholars and the public was fixed on single artists and single paintings. Thus the arrangement of the gallery had the simultaneous approval of scholars, art lovers and the general public. Meanwhile, the feeling of common ownership stimulated a widespread desire to know more about the pictures.

World War II created problems that are still with us. The pictures, which had been hidden during the war, could not be replaced immediately after the end of hostilities because the building had been badly damaged. This circumstance and Austria's uncertain political future led to a program of traveling exhibitions, which began in 1946. For some years a selection of masterpieces from the Picture Gallery (and from other collections in the Art History Museum) was shown in the main cities of Western Europe and America. In the 1950s the bomb damage to the museum was repaired and the paintings were reinstalled.

For the public it had become clear that art is not a luxury but a necessity. 13

Along with the museum's numerous shows that gave a sampling from various schools, there were scholarly exhibitions of single masters or specific periods. The catalogues were contributions to scholarship, and the exhibitions as a whole were favorably received. Now the average visitor was no longer the local art lover, but a tourist. Even if he has no particular interest in art, the tourist — not as an individual but as a mass phenomenon — visits museums and exhibitions, so long as he is somewhere abroad or at least outside of his own city.

The tourist does this because collecting has again become a status symbol: the status not of a particular class, but of an affluent society. This attitude, however, is not based only on money. Since the war there has been an extraordinary development in all fields of knowledge, and news of these advances has been spread widely in understandable form by the mass media. The production of art books, too, has been enormous, and even the process of leafing through the illustrations is educational.

The influence of the sciences has become so great that there is a tendency to mechanize connoisseurship and to trust to X-rays, chemical tests and even computers to establish the authenticity and the quality of works of art. But research in art history is also going forward, and along with the traditional methods there is a newer emphasis on the social and economic background of art. The public no longer dwells, as it did between the wars, on esthetic analysis, but also can view a work as an archaeological object that offers a clue to the past.

Visitors often are uncomfortable in a museum, and attribute this feeling to the formal architecture, bad lighting, poor display, too much or too little space. Some complain, as in the case of the Art History Museum, that the Italian 14th century is not represented, that there are no Leonardos nor one of Frans Hals' group portraits. In reality the visitors are dissatisfied because they unconsciously expect to find a complete review of art, as in a book. (Furthermore, each period has its fashions; and at the moment there is a

vogue for early medieval painting.) No art gallery, however, can offer a complete history of art. Yet the museum official must show what he has as completely as possible, including minor as well as major artists to document the development of styles. Good catalogues are of assistance, including brief guides to particular aspects of the gallery. These should pay particular attention to iconography and iconology, which have become important auxiliaries to art history. They have made it possible again for visitors to look at paintings directly and grasp their meaning, with the spiritual pleasure of the pure joy of seeing.

Friderike Klauner

GERMANY

MARTIN SCHONGAUER. *Holy Family.*

During the 15th century the art of the great Flemish painters, Jan van Eyck and Rogier van der Weyden, had a wide-ranging influence. Often the message of these two masters met and fused with that of the founders of Italian Renaissance painting. In the Germanic countries the artist with the greatest following was undoubtedly van der Weyden, and the splendid paintings of Martin Schongauer are an example of his impact. According to a tradition that goes back at least to the mid-16th century, van der Weyden is supposed to have been Schongauer's actual teacher. But the Flemish painter died in 1464 and at that time it seems Schongauer was barely an adolescent. It is thus more likely that he arrived in Brussels after van der Weyden's death and that he frequented the flourishing workshop that continued the master's repertory. Schongauer is primarily and properly famous for his extensive work as an engraver. He has left us no less than 155 prints, which were exceedingly popular not only in the 15th and 16th but in succeeding centuries. Schongauer's prints were sought all over Europe by collectors and artists, with the latter often utilizing them for thematic "inventions" regardless of their own stylistic convictions. Mention should also be made of Schongauer's drawings, some fifty in number. His paintings, on the other hand, are not numerous. The engraver's sensitivity, his subtlety and attention to detail, are evident in these, though not at the expense of the unity of the whole. His graphic qualities are revealed in the little *Holy Family,* reproduced here about actual size. Schongauer does not have the drama or the severity of van der Weyden; on the contrary, his images have a human sweetness and affability. He avoids expressionistic deformation, and this was one of the reasons for which he was loved by Dürer, whose precursor he may be considered. From the point of view of color, Schongauer often shows greater restraint than his Netherlandish models.

ALBRECHT DÜRER. *Madonna and Child.* *p. 20*

Dürer's art seeks to reconcile Northern "practice" with Italian "science," and thus seems to move constantly between two opposite poles. On the one hand, there is an analytical naturalism, expressed with a highly refined technique; on the other, the need for an ideal norm to guide the artist and keep him from falling into empirical craftsmanship. The concern with finding the "laws of form" was so impelling in Dürer that he wrote — as is well known — no less than three volumes on artistic theory. In his treatise on the science of proportion, 1528, Dürer noted that: "The German painters . . . in the use of color are inferior to no one, but they have shown some lacks in the art of proportion, perspective and similar things. . . . Without correct proportions no picture can be perfect, even if its execution shows every attention to detail." The Vienna *Madonna and Child,* monogrammed and dated 1512, reveals the creative impetus of the great German master. Although in conceiving it he had in mind the examples of Giovanni Bellini, Leonardo and Raphael (especially with respect to the Child), it certainly cannot be said that the work is Italianate. In fact the subtle and carefully worked out drawing and the powerful chiaroscuro that models the forms in sculptural fashion remove the painting from any suggestion of Italian softness. The Madonna and Child theme did not interest Dürer because of its

18

MARTIN SCHONGAUER
Colmar circa 1450 — Colmar 1491
Worked in Rogier van der Weyden's studio in Brussels (after 1464?); registered at the University of Leipzig in 1471. Active in Colmar from 1471, except for a stay in neighboring Breisach, where he painted some frescoes (1489).
Holy Family
Oil on panel; 10 1/4″ × 6 3/4″.
Acquired in 1865. Assigned to the artist's middle period (circa 1475–80).

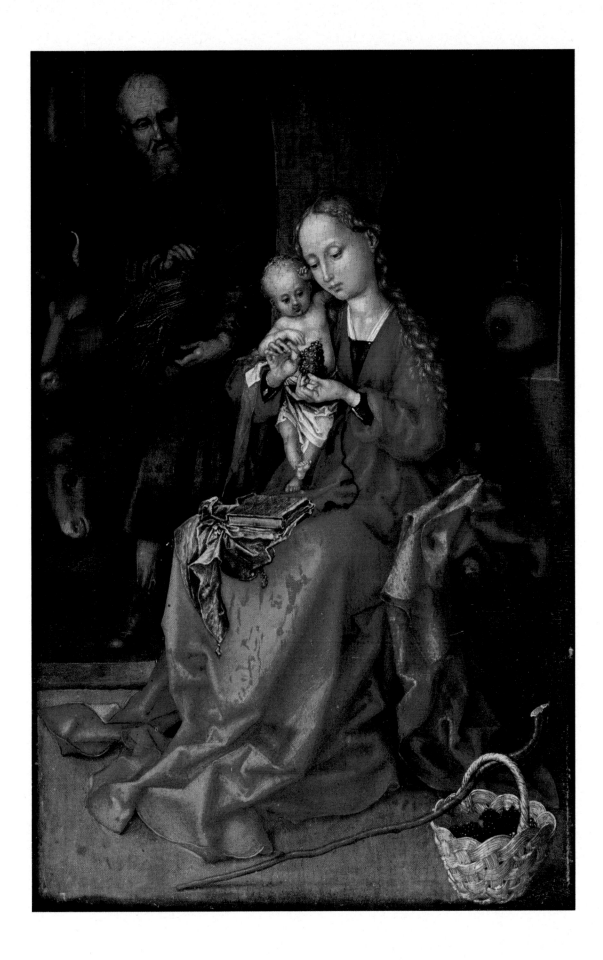

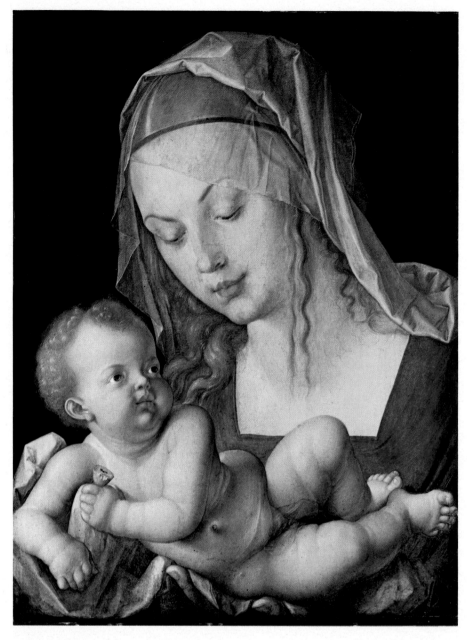

ALBRECHT DÜRER
Nürnberg 1471 — Nürnberg 1528
In 1486 worked with Michael Wolgemut.
1492–94 at Colmar, Basel and Strasbourg;
1494–95, Venice, Padua, Mantua; 1505–6,
Venice, Bologna. In 1520–21 traveled in the
Low Countries.
Madonna and Child
Oil on panel; 19 1/4″ × 14 1/2″.
Monogrammed and dated 1512.
Very probably it is one of two Madonnas
by Dürer acquired for Rudolph II in 1600
at Besançon from Count Cantecroy, nephew
of Cardinal Granvella. In 1758 it was in the
imperial *Geistliches Schatzkammer*. The
Child corresponds in part to a sketch made
in 1506 for the *Feast of the Rosary* in
Prague (the sketch is in the Bibliothèque
Nationale, Paris).

psychological and sentimental implications but as a problem in style. Faced with this theme, the artist found himself challenged to create a new image.

ALBRECHT DURER. *Portrait of a Young Venetian Lady.*
In 1505 and 1506 Dürer was staying in Venice for the second time (his earlier visit had been in 1494). This portrait is dated 1505, but we have no conclusive proof that it represents a Venetian lady, as the artist had certainly stopped in other north Italian cities before reaching Venice. For Panofsky the subject could be a Milanese woman; most scholars, however, agree in considering her Venetian. The painting seems to be unfinished. Dürer's second stay in Venice was full of consequences for his art, but his influence was also important for some of the young Venetian painters, notably Giorgione; and 1506 was a crucial year for Venetian painting.

ALBRECHT DÜRER
Portrait of a Young Venetian Lady
Oil on panel; 13 3/4″ × 10 1/4″.
Monogrammed and dated 1505.
At the end of the 18th century in the
Schwarz collection, Danzig; subsequently
in a private collection in Lithuania.
Acquired by the museum in 1923.
According to the museum catalogue
(1958), it is the oldest known painting
executed by Dürer during his second
stay in Venice.

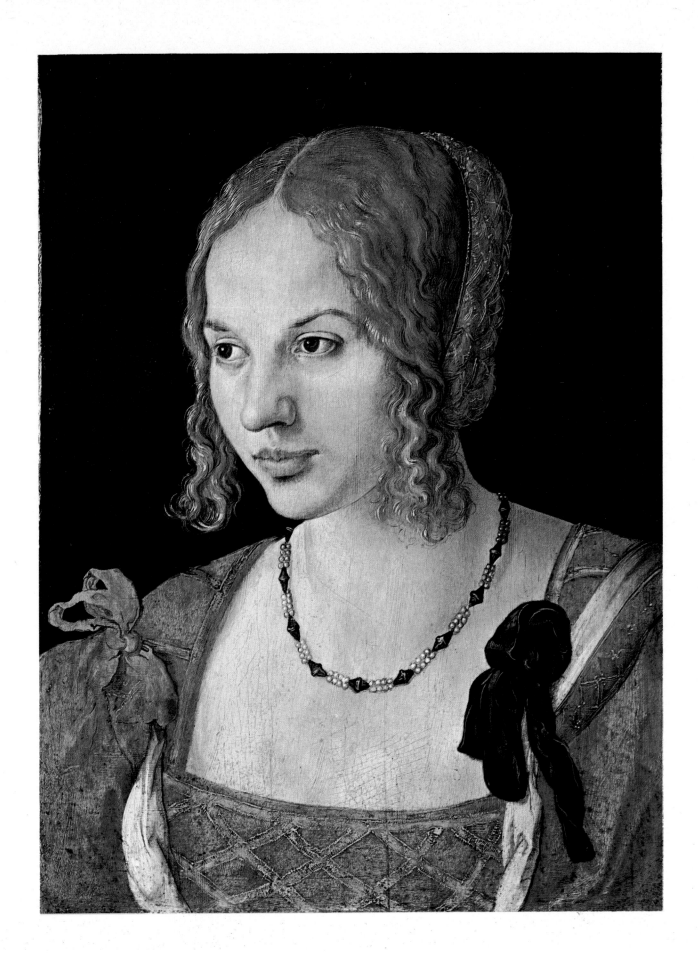

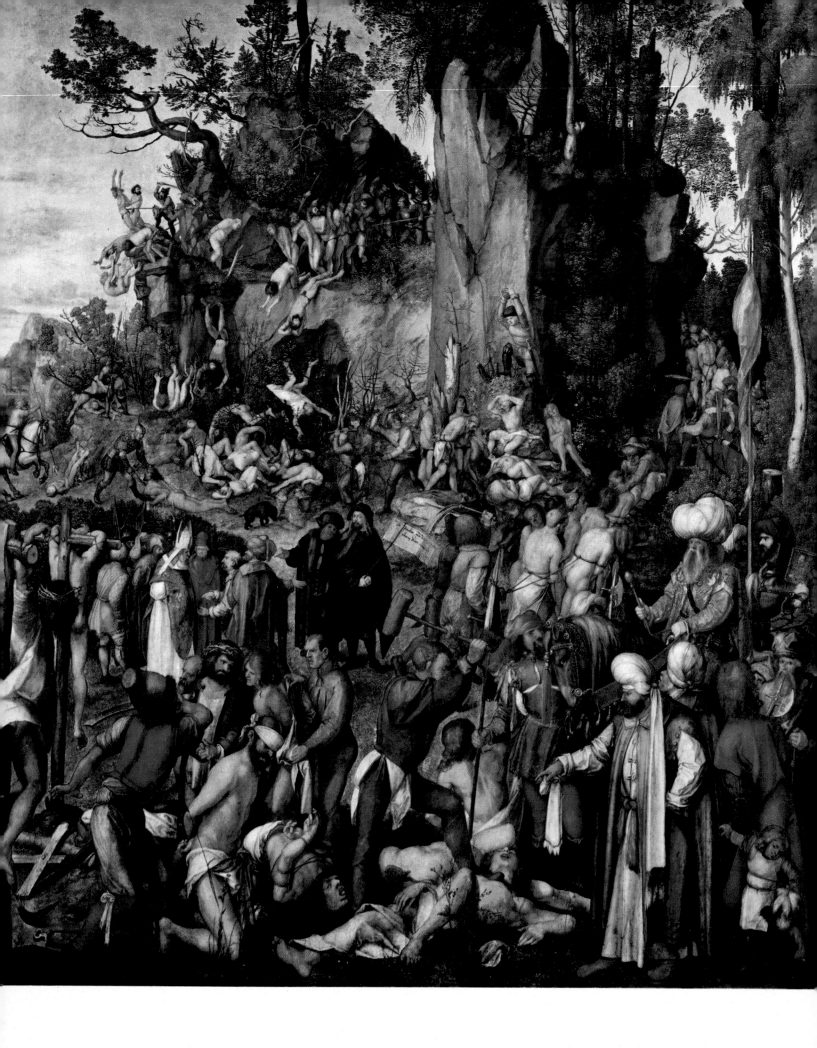

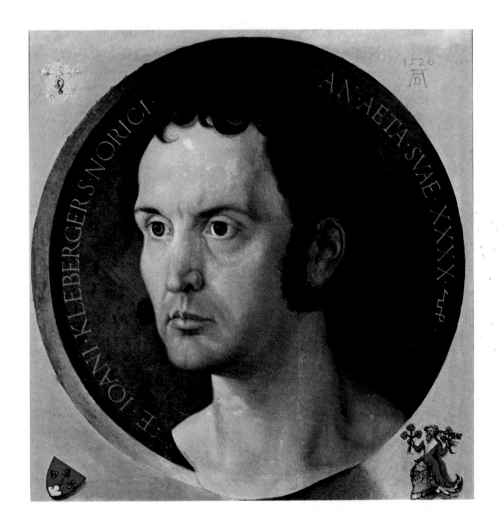

ALBRECHT DÜRER
Martyrdom of the Ten Thousand
Oil on canvas (transferred from panel);
39″ × 34 1/4″.
Signed and dated 1508.
In the center of the picture Dürer portrayed himself with a friend (Conrad Celtes?). The painter holds a banner bearing a Latin inscription that gives his name and the date of the work. It was painted for the Elector of Saxony, Frederick the Wise. In 1600 it was acquired by Rudolph II at Besançon from Count Cantecroy, nephew of Cardinal Granvella. A preliminary pen and ink sketch, narrower in format, is in the Albertina, Vienna. Dürer did a woodcut of the subject in 1498.

ALBRECHT DÜRER
Portrait of Johann Kleberger
Oil on panel; 14 1/2″ × 14 1/2″
(slightly cut down all around, but later enlarged again; without the additions it measures 13 1/2″ × 12 3/4″).
Monogrammed and dated 1526.
Acquired in 1564 by Wilhelm Imhoff from Kleberger's heirs, and subsequently by Rudolph II from the Imhoff family. It is one of Dürer's late works, executed two years before his death.

ALBRECHT DÜRER. *Martyrdom of the Ten Thousand.*
On the right of the picture there is an old king on horseback, who is wearing a large turban and holding a scepter in his hand. He is Sapor, King of Persia, who ordered the massacre of ten thousand Christians. According to tradition, in the year 343 Sapor had the Bishop of Seleucia-Ktesiphon, Primate of the Persian Church, executed along with a hundred other bishops and many of their followers. The Bishop of Seleucia, who is recognizable by the miter he is wearing, is shown on the left of the panel. Below, Christ crowned with thorns witnesses the martyrdom. The two Christians hanging on crosses, like the two thieves crucified with Jesus, also allude to the sacrifice on Golgotha. The painter has found an exemplary solution for the problem of incorporating a very large number of figures in the space. Furthermore, the small size of the panel obliged him to resort to a virtuoso detailed diminution of all the elements, akin to miniature painting. The color is restrained, and the painting of the trees shows exceptional sensitivity.

ALBRECHT DÜRER. *Portrait of Johann Kleberger.*
The bust of the subject is enclosed in a medallion that stands out against a pearly background. In the four corners are Dürer's monogram, the date of

23

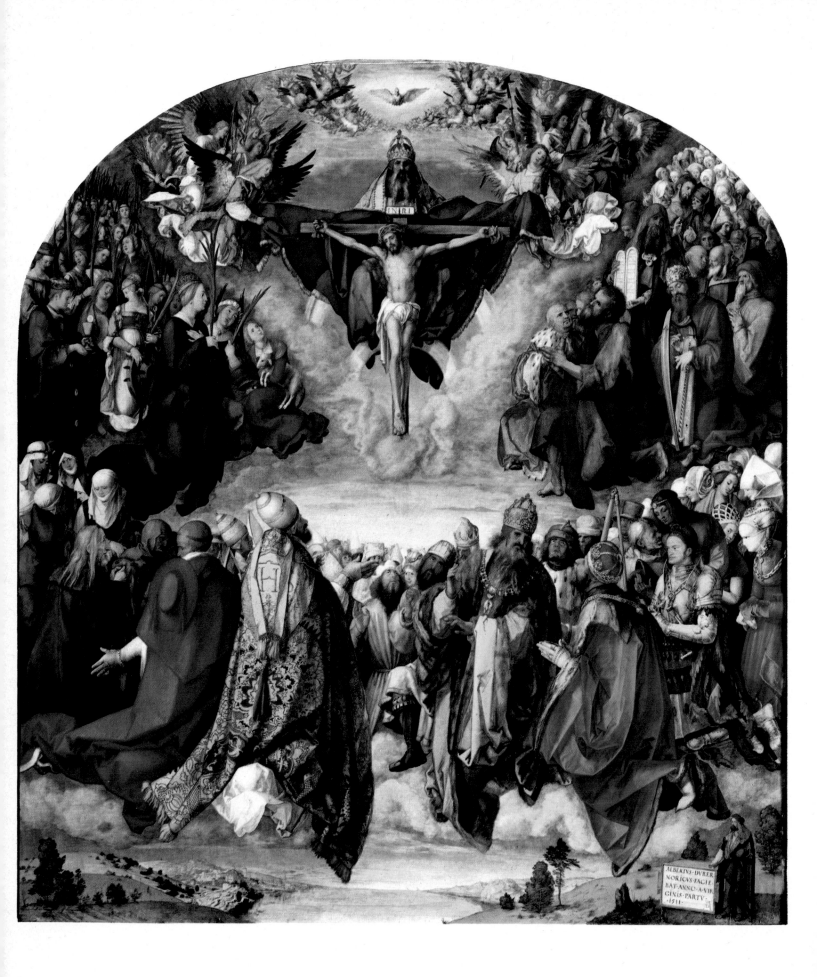

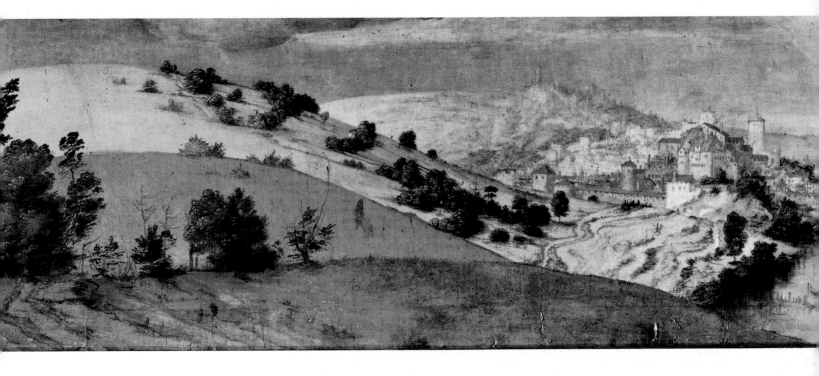

1526, as well as coats of arms and emblems. The biographical events of the proud personage who looks out with round staring eyes have been reconstructed by Panofsky. Thus we know that Kleberger's real name was Schewenpflug, and that he had left Nürmberg for unknown reasons. Later he returned under the name of Kleberger and in possession of an immense fortune. In 1518 he married a daughter of the Humanist Pirckheimer against the father's will, but soon left her and went to live in France, at Lyons. There he distributed his wealth to the poor and was called "the good German" by the citizenry, who put up a monument to him after his death.

ALBRECHT DÜRER. *Adoration of the Trinity*.

The Trinity, flanked by angels bearing the instruments of the Passion, is adored by the community of all the blessed. Left above, the ranks of female saints are led by Mary (dressed in blue), next to whom the saints Agnes, Barbara, Catherine and Dorothy are distinguishable. The group opposite is composed of Old Testament figures. At its head is St. John the Baptist, and behind him Moses and King David are identified. In the foreground below are seen representatives of the church (on the left) and of the laity (on the right). The old man with long hair, in profile, is Matthias Landauer, who commissioned the painting. On the opposite side, the knight in splendid golden armor is Landauer's son-in-law, Wilhelm Haller. Iconographically the picture derives from St. Augustine's *City of God*. The Christ sitting in judgment in the tympanum of the elaborate frame anticipates the final resolution of the half earthly and half heavenly city in the State of God. Perhaps in part for symbolic reasons the colors are dazzling and clear, for Dürer seems to have forgotten here the lesson of Venetian tonal painting that he had acquired only a few years earlier. In composition, however, the work has a "Renaissance" clarity and rigor.

ALBRECHT DÜRER
Adoration of the Trinity
Oil on panel; 53 1/4″ × 48 1/2″.
Signed and dated 1511.
At lower right, Dürer's self-portrait holding a Latin inscription giving his name and the date of the work, followed by his well-known monogram. The frame is a modern copy of the magnificent original designed by Dürer himself, which is in the Germanisches Museum, Nürnberg. The painting was commissioned by Matthias Landauer for the Chapel of All Saints in the Zwölfbrüderhaus (House of the Twelve Brothers), Nürnberg. It was from this religious institution that Rudolph II acquired the work in 1585. A sketch — dated 1508 — for the picture and its frame is in the Musée Condé, Chantilly. A preparatory drawing of the donor, made in 1511, belongs to the Städelsches Kunstinstitut, Frankfurt.

Above:
Detail of landscape in left foreground.

25

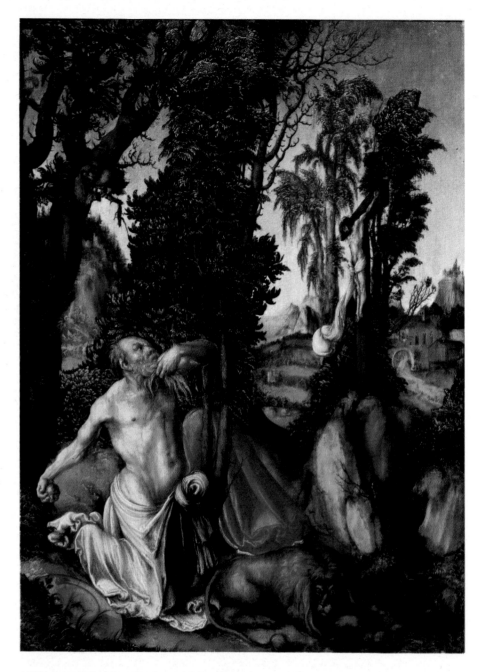

LUCAS CRANACH THE ELDER
Kronach (Northern Franconia) 1472 —
Weimar 1553
Active in 1502–3 in Vienna. From 1505 to
1550 at Wittenberg as court painter of Sax-
ony. Traveled in the Low Countries in 1508;
at Augsburg in 1550.
St. Jerome Penitent
Oil on panel; 21 3/4″ × 16 1/4″.
Dated lower center: 1502.
Formerly in the bishop's refectory at Linz
(probably having come from the abbey at
Mondsee), it was acquired by the museum
in 1927. The owl and the parrot in the tree
on the left are symbols of the planet Saturn
and the sun, and stand for the Melancholy
and Sanguine temperaments. The presence
of the symbolic birds indicates that the
painting was commissioned in 1500–1 by the
historian Johannes Cuspinian, rector of the
University of Vienna, and his wife Anna. A
portrait by Cranach of the Cuspinians shows
them with an owl and a parrot (Winterthur,
Reinhart Collection).

LUCAS CRANACH THE ELDER. *St. Jerome Penitent.*

The painting is dated 1502 and is thus a youthful work of the artist, exe-
cuted during his stay in Vienna. Unlike Dürer, Cranach was fundamentally
indifferent to Italian art and the principles of the Renaissance. He was a
painter by instinct, with a marked decorative taste and a highly developed
linear sensitivity. His wooded landscapes and the human figures that people
them seem to be following the patterns of a secret life. In the present work
St. Jerome's beard and his silvery drapery seem to be made of the same
vibrant and yeasty material as the landscape. As has been recognized by
modern art historians, the style of the Danube School — represented prima-
rily by the great masters, Albrecht Altdorfer and Wolf Huber — had its
origin in the paintings executed by Cranach in Vienna from 1500 to 1504.

LUCAS CRANACH THE ELDER
Judith with the Head of Holofernes.
Oil on panel; 34 1/4″ × 22″.
Signed with the artist's device of a winged
serpent. Datable around 1530. Since 1620
it has been in the imperial collection in
Vienna (Inventory "G").

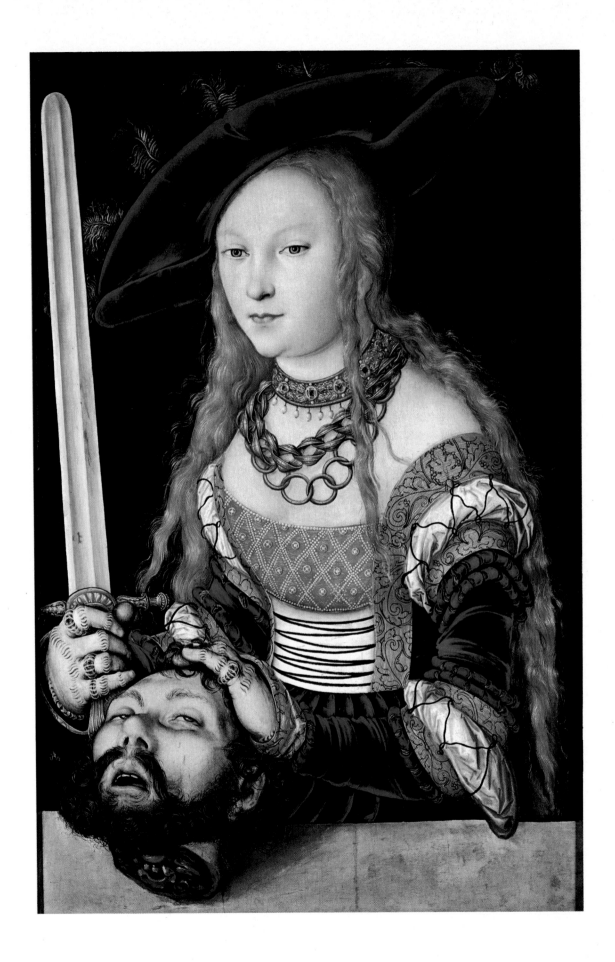

LUCAS CRANACH THE ELDER. *Judith with the Head of Holofernes.* p. 27

The image occupies nearly all the space within the frame and emerges from an unreal black ground which emphasizes the reddish blond hair and the intensely pink skin. Disquieting and subtly perverse, the heroine breathes satisfaction as she holds Holofernes' head — like a precious coffer — in her gloved hands. The sinister aspect of this feral female creature is accentuated by her showy courtesan's garb. This is perhaps the most exquisite part of the work, with its extraordinary linear refinement and its sober but masterly painting, in which the reds are dominant. It is one of Cranach's most distinctive works, executed probably around 1530. The success of this type of representation explains the numerous replicas and variants that followed. The theme is repeated in a painting in the Württembergische Staatsgalerie in Stuttgart, which is also considered to be from the hand of Cranach.

ALBRECHT ALTDORFER. *Entombment.*

With the *Resurrection,* also reproduced here, this panel originally was part of a large altarpiece executed for the Abbey of St. Florian, near Linz, Austria. A number of paintings by the great Danubian artist are still preserved in the abbey. The restless art of Altdorfer displays a broad range of interests. Like that of Grünewald it is substantially irrational and visionary, and is thus in strong opposition to the directions followed by the other great German artists, like Dürer and Holbein, who were powerfully attracted by the serenity and lucidity of Italian art. Sixteenth-century German art was not at all a unified phenomenon. There is in fact an abyss between the hallucinatory painting of Altdorfer, which at times seems "anti-Renaissance," and the terse and polished work of Holbein, which has the quality and often the spirit of Raphael. It should not be thought, however, that this lack of unity (which after all denotes richness and variety) is true only of art in the Germanic countries. In Italy at the same time we also see a large variety of styles, owing in part to the influence of German Gothic stylistic traits.

ALBRECHT ALTDORFER. *Resurrection.*

It was the art movements following Impressionism — Expressionism, Surrealism and so on — that helped us to understand better Altdorfer's powerful and original work, of which this painting is one of the most inspired creations. At first glance one sees that color, line and perspective have been carried to a point of extreme tension. The violence and the refinement of the color, in fact, would stand comparison with any contemporary psychedelic painting. Note the sky, which is tinged with the same gold that forms Christ's aureole and is traversed by blood-red clouds. Also note the dazzling white of Christ's drapery and his banner. The undulating contours deform the figures, which seem to be made of some mysterious fluid material. The perspective has been applied with virtuosity: forms are spread or contracted capriciously, in a pure play of style.

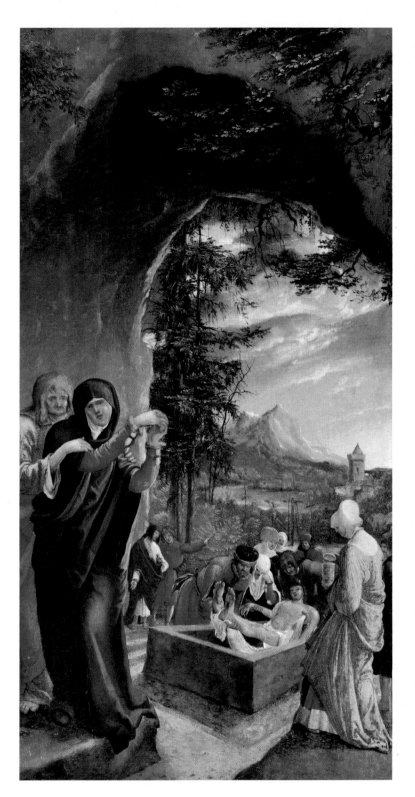

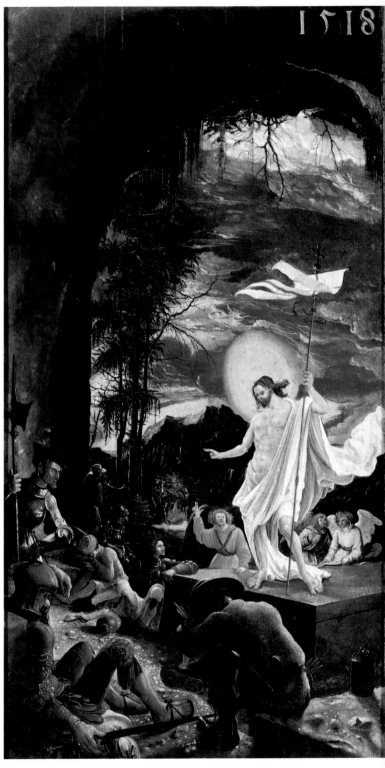

ALBRECHT ALTDORFER
Ratisbon (?) circa 1480 — Ratisbon 1538
Active at Ratisbon (Regensburg) and became a citizen there in 1506. Journeyed to Vienna in 1535.
Entombment
Oil on panel; 27 3/4″ × 14 1/2″.

With its companion piece, *Resurrection,* it was originally part of a large polyptych in the Abbey of St. Florian in Upper Austria. Formerly a relief was affixed to the reverse of the panels. The *Entombment* was acquired in 1923.

ALBRECHT ALTDORFER
Resurrection
Oil on panel; 27 1/2″ × 14 1/2″.
Dated 1518.
Companion piece to the preceding panel.
Acquired in 1930.

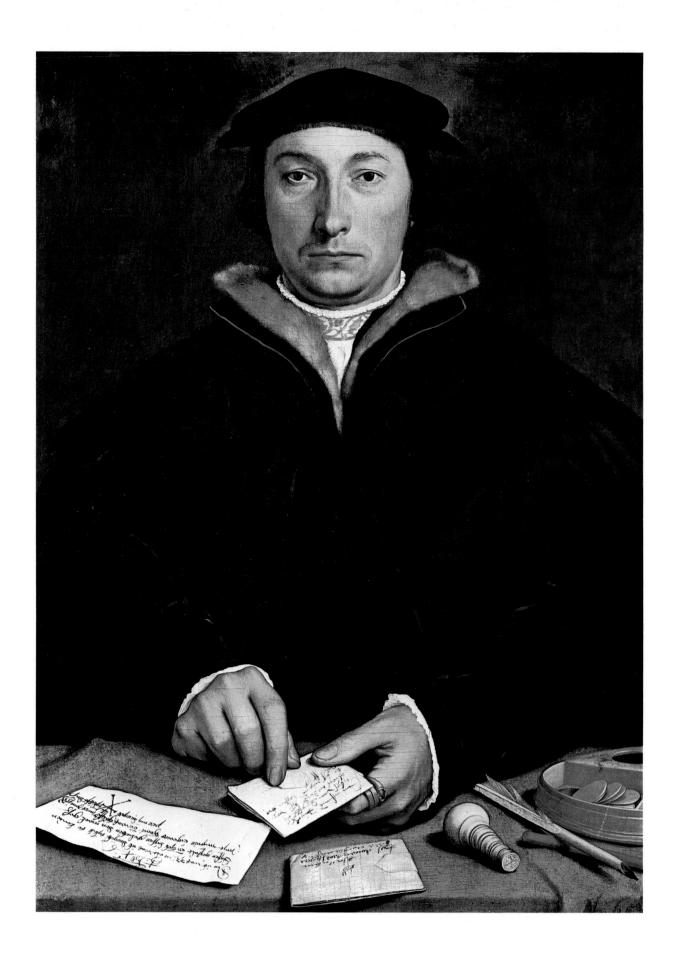

HANS HOLBEIN THE YOUNGER
Augsburg 1498 — London 1543
Son and pupil of Hans Holbein the Elder,
and brother of Ambrosius, who was also a
painter. Active in Basel from 1515 to 1526.
His first English sojourn was in 1526–28.
He was again in Basel in 1528–32, then in
England, except for visits to the Continent,
until his death.
Portrait of Dirck Tybis
Oil on panel; 18 3/4″ × 13 3/4″.
The writing in German in the open note on
the table and in the letter Tybis is holding
gives the name of the subject, his birthplace
(Duisburg) and the date of the work, 1533.
The painting is listed in Mechel's inventory
of 1783.

HANS HOLBEIN THE YOUNGER. *Portrait of Dirck Tybis.*

After working in Basel for ten years, the 28-year-old Holbein moved to England in 1526 and, except for two further stays in Basel, remained there until his death seventeen years later. It is apparent from some works of his English period (*Noli me tangere* at Hampton Court and the lost frescoes of the *Triumph of Wealth* and the *Triumph of Poverty* of which numerous copies exist) that Holbein could have become a figure painter on the level of Raphael or Titian. But as the artist chose to live in Protestant countries, he had to give up religious subjects almost entirely and specialize in portraiture. Yet in this limited field Holbein showed such a miraculous mastery of style as to count as one of the geniuses of European 16th-century painting. We know that when the Italian painter Federico Zuccari saw Holbein's numerous portraits in England he remarked that they went beyond the formal perfection of Raphael himself. The fascination of Holbein's portraits lies in their remarkable blend of meticulous objectivity and a spirit of abstract synthesis. Material appearances are transfigured into stylistic values.

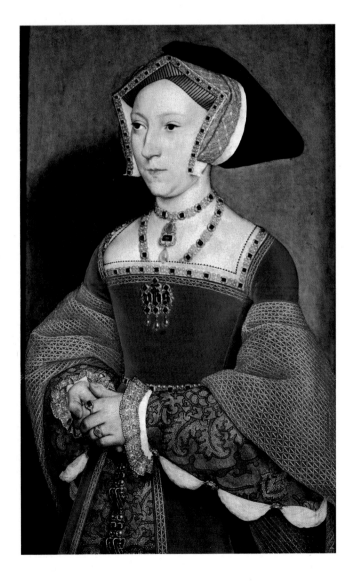

HANS HOLBEIN THE YOUNGER
Portrait of Jane Seymour
Oil on panel; 25 3/4″ × 18 3/4″.
Executed in 1536–37. Listed in Storffer's
inventory (Volume I, 1720). Preliminary
drawing in the Royal Library, Windsor
Castle. There is a replica in the
Mauritshuis, The Hague.

HANS HOLBEIN. *Portrait of Jane Seymour.* *p. 31*

Eldest daughter of John Seymour of Wolfhall, Jane went to court in 1530, at the age of seventeen. She was originally a lady-in-waiting to Catherine of Aragon and Anne Boleyn, but Henry VIII married her on May 20, 1536, one day after he had had Anne Boleyn beheaded. Jane Seymour died on October 24, 1537, after giving birth to the future Edward VI. In the Royal Library at Windsor Castle there is a drawing by Holbein which is generally considered a preliminary sketch for this painting. Here the subject is shown wearing a splendid dress, which Holbein painted with the meticulous care of a miniaturist. Despite its sumptuousness, the dress is pictorially sober and does not distract the observer from the pensive, plain face of the queen. Jane Seymour's skin has the purity of ivory. The light falls delicately over the whole image, and the shadows are clear. Although there is a vein of *trompe l'œil,* which is typical of almost all of Holbein's late portraits, the illusion separating the figure from the gray-blue wall does not appear excessive.

JOSEPH HEINTZ. *Venus and Adonis.*

Adonis takes leave of Venus to go on the hunt in which he will be killed by a boar. The story of Adonis as told by Ovid in the *Metamorphoses* was a favorite theme in the late 16th century. This picture by Joseph Heintz, executed on copper, is a typical product of the refined Mannerist painting at the court of the Emperor Rudolph II in Prague, whose major exponent was the brilliant artist from the Brabant, Bartholomeus Spranger. Having lived for ten years in Rome, Spranger was imbued with the "Italian Manner" and after he established himself at Prague he painted a series of stupendous mythological scenes that are charged with a disquieting sensuality (see page 125). Subsequently the German painter, Hans von Aachen, introduced a kind of painting more in the vein of Correggio and the Venetians to Prague. Heintz, the youngest master of the three, who was Swiss, adopted the softness and grace of von Aachen. His mythological compositions, with their nuances of contour and delicate shading, contrast somewhat with the sculptural form and the high color of Spranger's creations.

CASPAR DAVID FRIEDRICH. *View from the Painter's Studio.*

p. 34

The artist belongs to the great Romantic movement. His friends included such writers and philosophers as Novalis, Tieck, Schelling and Steffens, whose influence must have deepened the intense reflective quality that is fundamental to his art. For Friedrich, as for many other Romantics, art was something that is indissolubly connected with life. Through art he sought to express the religious sentiments that he felt when faced with reality — sentiments that are irresistible, overwhelming and exclude all else. Friedrich suffered from loneliness and hypochondria, and was mentally unbalanced during the latter years of his life. David d'Angers wrote that Friedrich had discovered "the tragedy of the landscape." One might also say that his landscapes, often inspired by Ruisdael, are dialogues with the absolute. In the present painting, which is one of his most original works and one of the least loaded with Romanticism, the artist emphasizes the structure of the large window and seems to prefigure the dream-effects of Surrealism.

JOSEPH HEINTZ
Basel 1564 — Prague 1609
Probably a pupil of Hans Bock the Elder at Basel. From 1584 he was in Rome, associating with Johann von Aachen. From 1591 he was in the service of the Emperor Rudolph II. Again in Rome in 1593. Documents exist showing that he was in Prague in 1594 and 1598. From 1604 to 1608 he was mainly in Augsburg.
Venus and Adonis
Oil on copper; 15 3/4" × 12 1/4".
Listed in Mechel's inventory of 1783.

On page 34:
CASPAR DAVID FRIEDRICH
Greifswald 1774 — Dresden 1840
After four years of study in Copenhagen, he moved to Dresden in 1798, and he taught in the local Academy from 1817.
View from the Painter's Studio
Sepia ink on paper; 12 1/4" × 9 1/2".
A note on the back of the picture states that the painter has shown his studio on the Elbberg in Dresden. It was executed in 1805-6. With its companion piece, which is also in the Art History Museum, it was donated in 1916 by the Viennese antique dealer, G. Nebehay.

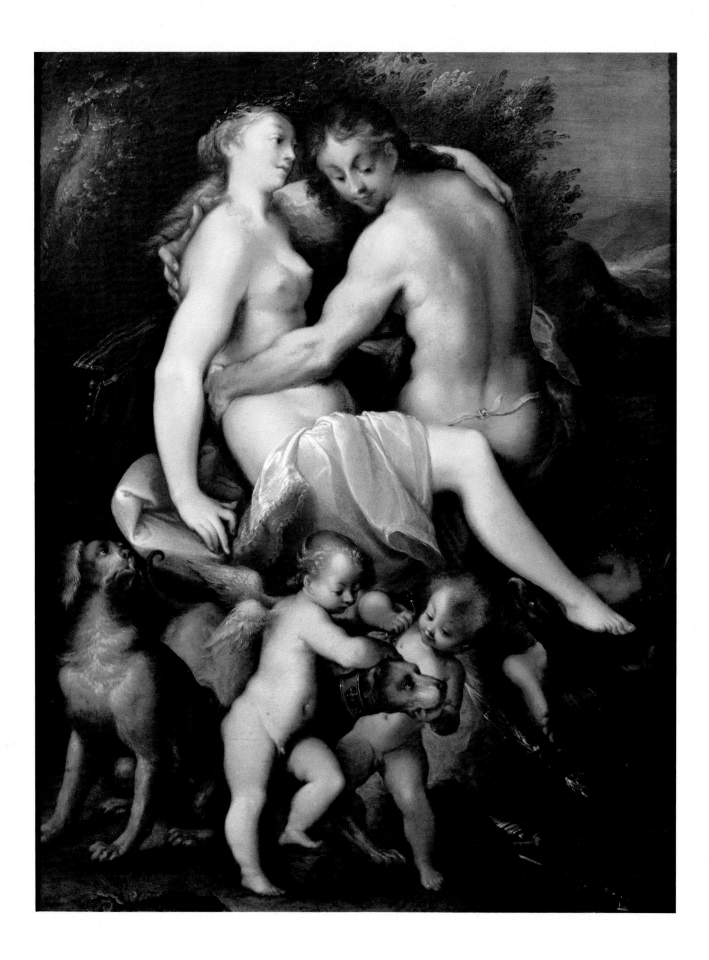

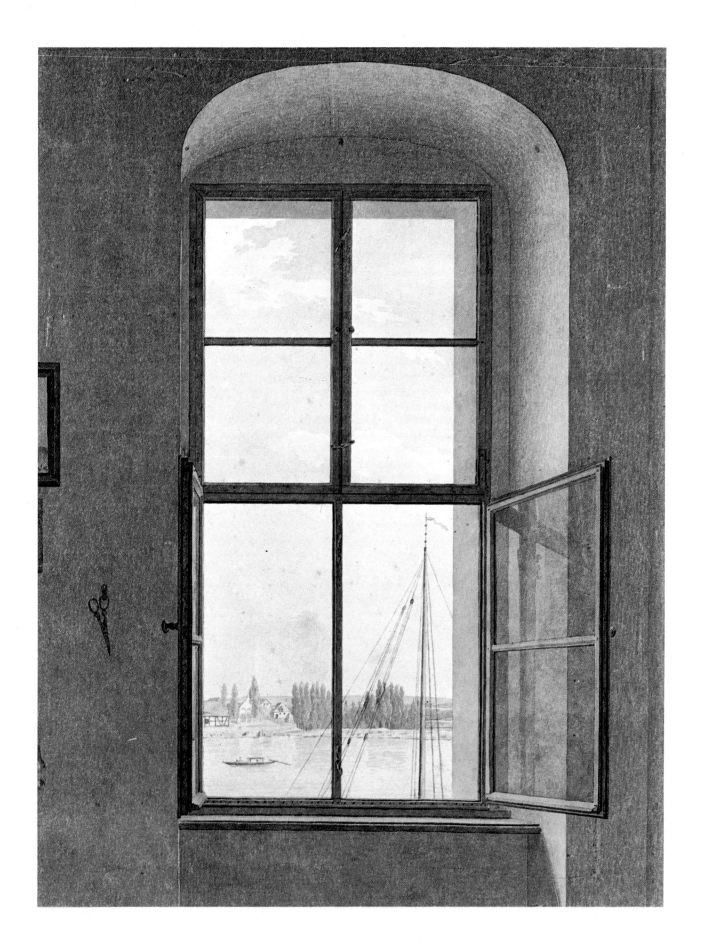

ITALY

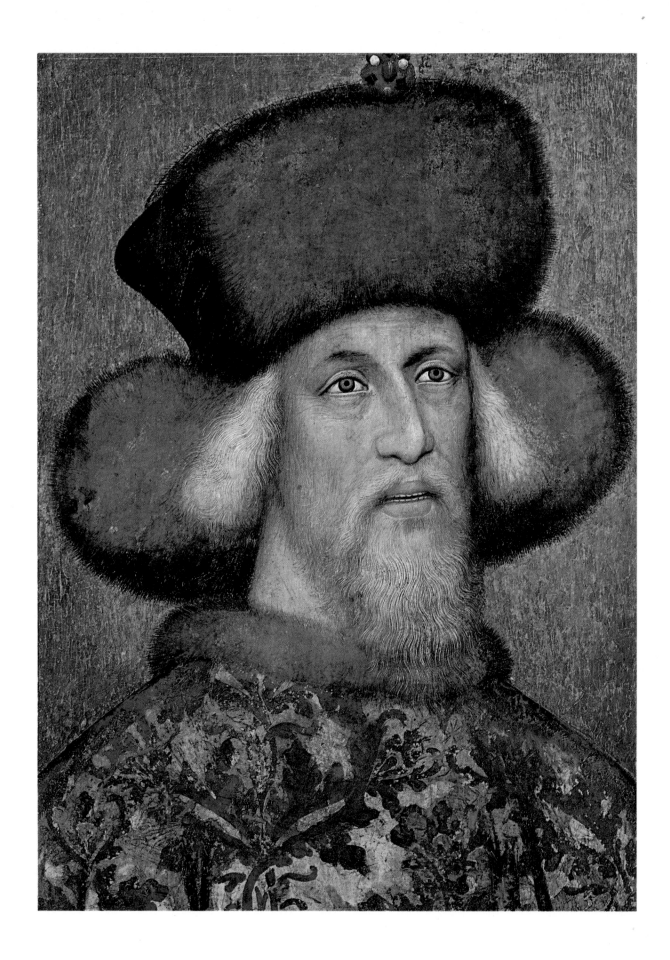

PISANELLO. *Portrait of the Emperor Sigismund.*

Sigismund of Luxemburg (1386–1437) had a high estimation of the imperial authority: he summoned the Council of Constance in an effort to end the Great Schism, and he was responsible for the burning of Jan Hus. During a visit to Italy in 1432 and 1433 he was portrayed — and other representations confirm the image — as white-haired and white-bearded, proud, looking straight ahead, with a slight smile on his lips and a suggestion of melancholy in his eyes. The figure is placed in three-quarter pose and looms large in the picture space. The fur hat makes an imposing volume that is as effective, say, as one of Paolo Uccello's *mazzocchios* (headdresses). The artist's taste for stylizing forms is seen in the cylindrical development of the face and neck, the rotundity of the fur-edged neck opening and the elimination of purely naturalistic detail. Such formal features endorse Degenhart's judgment, for he was the scholar who in 1944 ascribed the painting to Pisanello, conjecturing that it was executed during the Emperor's stay in Italy. Rasmo (1955), however, sees this as a Northern work and relates it to the anonymous decorator of the Capuchin Convent in Prague, who belongs to an entirely different — plastic and realistic — tradition. It seems to us that no other Bohemian painter, not even the creator of the *Namesi Polyptych,* is close to the author of this painting stylistically.

COSMÈ TURA. *Pietà* (or *The Dead Christ Supported by Two Angels*).

p. 38

This is the fragment of a large work, the rest of which has been dispersed. Time and human vicissitudes have reduced the artist's not very large production. Fortunately what remains of this mutilated painting is fairly complete in itself. And it is superb in the originality of its atonal and resounding colors, the incisiveness of the drawing and the luminescent metaphysical landscape against which the dark wings of the angels stand out. The mutilation, however, has unfortunately emphasized the glassy elements of the landscape, whereas their original function was to stay in the background and serve as relief to the compactly composed human forms in the foreground. Pathos was congenial to Tura's spirit and is emphasized here in the dead weight of the body of Christ. It is softened in the figures of the angels, especially the one shown in profile, which is a brother to the gentle creatures of the *Rovarella Altarpiece.* The present *Pietà* is close to that great altarpiece, which is considered to be Tura's most "classical" masterpiece. The softening of the Ferrarese artist's sculptural form, which was influenced by Mantegna and Pisanello as well as by Piero della Francesca and Rogier van der Weyden, is attributable to his attraction to painters of the Venetian School, such as Vivarini, the Bellinis and Marco Zoppo.

ANDREA MANTEGNA. *St. Sebastian.* p. 39

The painting has been identified by Tietze as the mysterious "little work" that Antonio Marcello had ordered from Mantegna, thus delaying the artist's departure from Padua to Mantua in 1450. It is difficult, however, to accept such an early date, which would make the "stony" *St. Sebastian* contemporary with the flexible, linear figures of the Cappella Ovetari. Nor is it possible to accept recent hypotheses that would relate it to the monu-

PISANELLO
(ANTONIO DI PUCCIO PISANO)
Pisa circa 1395 — Naples (?) 1455
Portrait of the Emperor Sigismund
(1432–33)
Parchment mounted on wood;
25 1/4″ × 19 1/4″.
At the Stallburg in 1772, and at the castle of Ambras in 1833.
Put on view in Vienna in 1930.

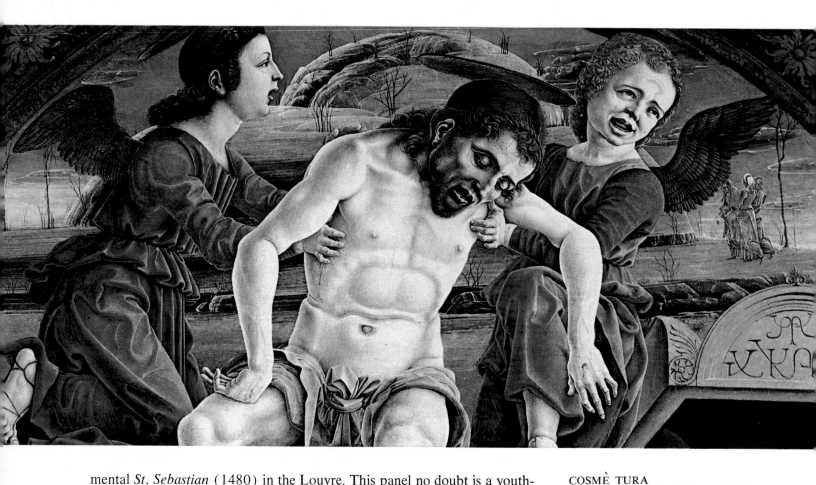

mental *St. Sebastian* (1480) in the Louvre. This panel no doubt is a youthful work, intense and richly developed in every detail, and it comes between the *St. Zeno Altarpiece* (1457–59) and the triptych in Florence. Otherwise there would be no explanation for such similarities as the architectural detail, the scanning of the pavement lozenges in perspective, the lovingly chiseled archaeological fragments and the eroded rocks along the road. In its narrative aspect, the painting is also concise and intense. Transfixed by arrows, the saint manages incredibly to resist the pain. Irene, with her pious, healing hands has not yet appeared; the cruel archers have gone off toward the city on the hill edged by the river. The event has thus been set in time, but one has the impression that it is an instance of the artist's youthful "cultural romanticism." The city is Rome, but not the sumptuous capital of Diocletian: it is shown as a hill sown with desolate and solitary ruins, as if after a devastating barbarian invasion.

ANTONELLO DA MESSINA. *The San Cassiano Altarpiece.*

pp. 40–41

This fragment is a valuable example not only of Antonello's development, but of that of Venetian painting. Taking into account derivations (like the altarpiece by Alvise Vivarini in Berlin) and copies of lost fragments (executed by Teniers), Wilde made a persuasive, ideal reconstruction of the entire work in 1929. The original composition was commissioned by the patrician Bon in 1474 from the Sicilian artist, who was by then at the end of his career. According to Wilde, we must imagine the Virgin sitting on a

38

COSMÈ TURA
Ferrara circa 1430 — Ferrara 1495
Pietà (or *The Dead Christ Supported by Two Angels*) (circa 1475)
Formerly transferred from wood to canvas, retransferred to wood in 1942;
17 1/2″ × 33 3/4″.
On the sarcophagus is an inscription in somewhat fanciful Hebrew letters which seem to read: "TURA."
Acquired in 1857 from the Adamovicz collection. Originally it was the lunette of an altarpiece or a polyptych. According to Ruhmer's hypothetical reconstruction, the composition also included the *Madonna* in Bergamo, the wing in Nantes and the *Bishop* in New York — but these works do not appear to be contemporary.

ANDREA MANTEGNA
Isola di Carturo 1431 — Mantua 1506
St. Sebastian (1459–60)
On wood; 26 3/4″ × 11 3/4″.
The column on the left bears the Greek inscription: "TO ERGON TOU ANDREOU" ("The work of Andrea").
Cited in 1659 as being in the collection of the Archduke Leopold William.

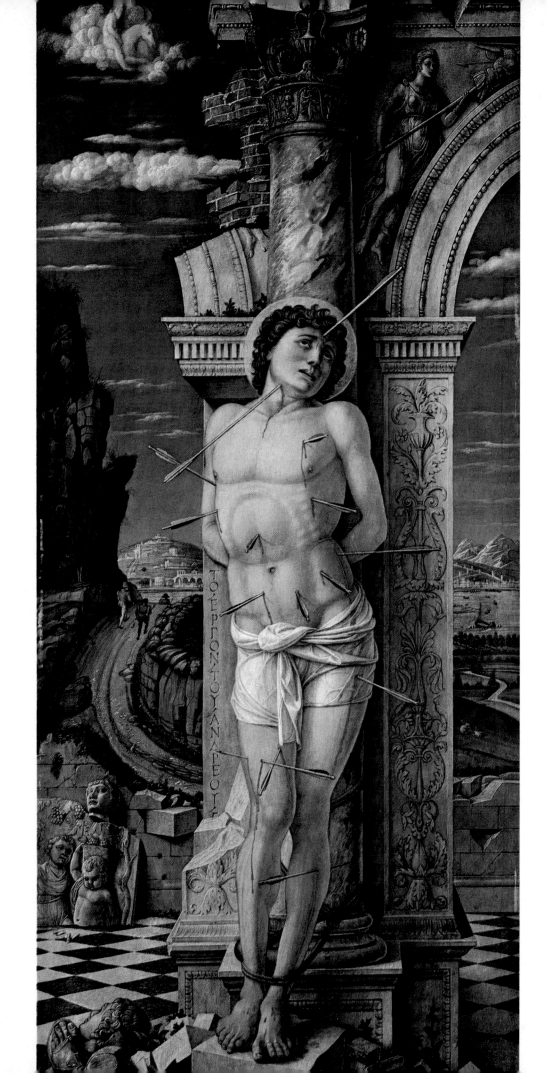

ANTONELLO DA MESSINA
(ANTONELLO D'ANTONIO)
Messina, perhaps in 1430 — Messina 1479
The San Cassiano Altarpiece: Madonna and Child with Saints. (On the left, St. Nicholas of Bari and St. Anastasia (?); on the right, St. Ursula and St. Dominic) (1475–76) Fragment.
On panel: the left, 21 3/4″ × 13 3/4″; center, 45 1/4″ × 24 3/4″; right, 22 1/4″ × 14″.
The altarpiece was removed from the church of S. Cassiano in Venice during repairs in 1620. Until 1636 it was in Bartolomeo della Nave's collection. Subsequently it was owned by the Duke of Hamilton, and in 1659 it entered the collection of the Archduke Leopold William.
Left:
Detail showing St. Anastasia.

high throne with four saints at the sides, and also the full figures of a warrior saint (George or Liberale) with St. Rosalia on the left, and of St. Helena with St. Sebastian on the right. The scene was set under the vault of a Renaissance arcade, an arrangement clearly echoed in Cima's altarpiece in the Duomo of Conegliano and in Bellini's for San Giobbe. It should not be forgotten, however, that Bellini had already composed a *Sacra Conversazione* in an architectural setting, in the lost *Altarpiece* of S. Giovanni e Paolo. But it is clear what a stimulus Antonello provided for the Venetians, "in going beyond the harsh heredity of Mantegna and his nervous line, which is now converted in a broader and more relaxed play of planes, where the color has a more intense definition" (Bottari). The encounter between Bellini and Antonello, representing two different traditions and creative approaches, was certainly facilitated by their common experience of the art of Piero della Francesca. Antonello's perspective monumentality and Bellini's linear sensitivity were softened by that influence. Sensual Flemish color was wed in Venice with color of eastern origin, and this perhaps explains why the *San Cassiano Altarpiece* spoke a fascinating, comprehensible language to the Venetians.

41

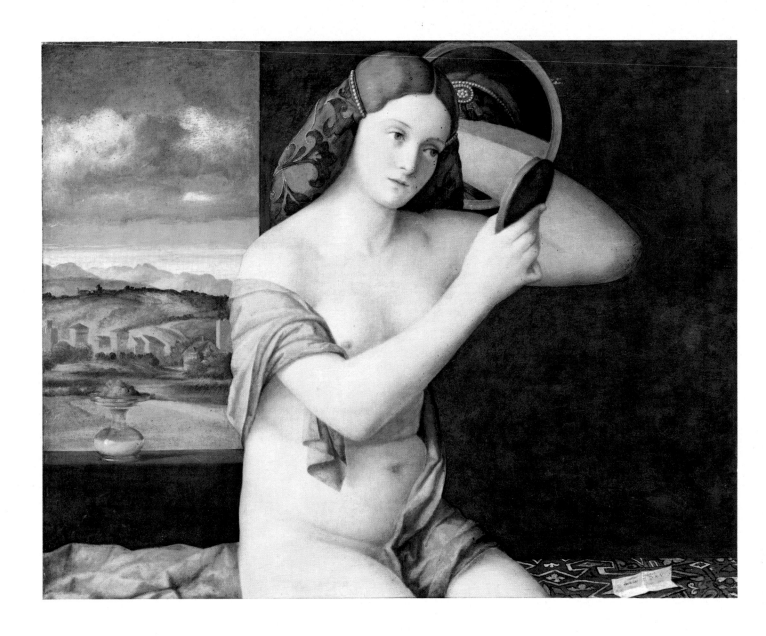

GIOVANNI BELLINI. *Young Woman Doing Her Hair.*
A rare work because of its secular subject, it was painted a year after the *Feast of the Gods* (see *National Gallery/Washington,* page 36). It testifies to the vitality and capacity of renewal of the great, octogenarian painter. In the clarity of the color and the regular division of the planes, it still seems to show a 15th-century approach, but in fact it reflects the topical concerns in art at the beginning of the second decade of the 16th century. The Giorgionesque motif of the mirror on the wall is utilized for a refined play of geometrical, sculptural forms, rather than for a multiplication of views. The chaste subject, with its light, measured and luminous passages, corresponds to the canon of beauty of Giorgione's Venuses and Titian's early nudes. Its Neo-Hellenic flavor has its natural climate in the subtle literary psychologizing that became current in Venice through Bembo's *Asolani,* with its descriptions of idealized feminine beauty and its disquisitions on love.

GIOVANNI BELLINI
Venice after 1430 — Venice 1516
Young Woman Doing Her Hair (1515)
On wood; 24 1/2″ × 31″. Slightly cut down on the right.
The Latin inscription on the slip of paper states that Giovanni Bellini did the work in 1515.
From the collection of the Archduke Leopold William (1659). The background, which had been repainted black, was cleaned in 1937.

42

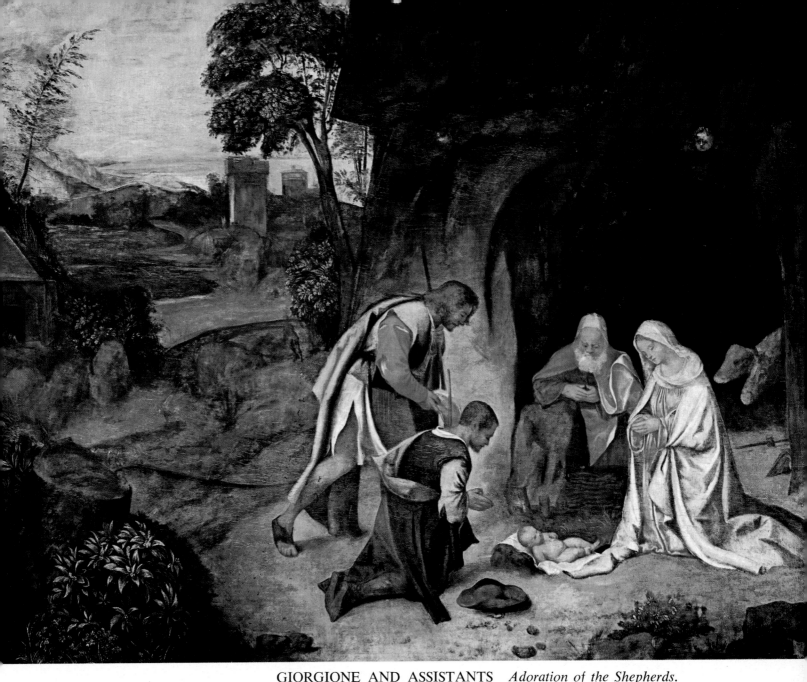

GIORGIONE AND ASSISTANTS *Adoration of the Shepherds.*
In the body of Giorgione's works this *Adoration* is the only probable instance of a replica, repeating the very fine *Allendale Adoration* (see *National Gallery/Washington,* pages 46–47). A few days after Giorgione's death (October 25, 1510) Taddeo Albano wrote to Isabella d'Este that there were two identical compositions of the "Night," one which was "not entirely perfect" and the other "better drawn and better finished." He added that both were "considered to be by Giorgione by the friends who were closest to him." It is probable that, commissioned by Taddeo Contarini, Giorgione had laid out this replica of the original work he had created for Vittorio Beccaro, without having been able to bring it to completion. In this painting — in comparison with the *Allendale Adoration* — the landscape is vague and summary, the atmosphere somber and leaden, and all the elements of the composition show the approximations of a copyist's hand. Baldass and Heinz, who defend the high quality of the work, believe that the painterly aspects to be seen here and there are due to Titian.

GIORGIONE and assistants
(GIORGIO DA CASTELFRANCO)
Castelfranco circa 1477 — Venice 1510
Adoration of the Shepherds
On panel; 35 3/4″ × 45 1/4″. Unfinished.
In Bartolomeo della Nave's collection in Venice until 1636. Subsequently in the Duke of Hamilton's collection from 1638 to 1649, and finally in the collection of the Archduke Leopold William.

43

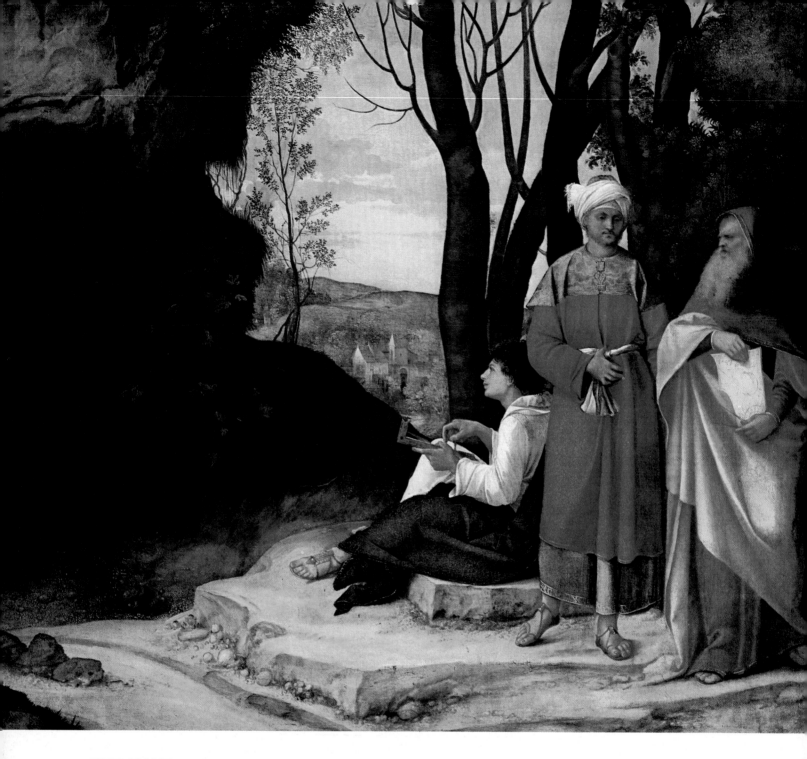

GIORGIONE. *The Three Philosophers.*

Marcantonio Michiel (1525) noted the presence in Taddeo Contarini's house of a "canvas painted in oil of three philosophers in a landscape . . . [which] was begun by Zorzo [Giorgio] da Castelfranco and finished by Sebastiano Veneziano [del Piombo]." The attribution has not been questioned, but the part that Sebastiano del Piombo had in it is considered very slight. It would seem logical to place this work between the *Castelfranco Madonna* and the *Tempest,* stressing the tendency toward monumentality which prepares the way for the painter's grandiose mural decoration of the Fondaco dei Tedeschi. The three mysterious figures are skillfully grouped to dominate the foreground; in the variety of their poses, they suggest the

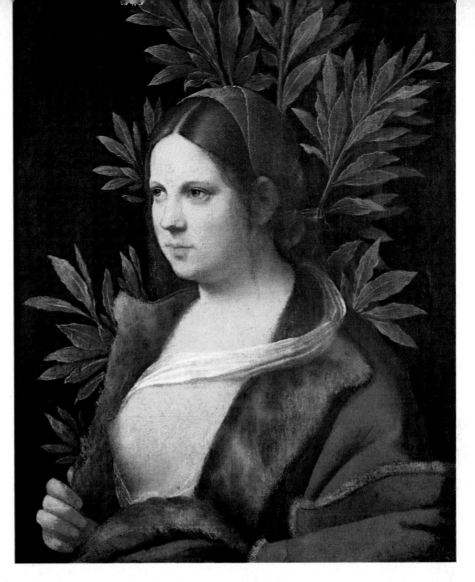

extent of that foreground, which the fanciful rock limits in order to give a feeling of vast spreading space. The color, with its luminous gradations, still defined by clear, elegant contours, fully renders the plasticity as well as the psychological subtleties of the figures.

Philosophers? The Magi? Certainly they do not meet by chance. In the 18th and 19th centuries Michiel's description was replaced by the suggestion that the figures represent historical personages or the biblical Three Kings. And Giorgione was supposed to be revealing a spiritual attitude, stemming from Padua, that influenced Venetian society of his time. The three figures are taken to represent: the authority of ancient thought, the meditations of the Aristotelian Arab thinkers and the empirical and naturalistic approach of modern philosophy. The picture would accordingly be a non-religious epiphany, symbolizing the wait for the revelation of truth, which is identified with the miracle of that extraordinary light on the horizon.

GIORGIONE. *Laura.*

This painting bears an inscription on the back that must be taken as contemporary, and the attribution has been largely accepted by scholars since 1908, when Justi supported it. The elaboration of the color as the main expressive means suggests a period close to that of the *Tempest*. It is very unlikely that the painting is a portrait. The type of regular, oval face is seen

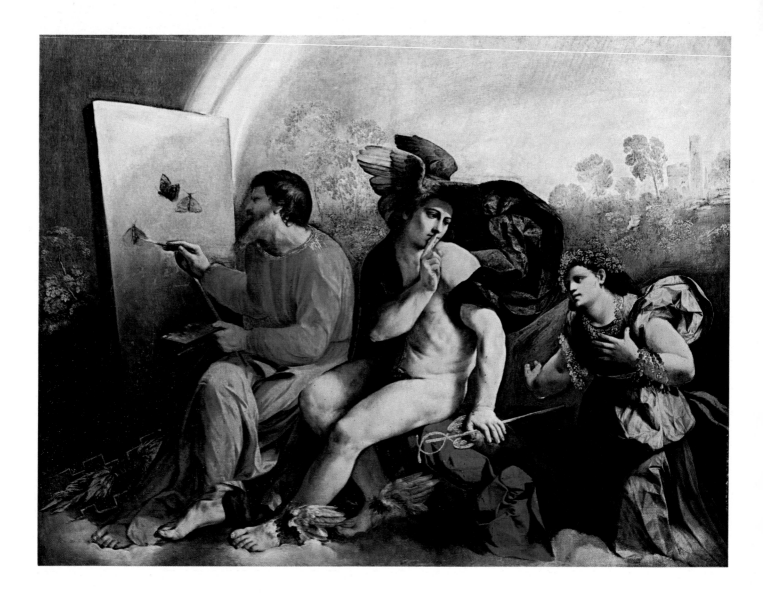

in two figures in the youthful *Adoration* in London, as well as in the *Tempest*. Rather the image seems to be a symbol of femininity, and its title, which derives from the laurel branches, is in keeping with the lively revival of Petrarchism·in the Venetian literary world at the beginning of the 16th century. It is warmed, however, with a refined sensuality. The golden flesh tones and the bright carnality of anatomical details are exalted, as in Titian later on, by the sumptuous red dress and the soft fur. A renewed Flemish influence accounts for the richness of color and the tactile sensuality.

DOSSO DOSSI. *Jupiter, Mercury and Virtue.*

In 1900 Schlosser identified this subject from a note inserted in a text of Lucian's dialogues. Further speculation by Panofsky and Klauner complicated the original interpretation with allegorical and astrological hypotheses. The subject is seen as the indifference of the gods to human circumstances: Virtue has come to Olympus to complain about the wrongs done by Fortune, and is prevented by Mercury (center) from disturbing Jupiter at his easel.

DOSSO DOSSI
(GIOVANNI DE' LUTERI)
Mantua (?) 1479 — Ferrara 1542
Jupiter, Mercury and Virtue (circa 1525)
On canvas; 43 3/4″ × 59″.
Martinioni describes it in 1663 as belonging to Count Widman in Venice, and as being a work by Dosso. Boschini also mentions a painting of the same subject owned by the Bonfadini family, which was perhaps a copy. In the 19th century it was in the Daniel Penther collection in Vienna, then in that of Count Lanckoronski. Donated to the museum in 1951 by Count Dr. Anton.

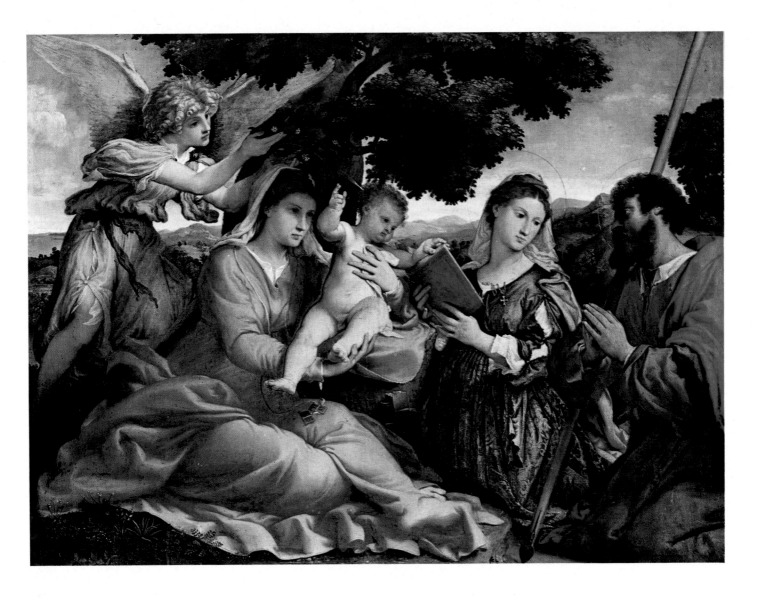

This would be in keeping with certain ironic aspects of Dossi's attitude toward life. The painting has been correctly dated in the second half of the third decade of the 16th century. This is borne out by its fundamentally Venetian character expressed in the chromatic turmoil of the reds, orange and magenta against the green blues of the background. At the same time the light derives from Lombard realism and the influence of Dossi's brief stay in Rome (1519–20) is evident. The fine pictorial rendering makes a pleasing work of this good-natured and even middle-class Olympus.

LORENZO LOTTO. *Madonna Crowned by an Angel,*
with SS. Catherine and James the Elder.

LORENZO LOTTO
Venice circa 1480 — Loreto 1556
Madonna Crowned by an Angel, with
SS. Catherine and James the Elder (circa
1530–31)
Oil on canvas; 44 1/2″ × 59 3/4″.
Mentioned by Boschini (1660) as in the
imperial collection in Vienna.

This is one of the most impressive works of Lotto's maturity — the composition is elegant, the colors exquisite in the springtime light and the figures are linked by a unity of feeling. It is also one of the few works by Lotto in which the delightful spectacle of nature harmonizes with a serene awareness of the meeting of the human and the divine in the figures. Probably St.

47

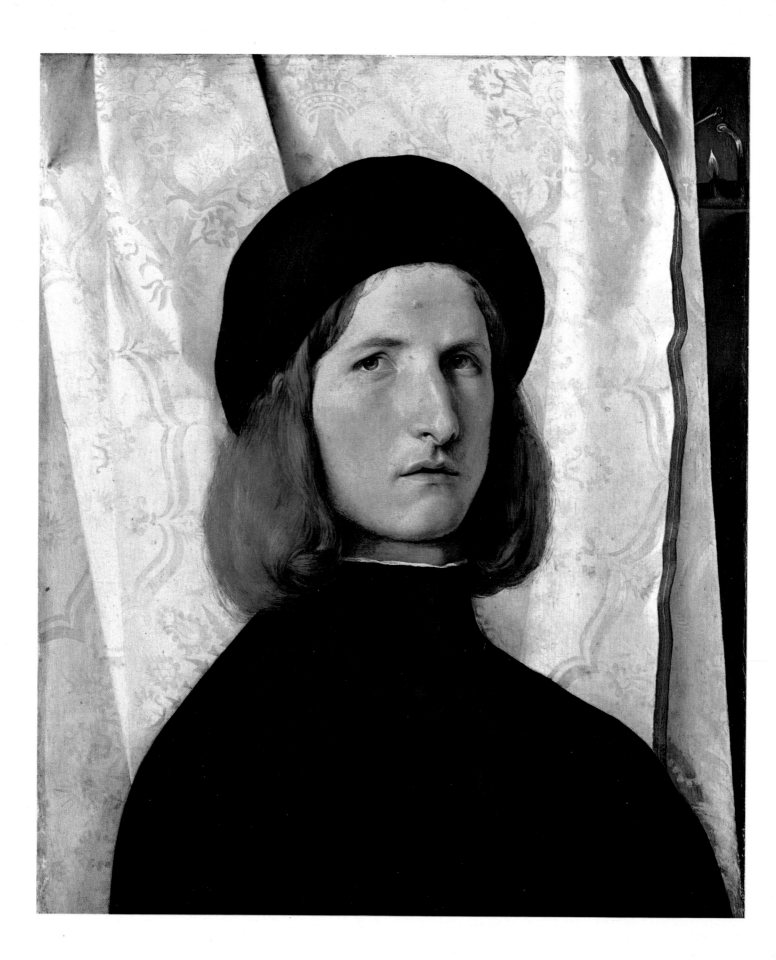

Catherine is a portrait, and she is certainly dressed with refined elegance. The little gold cross and chain glinting against the greenish dress is an extremely subtle detail. Berenson holds that it is Lotto's only work in the taste of Palma Vecchio's various *Sacre conversazioni*, and he dates it 1527–28. However, we believe that it should be dated some years later, but in any case before the *Madonna and Sleeping Child, with Saints* (1533) in the Accademia Carrara at Bergamo.

LORENZO LOTTO. *Portrait of a Young Man.*
This masterpiece is datable at the end of Lotto's first "Venetian" period. Perhaps it was executed during his sojourn in the Marches, before he moved to Rome in March, 1509, to work on the decoration of one of the Stanzas later frescoed by Raphael. In the turn of the dark chest and shoulders, the brown hair and the dark beret, the image of the young man is set forth decisively against the very light satin edged with green. Beyond the curtain in front of which the subject is posed, there is a hanging oil lamp: it symbolizes the transitory nature of time. Lotto has reduced his color range to a few elements, within a structure of cool relationships, and has given the maximum vibrancy to the linear contours which circumscribe the color. The binding element between color and the taut but fluid line — still following the suggestion of Dürer's work — is the light. Whereas Giorgione imbues his portraits with a mysterious dream quality by means of warm and enveloping color, Lotto attacks his subjects with lucid and nervous precision, looking within them.

PERUGINO. *Baptism of Christ.* *p. 50*
A work of Perugino's full maturity, the painting dates from the beginning of the 16th century. In reduced size it repeats the central motif of his fresco in the Sistine Chapel (around 1480). Christ is the usual young neophyte, similar to the pensive Apollo in the *Apollo and Marsyas* of the Louvre (see *Louvre/Paris,* page 129). The two figures are enclosed in an oval whose summit is marked by the white dove. They have a symmetrical rhythm and are statically constructed, with the linear development of their bodies contained within the oval scheme. While this aspect of the composition is evident, the spatial grouping of the angels is not resolved, bunched up as they are to the left against a background of dense, dark foliage. The aureoled figure on the right (Christ transformed by baptism and ready for his mission?) is also superfluous and sacrifices the space of the magnificent landscape, which extends to the lake and the distant mountains.

RAPHAEL. *Madonna in the Meadow (Madonna nel Prato).* *p. 51*
It is one of three versions of the same theme, the other two are the *Madonna del Cardellino* (Florence, Uffizi, 1506) and the *Belle Jardinière* (Louvre, 1507). There is general agreement that this painting is the prototype of the felicitous invention — and thus the earliest of the three. From 1504 Raphael was occasionally in Florence, and about 1506 he settled there. There he found an art world full of developments and stimulation, which was dominated by Leonardo and Michelangelo. In this early phase Raphael seems to have been attracted only by Leonardo, as is seen in his

LORENZO LOTTO
Portrait of a Young Man (circa 1508)
Oil on panel; 16 1/2″ × 21″.
In the museum since 1816.

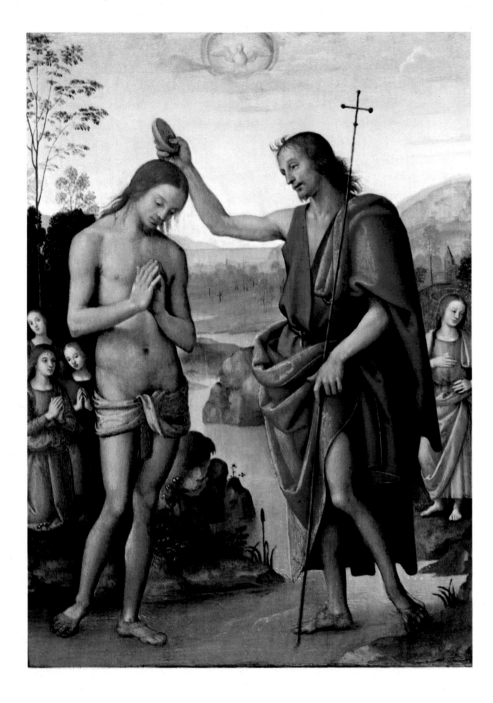

PERUGINO
(PIETRO VANNUCCI)
Città della Pieve (Perugia)
circa 1450 — Città di Castello 1523
Baptism of Christ (1490–1500)
On olive-wood panel; 11 3/4" × 9 1/4".
Cited in the inventory of
Ambras Castle in 1723.

RAPHAEL
(RAFAELLO SANTI)
Urbino 1483 — Rome 1520
Madonna in the Meadow
(*Madonna nel Prato*) (1505–6)
On poplar-wood panel; 44 1/2" × 34 3/4".
The date, "M.D.V.I.", is inscribed on the
border of the Virgin's robe. The last figure,
however, may be part of the ornamentation,
and the date may thus be 1505. According
to Vasari and Baldinucci, the painting was
a present from Raphael to the Florentine,
Taddeo Taddei. In 1662 it was acquired
from the Taddei family in Florence by the
Archduke Ferdinand. Until 1663 it was in
the castle of Innsbruck, then at Ambras.
Since 1773 it has been in Vienna.

use of a pyramidal composition, the atmosphere of static contemplation and the type of Madonna who recalls the psychological subtleties of the *Gioconda*. It has been observed that the over-all pyramidal scheme generates a smaller one, which is formed by the figures of the tender little children; their light bodies stand out against the dark blue of the robe and the green of the meadow. We know that Raphael had a deep and inherent disposition toward simplification of form, which he achieved through inspired and carefully thought out preliminary drawings (at Oxford and in the Albertina, Vienna). The *Madonna del Cardellino* is later, but the landscape in the present painting represents a higher expression, for in it the artist avoided

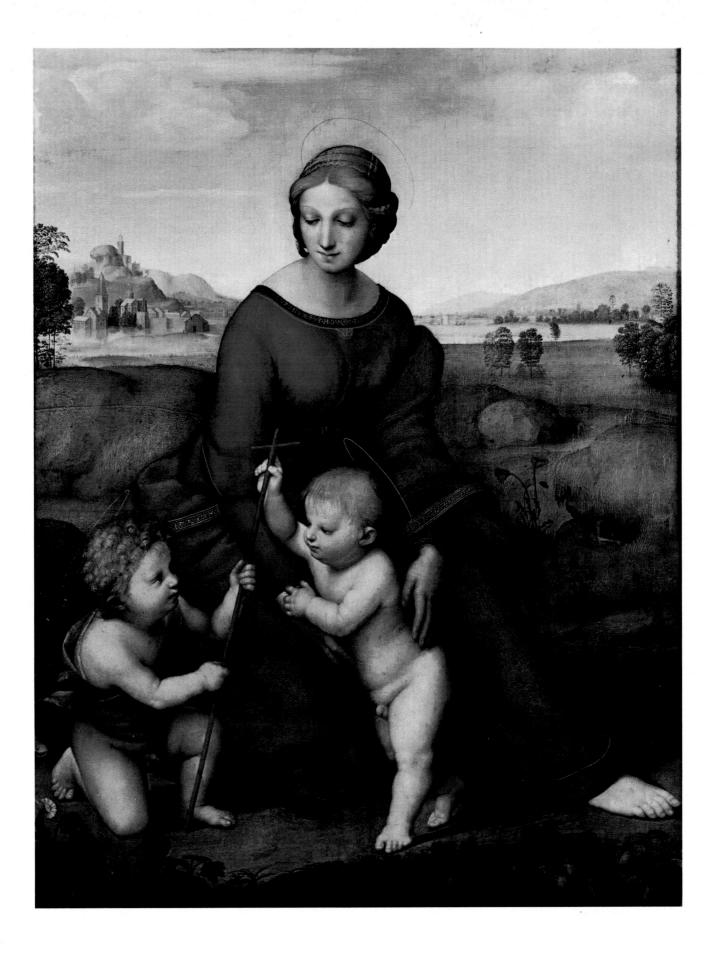

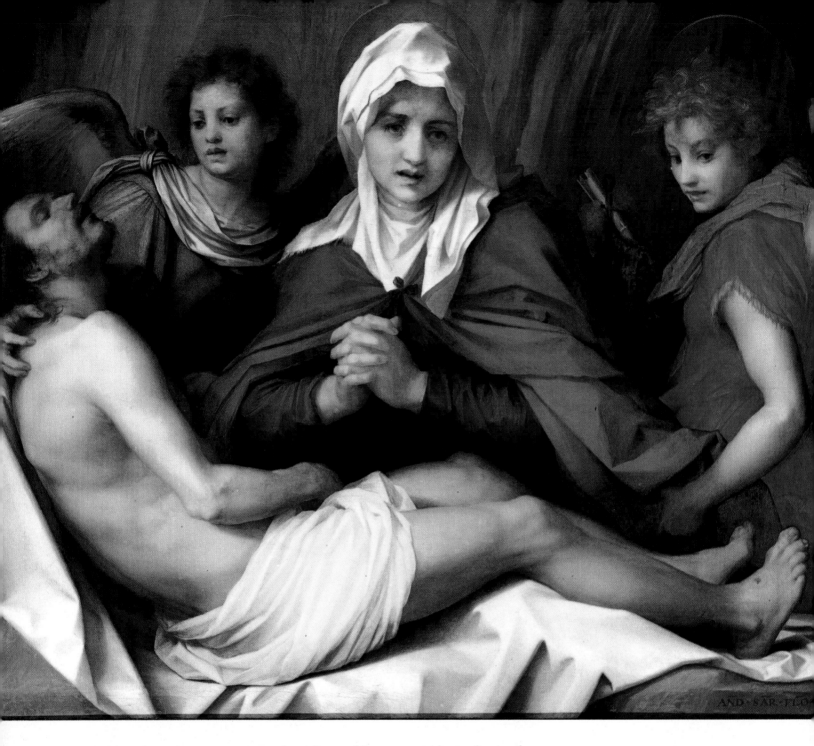

accidentals and unnecessary variety. It provides a reassuring echo to the shadow of melancholy that has descended on the Virgin's face as she contemplates her son playing with the cross — a plaything handed to him by the oblivious St. John.

ANDREA DEL SARTO. *Pietà.*

The complicated personality of Andrea del Sarto, admired mainly for his remarkable skill and his somewhat pietistic religious feeling, has recently been put into new historical perspective. In relation to the art of his times, he was drawn to Raphael's classicism but perturbed by Leonardo's subtleties and Michelangelo's heroic amplitude. This *Pietà* represents a moment of stylistic tension, coming after his stay in France and was stimulated by

52

ANDREA DEL SARTO
(ANDREA D'AGNOLO DI FRANCESCO)
Florence 1486 — Florence 1530
Pietà (1519–20)
On panel; 39″ × 47 1/4″.
Inscribed: "AND. SAR. FLOR. FAB" ("Made by Andrea Sarto of Florence").
Vasari mentions a painting of this subject in SS. Annunziata. In 1635 it was in the Duke of Buckingham's collection. After the sale at auction of the collection at Antwerp in 1648, the work was acquired by the Emperor Ferdinand III and taken to Prague. In 1953 the panel was cleaned and restored, at which time repainting on the sheet was removed.

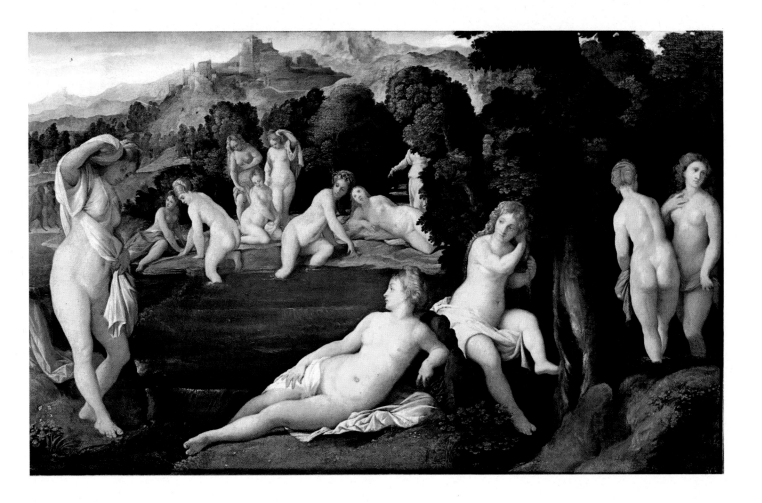

Pontormo's work and perhaps by an acquaintanceship with Northern European prints. A very carefully calculated composition is made up of the Christ supported by an angel, the Virgin blanched by sorrow and her angelic attendant who could be a figure sprung from Lotto's subtle imagination. The figure of the dead Christ is drawn with unusual attention to naturalistic detail. This is accompanied by vivacious color, as in the iridescent wings of the angels and the blood-red smears on the loincloth.

PALMA VECCHIO. *Diana and Callisto.*

Formerly ascribed to Cariani, this painting was identified by Wilde (1931) as a work by Palma Vecchio. The composition, cut down at the sides and above, represents the moment in which Diana, bathing with her virgin nymphs, discovers that one of them, Callisto, is pregnant. In the reclining figure of Diana the artist repeats a representational scheme he has used before, in the *Venus* of Dresden and elsewhere. Some of the nymphs recall the poses of classical statuary. Nevertheless, the composition is particularly coherent, in the ease with which the elegant nudes are disposed in the open, luminous space, and in the idyllic feeling of the landscape. The work is a significant development of the naturalistic tradition stemming from Giorgione, before the crisis of Mannerism revolutionized Venetian painting.

PALMA VECCHIO
Serina (Bergamo) circa 1480 — Venice 1528
Diana and Callisto (circa 1525)
Oil on canvas
(subsequently transferred to panel);
30 1/2″ × 48 3/4″.
In Bartolomeo della Nave's collection until 1636, then in the Duke of Hamilton's, in London. In 1659 it entered the collection of the Archduke Leopold William.

53

TITIAN. *Gypsy Madonna.*

The Art History Museum is second only to the Prado in its number of Titians. These show the various aspects of the painter's development, which is one of the most adventurous and dramatic in the history of Italian art. In this composition, the Madonna supports the Child who is standing on the edge of a parapet; behind them is a curtain and beyond, an extensive landscape (X-ray examination has shown that the horizon line when first laid in was higher). Here the teachings of Giovanni Bellini and Giorgione merge, but in an intensely personal interpretation marked by Titian's use of soft, tonal and highly structural color. The warm light of imminent dusk envelops and gives substance to the color, which is serenely calibrated in the space. The Madonna, who is a sister to the *Salome* in the Doria collection, already has all the majesty of Titian's great religious subjects.

TITIAN. *Madonna of the Cherries.*

This composition certainly belongs to the group that includes the *Sacra Conversazione* and the *Christ with the Coin* in Dresden, as well as the *Annunciation* in Treviso. The art historian Gronau (in 1904) proposed a date be-

TITIAN
(TIZIANO VECELLIO)
Pieve di Cadore circa 1488–90 — Venice 1576
Gypsy Madonna (not later than 1512)
Oil on panel; 26″ × 32 3/4″.
Cited as being in the
Archduke Leopold William's collection in 1659.

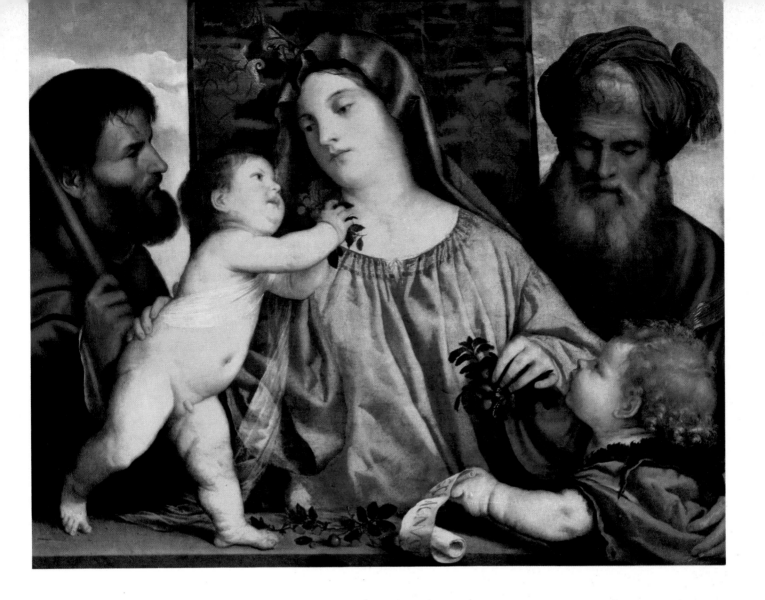

tween 1512 and 1515, but this should obviously be amended to between 1516 and 1518. When the painting was transferred from canvas to panel a century ago, it was found that St. Joseph and St. Zacharias were later additions intended to balance the composition. The theme of the three central figures derives from Dürer. The different points of view of the figures, their grandiosity and their interrelationship somehow all work to create a particularly affectionate atmosphere. The painting is religious in inspiration, but conceived with a naturalism and a power of expression that are entirely new.

TITIAN. *Violante.* *p. 56*

In 1927 Longhi established Titian as the author of this portrait of a girl, which had previously been ascribed to Palma Vecchio. Perhaps Titian had Raphael's *Donna Velata* in mind; certainly the composition of the two half-figures is similar. Deep and rigorous stylistic development marks "the beautiful kitten," as she was called in the 17th century. The ample turn of the arms and the round line of the shoulders are coherently linked; the curving planes of the face are animated by the slight smile on the girl's lips. Al-

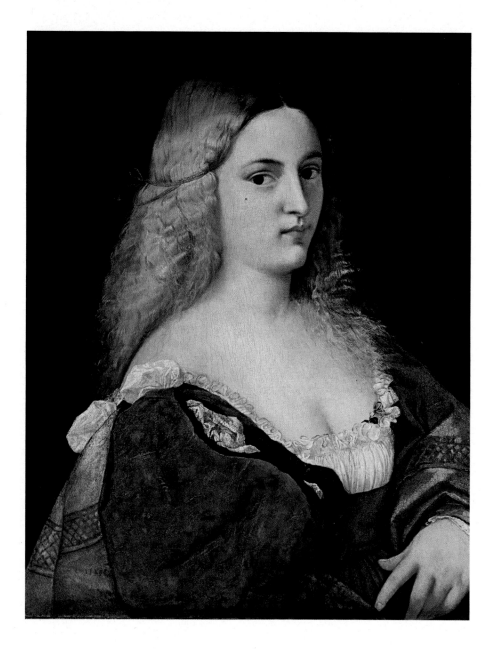

TITIAN
Violante (circa 1515)
Oil on panel (cut down a little below
and on the right); 25 1/2″ × 20″.
Until 1636 in Bartolomeo della Nave's col-
lection in Venice, then in the Duke of Ham-
ilton's and in that of the Archduke Leopold
William.

though today the surface of the portrait appears a little hard and metallic, it
is still possible to discern the fine brushwork of subtle passages of light and
shadow, which becomes freer in the light-drenched hair.

TITIAN. *The Bravo.*

In the brutality of the subject and the corruscating light, the two-figure com-
position is highly dramatic. It is not unlikely that *The Bravo* was executed
during the same years as the *Polyptych of SS. Nazarius and Celsus* in
Brescia (1520–22). Stylistically they are the same. Probably this is the
painting described by Michiel as "two half-figures assailing each other" by
Titian, which in 1528 was in Gianantonio Venier's house in Venice.

TITIAN
The Bravo (1520–22)
Oil on canvas; 29 1/2″ × 26 1/4″.
The painting was variously ascribed to
Giorgione, Cariani and Palma Vecchio.
Longhi and Suida are responsible for its
present attribution. In Bartolomeo della
Nave's collection in Venice until 1636;
subsequently in those of the Duke of
Hamilton and the Archduke Leopold
William.

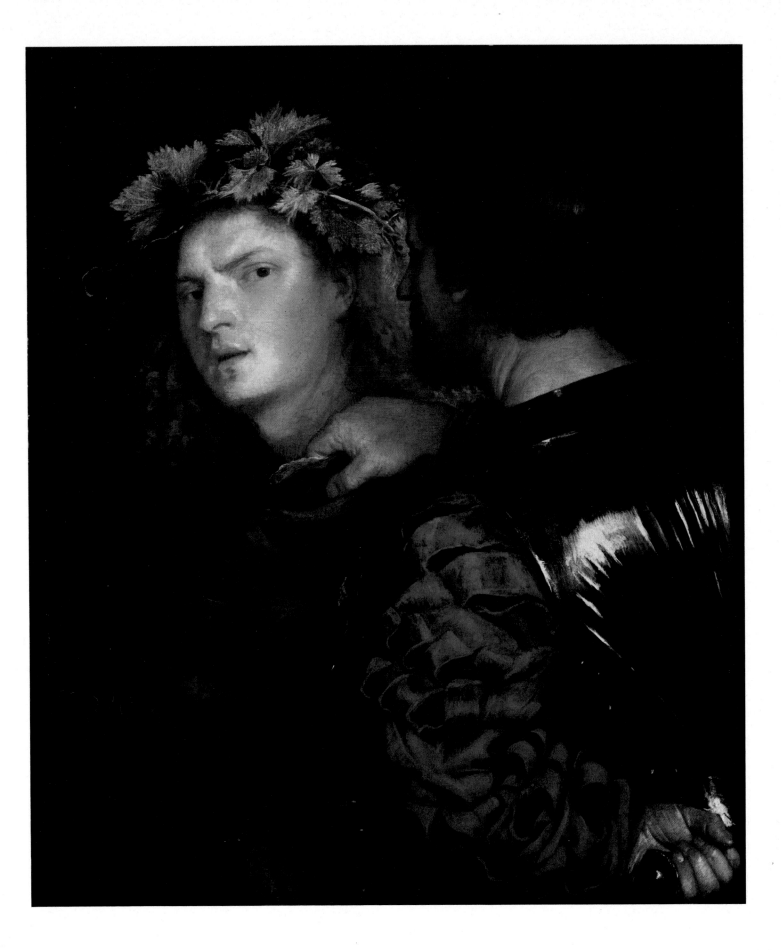

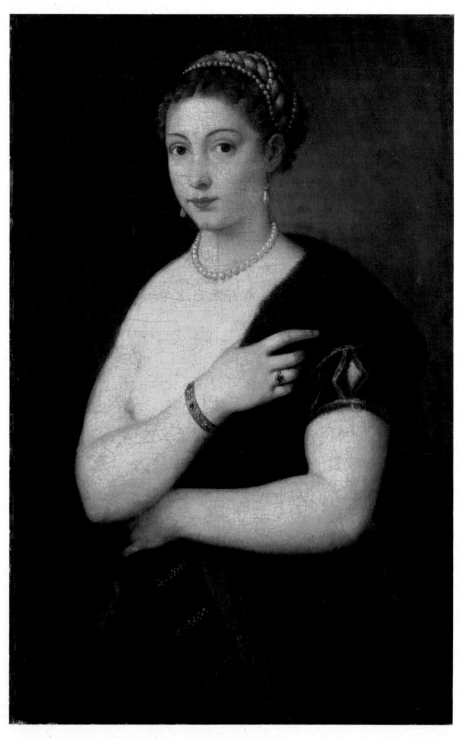

TITIAN
Portrait of a Young Woman in a Fur (1536–38)
Oil on canvas; 37 1/2″ × 24 3/4″ (cut down on both sides).
Perhaps from the collection of Charles I of England. It was cited as being in Vienna in 1720.

TITIAN. *Portrait of a Young Woman in a Fur.*
The subject of this portrait is the same as the *Bella* in the Pitti Palace, Florence; thus it belongs to the same period of the artist's stylistic development, that is, 1536–38. In this painting, too, the young woman is caught in a tasteful harmony of gestures which softly relate the figure to the space. There is a rich contrast between the warm rosy flesh tones of the face, the arms and the bust and the soft fur and dark background. It is an intimate portrait, characterized by the live and immediate naturalness of the expression.

TITIAN
*Portrait of
Jacopo da Strada*
(1566–67)
Oil on canvas; 49 1/4″ × 37 1/2″.
Signed: "TITIANUS. F." Formerly cited as in the collection of the Archduke Leopold William.

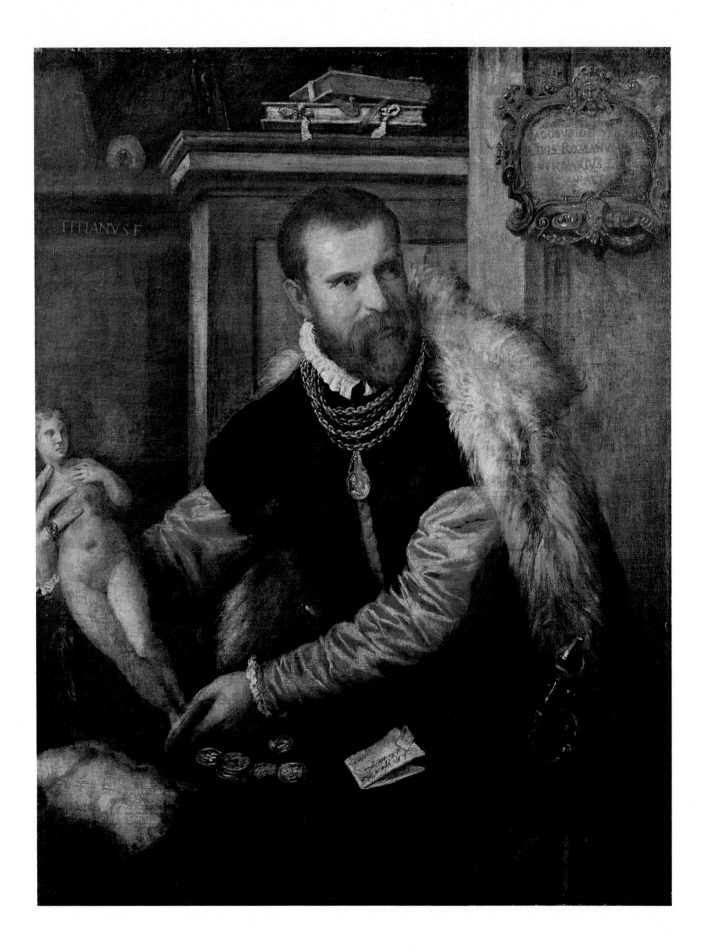

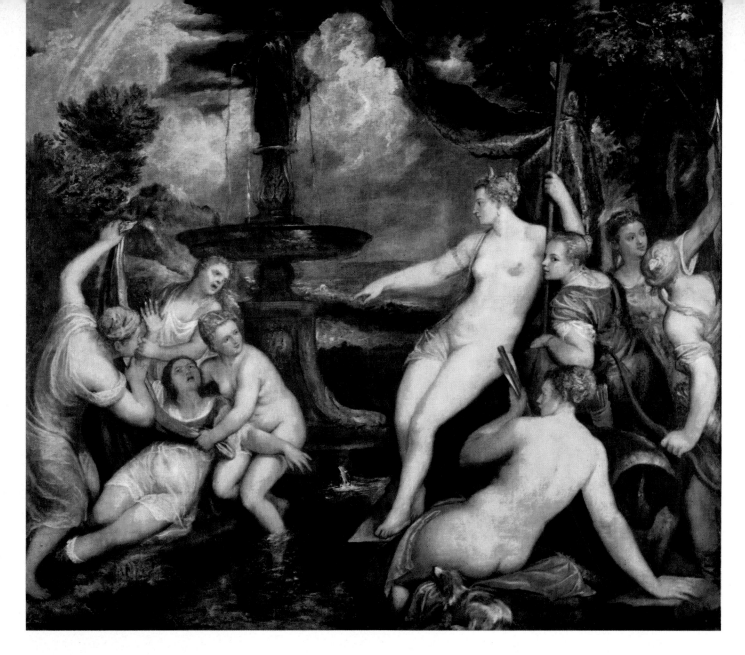

During these years Titian's taste was to some extent testimony to the Aristotelian ferment that marked the Renaissance in Venice, for just as he achieved his naturalistic aim, the artist added an idealizing and classical interpretation to the reality he sought to represent.

TITIAN. *Portrait of Jacopo da Strada.* *p. 59*

Although a plaque added in the 17th century bears the date of 1566, Zimmerman has established the fact that the portrait was executed by Titian between 1567 and 1568. Jacopo da Strada, an antique collector and dealer, is portrayed in his own setting. He stands behind a table on which are coins and a torso, as he proudly shows an imaginary visitor a little statue of Venus. The movement of the figure, inclined to the left, is accentuated by the articulation of the background space. The color scheme is unusually sumptuous for a Titian portrait, but it is motivated here by the complex structure of the composition. The free brushwork of the fur thrown across his shoulder is echoed in the lively illusionistic rendering of the satin sleeve, achieved by rapid strokes of light on the shadowed passages.

TITIAN
Diana and Callisto (circa 1568)
Oil on canvas (cut down all around);
6' × 6'6 3/4".
It is probably one of the "fables" presented by Titian to the Emperor Maximilian II in 1568. In 1659 it was in the Archduke Leopold William's collection.

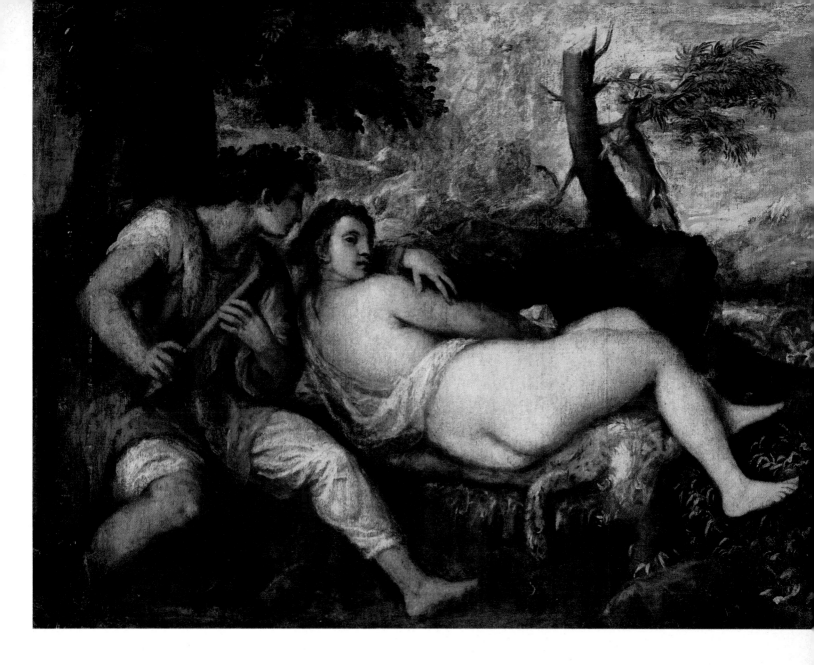

TITIAN
Nymph and Shepherd (circa 1570)
Oil on canvas (cut down at the sides);
4'11" × 6'1 1/2".
From Bartolomeo della Nave's collection in
Venice to the Duke of Hamilton's and then
to that of the Archduke Leopold William.

TITIAN. *Diana and Callisto.*

This is a replica with variations of the *Diana Surprising the Guilty Callisto,* executed by Titian for Philip II and now in the National Gallery of Edinburgh. Probably an assistant made a literal copy of the drawing of the other composition (as revealed when it was relined), but several details were changed during its execution, indicating the direct participation of Titian. According to one authority, the assistant was Girolamo di Tiziano. It is interesting to compare the same theme painted in full Renaissance spirit by Palma Vecchio around the middle of the third decade of the 16th century (page 53), with this work by Titian, which was done almost forty years later. It is Titian after the crisis of Mannerism (around 1540–45), when he has freed himself of any perspective framework and corresponding plastic structure, and has developed his magic impressionism which dissolves all naturalistic appearance. The sketchy brushwork, which creates a unitary fabric of light and color, foreshadows the developments that lead to Rubens and Velázquez.

TITLE. *Nymph and Shepherd.* *p. 61*

It has often been pointed out that the female figure in this work, perhaps derived from an idea from Giorgione, recalls the *Reclining Nymph Looking Back* in Giulio Campagnola's engraving. Indeed, it has been proposed that Titian returned in this late work to a Giorgionesque motif. In his last period, Titian's inspiration broadened to the universal, and he gave up the rhetorical complications promoted by Mannerism. His conception becomes anti-classical and he dives into barbaric, expressive violence. Spatial representation is destroyed, the subject is simplified and the psychological insight deepened. Such elements match those in Giorgione's art, but their results are almost the opposite. In this masterpiece the color envelops everything, with no perspective disjunctions, and stamps the amorous scene with a savage power of expression.

CORREGGIO. *Jupiter and Io* and *Abduction of Ganymede.*

His series on the loves of Jupiter comes very late in Correggio's career, following the bold compositional and chromatic inventions of the cupola of the Cathedral of Parma (1526–30). It represents a skillful adaptation of contemporary religious themes to ancient motifs, and the transposition of the extraordinary visual innovations developed in fresco to the more subtle medium of oil. Vasari did not connect Correggio with the events of the Roman art world; only recent studies have established his presence there, in particular with Raphael in the Stanza della Segnatura and at the Farnesina. Other components of the artist's style — the early influence from Mantegna, the color of the school of Ferrara and the luminous effects of Beccafumi — are admirably fused and transformed beyond recognition in these late works. The classical source of the fables is Ovid's *Metamorphoses,* as it had been for Titian ten years earlier when he created his pictures for the nearby court of Ferrara. Correggio, however, reaches back to more remote antiquity, to an extenuated Hellenism or, better, Alexandrianism. A verbal description of the embrace of Jupiter and Io is really inadequate to convey the quality of the work and its audacity combined with composure. The musical line defining the nude nymph is reminiscent of Raphael's *Graces,* but more fluent and sinuous. With great refinement, the skin is rendered in transparent shadows, and the cloud that has descended shades from gray to violet. If the lightness and relaxation of Io are foreshadowed by some of the celestial creatures Correggio had painted in the cupola of Parma Cathedral, Ganymede faithfully repeats one of the angels in a pendentive at San Bernardo. The boy's soft pink skin stands out against the dark note of the eagle. Closer to us, in the foreground, the arabesque of landscape forms shows us the green slopes of the Apennines.

CORREGGIO
(ANTONIO ALLEGRI)
Correggio between 1489 and 1494 —
Correggio 1534
Jupiter and Io and *Abduction of Ganymede*
(circa 1531)
On canvas. The first, 64 1/4″ × 29 1/4″; the second, 64 1/4″ × 27 3/4″.
These paintings, together with the *Leda* in Berlin and the *Danae* in the Borghese Gallery, Rome, were perhaps part of a series on the loves of Jupiter commissioned by Federico Gonzaga for the decoration of a room in his palace at Mantua. According to Vasari, Gonzaga made a present of the *Leda* and the *Danae* to the Emperor Charles V on the occasion of his coronation at Bologna (1529–30). The four paintings were together in the house of Antonio Perez, the favorite of Philip II, who sold the second canvas to Rudolph II in 1603. In 1585 the first canvas already belonged to the sculptor Leone Leoni in Milan. His son Pompeo, who had brought it from Spain, sold it through Count Hans Khevenhüller to the Emperor Rudolph II in 1601.

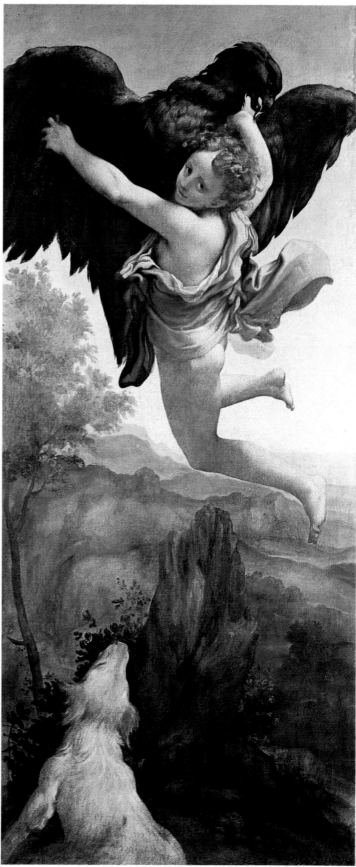

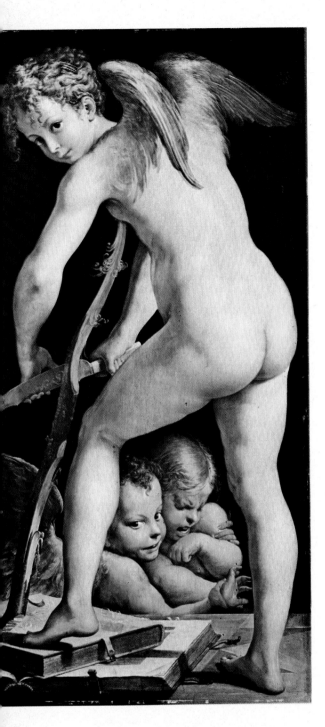

PARMIGIANINO
(FRANCESCO MAZZOLA)
Parma 1503 — Casalmaggiore 1540
Cupid Carving His Bow (1532–34)
Oil on panel; 53 1/4″ × 25 3/4″.
In 1585 it was in the possession of Philip
II's secretary in Madrid. Acquired in 1603
for the Emperor Rudolph II. Since 1631 it
has been in Vienna.

Right:
64 Detail showing the two children.

11596-1-0 Museums Germany 11 Times Roman 13 29w s.d. (38) Noty
Galley 8

PARMIGIANINO. *Cupid Carving His Bow.*

Here is the lively description that Vasari gives of the picture (1568). "At the same time [that is, while he was working at S. Maria della Steccata] he did a Cupid making a bow, for the Knight Baiardo, a nobleman of Parma, a great friend, with two seated infants at his feet, one taking the other's arm and laughing, trying to touch Cupid, and one is afraid and weeps, indicating that he does not wish to warm himself at the fire of Love. It is beautiful in coloring, ingenious in invention and graceful in style, and consequently much valued by artists and connoisseurs. It now rests in the studio of Sig. Marc Antonio Cavalca, the knight's heir . . ." As a Mannerist himself, Vasari could not have understood better the capricious or, better, captious, inventiveness of Parmigianino. This highly original representation is executed with a minute attention to detail that lends the work an element of the absurd and the surreal. Cupid's pose is the first thing that surprises. He is seen from the back, bending over the branch he is carving into a bow. His ambiguous, curly head is turned toward us, and his legs are spread, with one foot resting on a pile of books. In the arch thus formed appear the two contending infants. The technique corresponds very well to the composition, with subtly marmoreal effects of light and shade in a compact space that has no atmosphere of its own. It is understandable why Rudolph II wished to have this masterpiece in his collection, a work contemporary with the *Madonna with the Long Neck* (see *Uffizi/Florence,* page 116).

BRONZINO. *Holy Family with St. Anne and the Infant St. John.* p. 66

Bronzino, after his first period of strong influence from Pontormo, may seem a rather systematic and monotonous artist, especially from the point of view of form, which usually is characterized by compact planes caressed by an abstract light and modeled by an elegant line. But he was capable of envisioning implacably analyzed bits of reality, as well as the rich mineral fantasies of ground and landscape. A large part of Bronzino's production consists of court portraits showing the elect as ceremonial figures, but his most important work is in the chapel of the Palazzo Vecchio, Florence. Here Bronzino's style achieves its supreme expression in *Punishment of the Serpents.* The *Holy Family* in the Louvre and this very fine replica of it should be placed just before or just after this high point. If the Louvre *Holy Family* seems rather formal, almost harsh, compared to later developments in Bronzino's taste, the present painting, which is perhaps more subtle in execution, shows a relaxation of the linear cadences and a more savory orchestration of colors. The replica is faithful in every detail, but the relationship between the group and the landscape is new. The astral light of the first is replaced here by a leaden sky, while a gleam of sun reveals the dark green of the fields, lonely castles and forbidding fortifications.

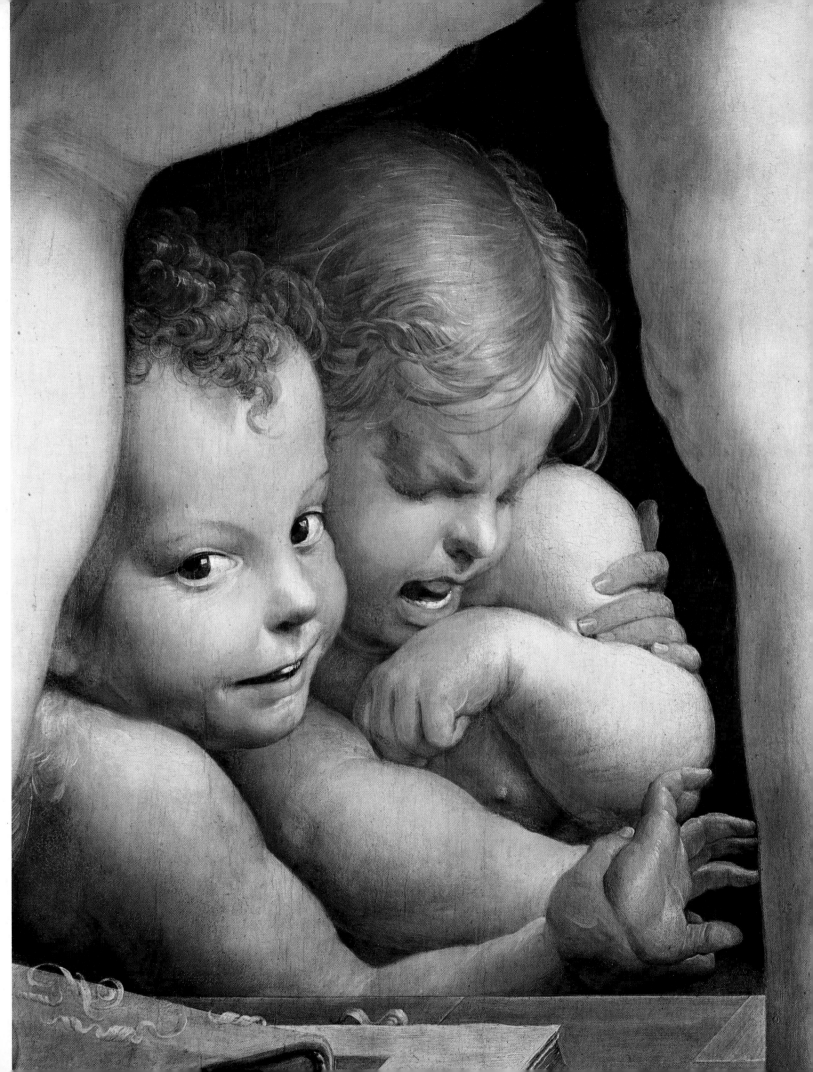

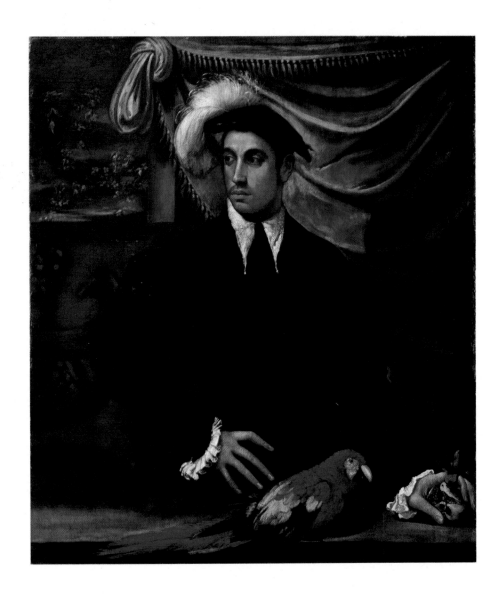

NICOLÒ DELL'ABATE. *Portrait of a Gentleman with a Parrot.*

Held by Berenson (1907) to be by Giulio Campi, this formal yet fanciful portrait was attributed by Gamba (1924) to Nicolò dell'Abate, and ascribed by Bodmer (1943) to the beginning of the artist's French period. Certainly it still recalls the gentlemen in the merry brigades of Palazzo Poggi, but with a hauteur and a detachment reflecting the Modenese painter's new position as a court painter at Fontainebleau. Nicolò dell'Abate's painterly quality was formed by influences from Dossi. The grandiose structural articulation of the portrait is limited to a strict harmony of hues, enlivened by the luminous notes of the collar and cuffs, of the white shirt. Nicolò's virtuosity is seen in the prodigious painting of the parrot in the foreground, standing on the parapet.

JACOPO BASSANO. *Adoration of the Magi.* p. 68

The cold color harmony and the stylistic elegance of this painting led some critics, less than half a century ago, to believe that it was by El Greco. A

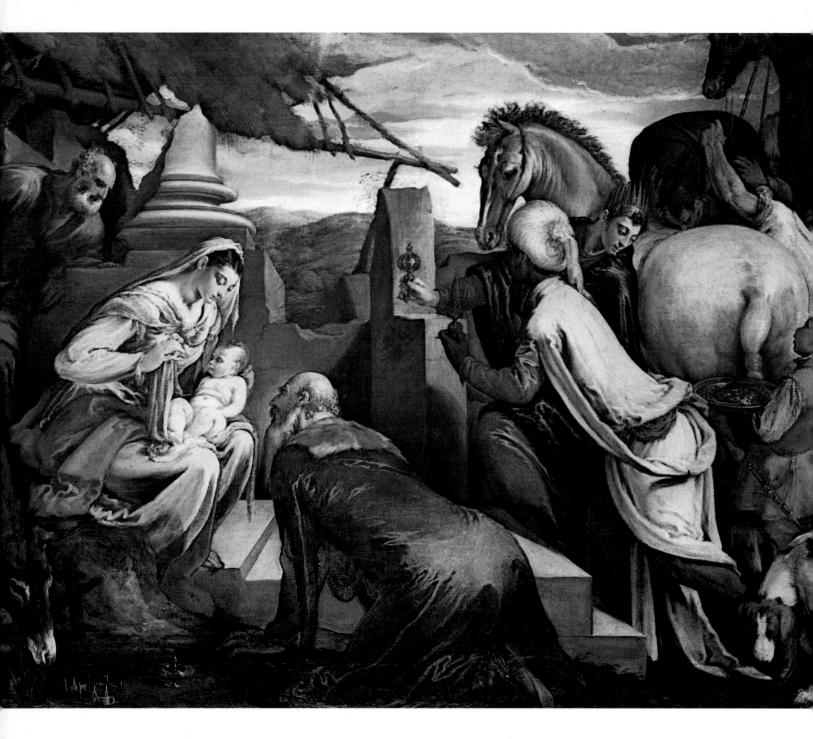

closer study of the development of Jacopo Bassano's style confirmed the
present attribution of this magnificent picture, which belongs to Bassano's
middle period, a time when he was drawn to Mannerist elegance mainly
derived from Parmigianino's prints. Whereas Arslan dated this work to
1565–70, we believe that it is somewhat earlier, coming between the *St.
John the Baptist* (1559) in the Bassano Museum and the *Crucifixion* in
S. Teonisto (1561–63). Only after historical and critical studies had been
made of the effects of Mannerism in the Veneto was it possible to understand
the meaning of these figures. "Elongated and hypersensitive," the critic

68

JACOPO BASSANO
(JACOPO DA PONTE)
Bassano circa 1517–18 — Bassano circa
1592
Adoration of the Magi (1559–61)
Oil on canvas (cut down all around);
36 1/4″ × 46 1/4″.
Until 1636 in Bartolomeo della Nave's col-
lection in Venice, then in the Duke of Ham-
ilton's and subsequently in that of the Arch-
duke Leopold William.

JACOPO BASSANO
Carrying Christ to the Tomb (1574?)
Oil on canvas; 32 1/4″ × 23 3/4″.
From the collection of the castle of Ambras.

Oberhammer noted in 1960, "they are a prelude to El Greco, and move like phantoms. The color is abstract, immaterial and singular. A subtle intellectuality dominates the entire composition." It is a masterpiece that stands up to a comparison with the *Beheading of the Baptist* in Copenhagen.

JACOPO BASSANO. *Carrying Christ to the Tomb.*
In the development of Bassano's taste, after the *Crucifixion* of S. Teonisto (1561–63) there is a progressive darkening of the color and a fragmenting of the form. The *Carrying Christ to the Tomb* in S. Maria in Vanzo, Padua, which is signed and dated 1574, is one of the most significant achievements of Bassano's last period, even if the hand of his son Francesco is apparent

69

in the landscape. Very likely the present work was the preparatory sketch for the painting in Padua. It is more unified, as the landscape is by the same hand that brushed in, jaggedly and urgently, the torch-lit figures.

JACOPO TINTORETTO. *The Queen of Sheba's Visit to Solomon.*
One of six Old Testament scenes formerly attributed to Schiavone, this painting was recognized by von Hadeln (1922) as the work of Tintoretto. The scenes include, besides this one: *Belshazzar's Feast, Bathsheba Before David, Samson's Revenge, The Ark of the Covenant Is Conveyed to Jerusalem* and *David's Protest.* Judging from their format they were probably the decorations of a *cassone,* or linen chest. These works are considered to date from the beginning of Tintoretto's career, that is, in the early 1540s. The impulse toward narration is dominant, and thanks to Schiavone's influence the artist achieves a free and coherent means of expressing his purpose. From the left, where the meeting of the two Biblical personages is depicted, the space spreads out to the distant horizon of the sea. In the center of the scene, the loggia has the function of multiplying the spatial effects with its colonnades, in which appear elongated, attenuated figures.

JACOPO TINTORETTO. *Portrait of an Officer in Armor.*
Among the portraits by Tintoretto in the Art History Museum, this is certainly one of the most interesting even though it does not have the stylistic qualities of the *Portrait of Lorenzo Soranzo* of 1553. The thirty-year-old officer (the inscription tells us his age) is wearing armor in the style of twenty years earlier, which perhaps had a heraldic meaning. Tintoretto renders the features of the young commandant in a mobile painterly manner and takes great pains over the details of breastplate, helmet and gauntlets, giving us a portrait in the manner of Moroni (see *Uffizi/Florence,* page 127). The landscape passage with the galley weighing anchor in threatening weather lends the portrait a narrative dimension.

JACOPO TINTORETTO
(JACOPO ROBUSTI)
Venice 1518 — Venice 1594
The Queen of Sheba's Visit to Solomon
(1542–43)
Oil on canvas; 11 1/2″ × 61 3/4″.
With five companion pieces it came from Prague in 1880.

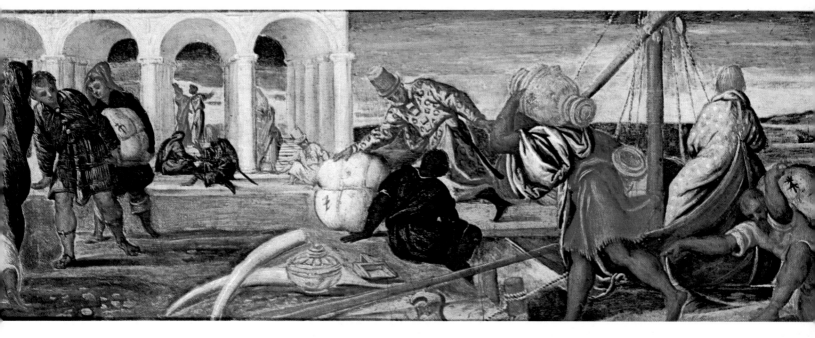

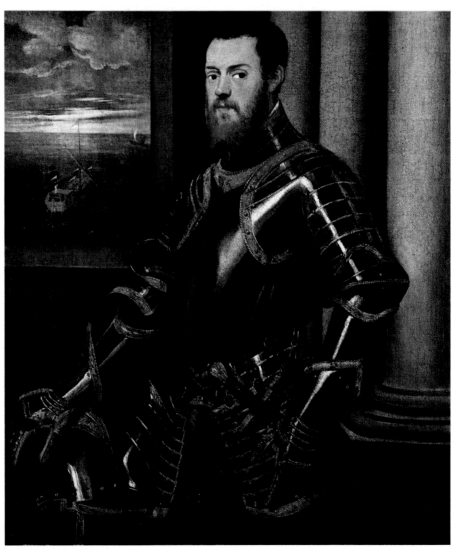

JACOPO TINTORETTO
Portrait of an Officer in Armor (1558–60)
Oil on canvas; 45 1/2″ × 38 1/2″.
It was in the Archduke Leopold William's
collection in 1659.

JACOPO TINTORETTO. *Susanna and the Elders.*

This masterpiece, which in a certain sense closes Tintoretto's first period, is stylistically akin to his *Narcissus* in Rome and to the group of canvases representing scenes from Genesis, executed between 1550 and 1553 for the Scuola della Trinità in Venice. These works show a taste for landscape that was to become one of the new aspects of Tintoretto's art and have decisive importance in his cycle for the Scuola di San Rocco, Venice. A hedge of roses creates an area of cool shadow which gives greater prominence to the lighted figure of Susanna. To the left and in the background, the landscape is organized in a more regular rhythm of light and dark. The light reveals the Junoesque nude in an atmosphere of crystal clarity. All the surrounding details are lovingly rendered, with a feeling of springtime freshness. Liquid and fluid brushwork describes the toilet articles, the pearl necklace, the robe and the white cloth lying in the shadow created by the hedge. Trees, shrubs, flowers and even animals take their place in the capricious rhythm of the dappled sunshine.

JACOPO TINTORETTO
Susanna and the Elders (1552–54)
Oil on canvas; 57 3/4″ × 76 1/4″.
According to Ridolfi (1648) it was in
Nicolò Renier's collection in Venice.
Similarities in composition suggest that
Tintoretto's *Narcissus* in the
Colonna Gallery, Rome, is the companion
piece to this work.

PAOLO VERONESE. *Lucretia Stabbing Herself.* p. 74

This masterpiece of Veronese's late years was attributed to Paolo Farinati before modern art historians reconstructed the last phase of the Venetian master's career. The figure emerges from nocturnal shadow, illuminated by an arcane light that emphasizes the skin tones, the blond tresses set with jewels, the blouse that has slipped off the shoulders and the olive-green silk scarf hiding the dagger from the suicide's eyes. The refinement of the painting is almost decadent and extenuated, with the color harmony com-

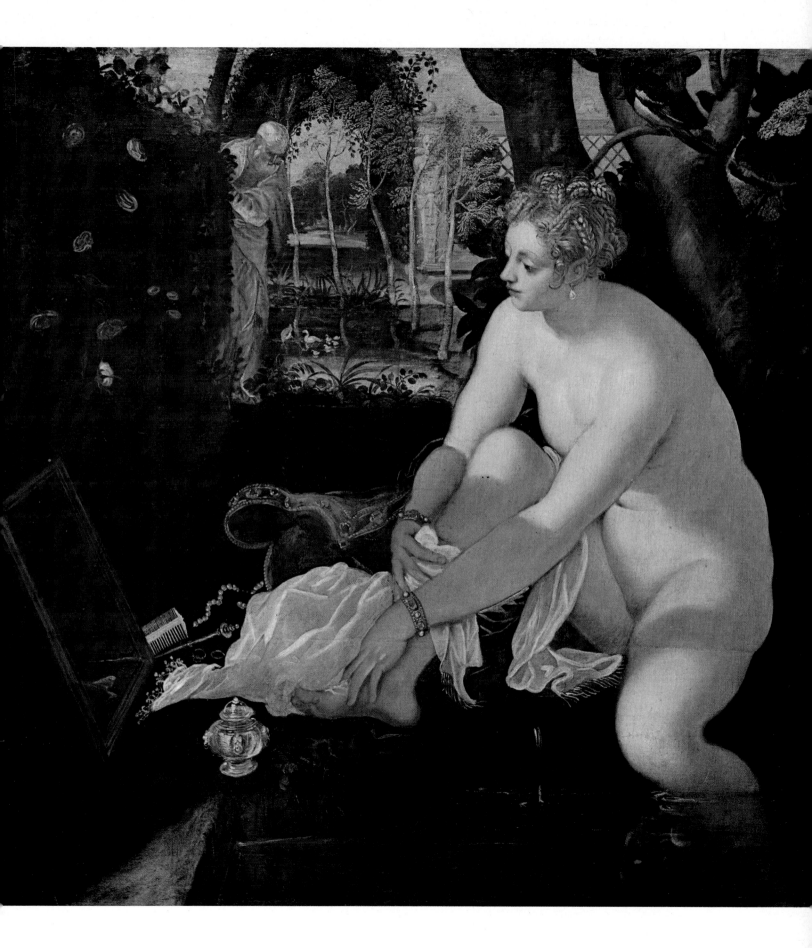

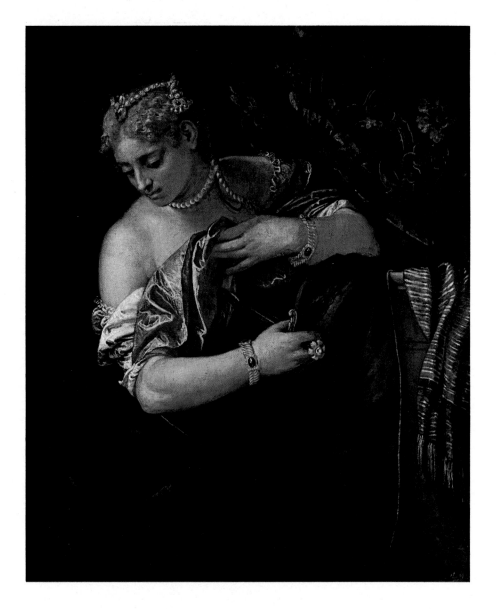

PAOLO VERONESE
(PAOLO CALIARI)
Verona 1528 — Venice 1584
Lucretia Stabbing Herself (1583–84)
Oil on canvas; 43″ × 35 1/2″.
From the Archduke Leopold William's collection (1659).

posed of cool and muted tones. All is aimed at throwing the figure of the heroine into relief. She is placed somewhat obliquely, so that the arc made by the shoulders completes the broad sweep of the arms.

PAOLO VERONESE. *Christ and the Woman with the Issue of Blood.*
One of the most impressive of Veronese's paintings in the Art History Museum, it is certainly from his late maturity, despite the opinion of Berenson (1957) who held it to be a youthful work. The composition is laid out along a line culminating in the head of Christ, who is standing on a landing at the door of Jairus' house and listening to the woman with the issue of blood. By this compositional means the artist has not only created a centralized point of psychological tension, but has also freed the scene at the left. The porticoed building corresponds to the one represented in *St. Barnabas Healing*

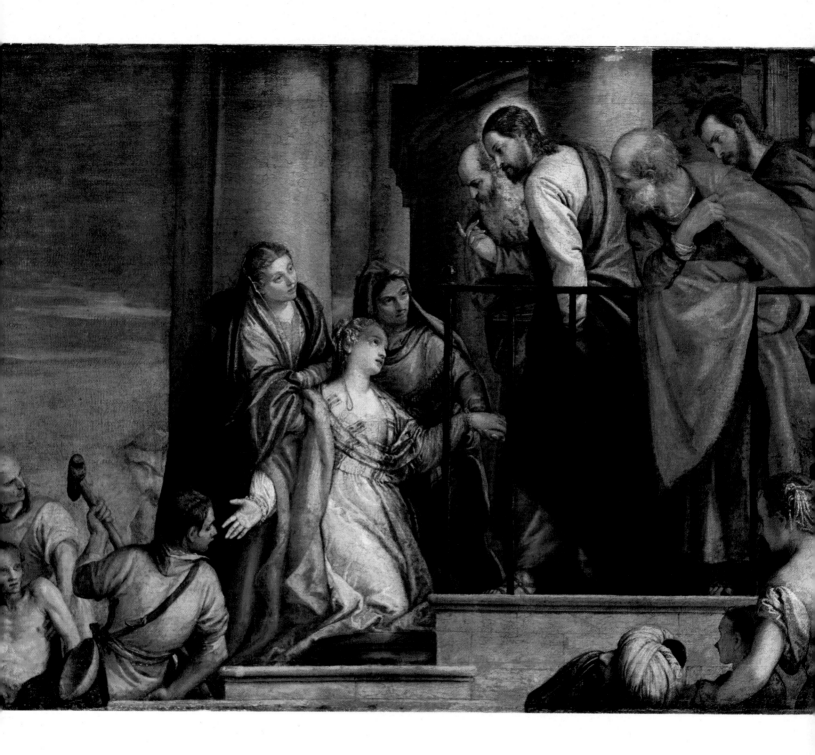

PAOLO VERONESE
Christ and the Woman with the Issue of Blood (1565–70)
Oil on canvas; 40 1/4″ × 53 1/2″.
Probably the same painting that was cited as being in Bartolomeo della Nave's collection, under the title of *The Raising of the Youth at Nain*. Subsequently it passed into the collections of the Duke of Hamilton and the Archduke Leopold William.

the Sick in Rouen. The color scheme, with its subtly refined passages, foreshadows the colder and more crepuscular turns that Veronese's palette will take in the Cuccina paintings, now in Dresden.

PAOLO VERONESE. *Christ and the Woman of Samaria.* *pp. 76–77*
This painting belongs to a group of Old and New Testament scenes formerly in the Duke of Buckingham's collection. They were acquired by the Austrian court for Prague, where two of the series have remained — and

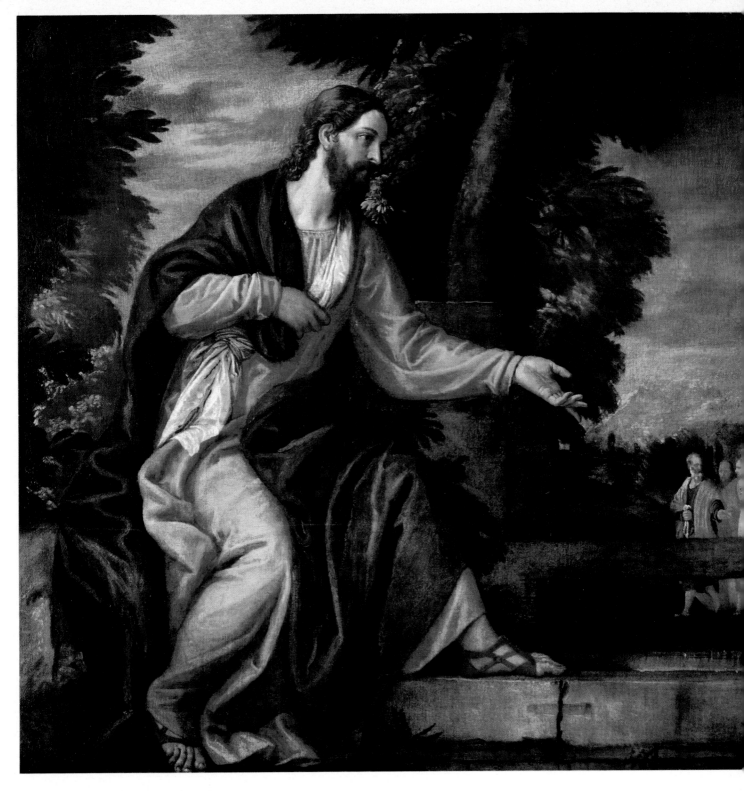

have only recently been identified. Of the eight paintings that came to Vienna, *Rebecca at the Well* was acquired after the last war by the National Gallery, Washington. The art historian Fiocco (1934) is responsible for calling the attention of scholars to the series and for justifying their attribution to Veronese, at least in part. Since the Paolo Veronese Exhibition (Venice, 1939), the present writer has felt that a revaluation of the artist's last period — less spectacular but no less intensely poetic than the preceding ones — is necessary, and holds that the Vienna cycle is one of

76

PAOLO VERONESE
Christ and the Woman of Samaria (1580–82)
Oil on canvas; 4′8 1/4″ × 9′5 3/4″.
With the other canvases in the series it belonged to the Duke of Buckingham's collection, which was sold at auction in Antwerp in 1648. Acquired by the Austrian court with the others for the collection at Prague, where two of the works have remained.

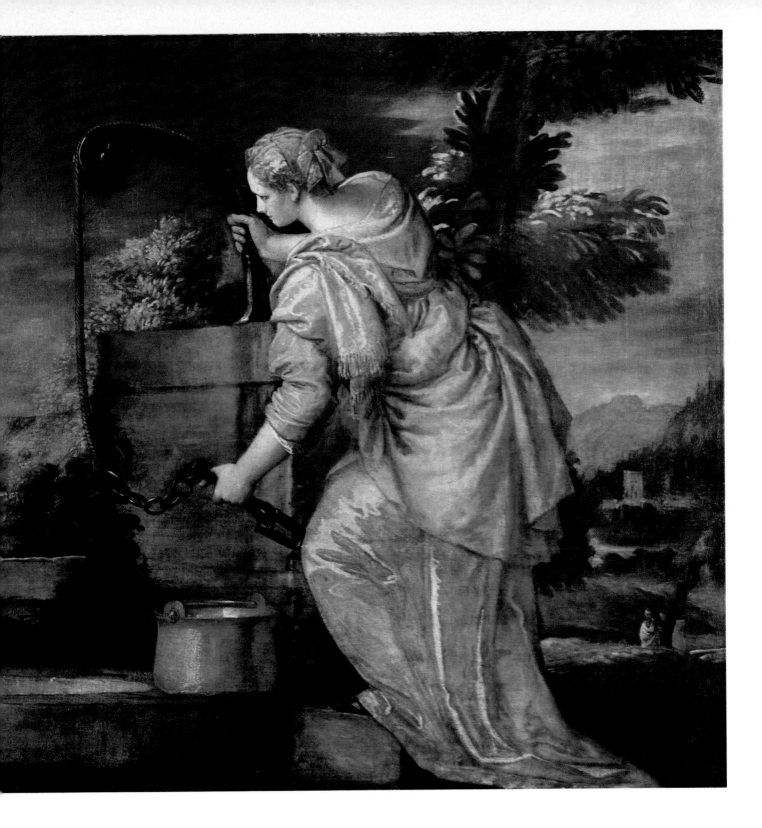

Veronese's most coherent achievements — even if studio work cannot be excluded in some cases. A new feature is the conception of landscape, which is no longer scenic decoration as in the Villa Barbaro-Volpi at Maser, but takes part in suggesting the onset of nightfall connected with the event. Here, beyond the intense counterpoint of the foreground figures, the landscape with its low horizon line becomes fabulous, and it is animated by little figures elegantly sketched in with a loose and fluent brush.

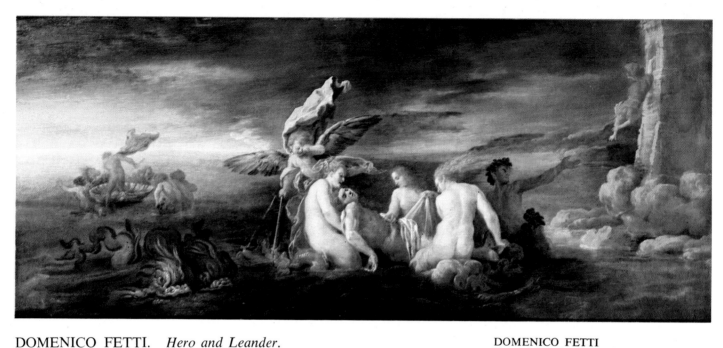

DOMENICO FETTI. *Hero and Leander.*

The romantic story of *Hero and Leander,* written by Musaeus in the 6th century A.D., became very popular in the 17th century. Leander swam the Hellespont every night to join his beloved Hero, a priestess of Aphrodite. Here he is shown after having drowned in a tempest unleashed by Neptune, who is going off at left in a shell drawn by Tritons. Sorrowing naiads recover Leander's body, while the despairing Hero (right) throws herself from the tower, in which she had vainly awaited the arrival of her lover. Extraordinarily refined and intense, this exquisite work is generally ascribed to the beginning of the artist's stay in Venice (1622–23), where he met an untimely death. A poetic flame seems to light up his imagination in giving life and form to the fable, in which the real protagonist is the iridescent dawn coming up on the now becalmed sea. The feeling for landscape that Fetti had acquired in the Roman art world, took on a new character after he came in contact with Venetian color, especially with Veronese's technique of complementary tones. He also mastered the atmospheric brushwork that he had admired at Mantua in the work of Rubens.

DOMENICO FETTI
Rome 1589 (?) — Venice 1623
Hero and Leander (circa 1622–23)
On poplar-wood panel; 16 1/2″ × 37 3/4″.
From the Archduke Leopold William's collection. With the *Andromeda and Perseus* and *Galatea and Polyphemus;* it belongs to a series of panels which perhaps decorated a piece of furniture.

GIOVANNI BATTISTA MORONI. *Portrait of a Man.*

Not as well known as, but superior to, the *Portrait of a Sculptor,* also in the Art History Museum, this picture of a man with a letter in his hand has the naturalness and the affability that are typical of Moroni. It has been dated around 1560, but the unknown subject cannot be placed in a definite social category. At any rate, he represents himself alone and the melancholy that life has impressed on his pointed face. The elegant, well-fitting dark suit stands out against the pale background. It reveals that Mannerist influences, perhaps through Venice, are still at work in Moroni, who had adopted them during his early period. They taper off progressively as he recovers the affectionate concern for reality with which he had started in the art world of Brescia dominated by Moretto.

GIOVANNI BATTISTA MORONI
Albino (Bergamo) circa 1529–30 —
Bergamo 1578
Portrait of a Man (circa 1560)
On canvas; 34 1/2″ × 27 1/2″.
Probably the portrait mentioned as being in Bartolomeo della Nave's collection in 1636. From 1638 to 1649 it belonged to the Duke of Hamilton, then (1659) to the Archduke Leopold William.

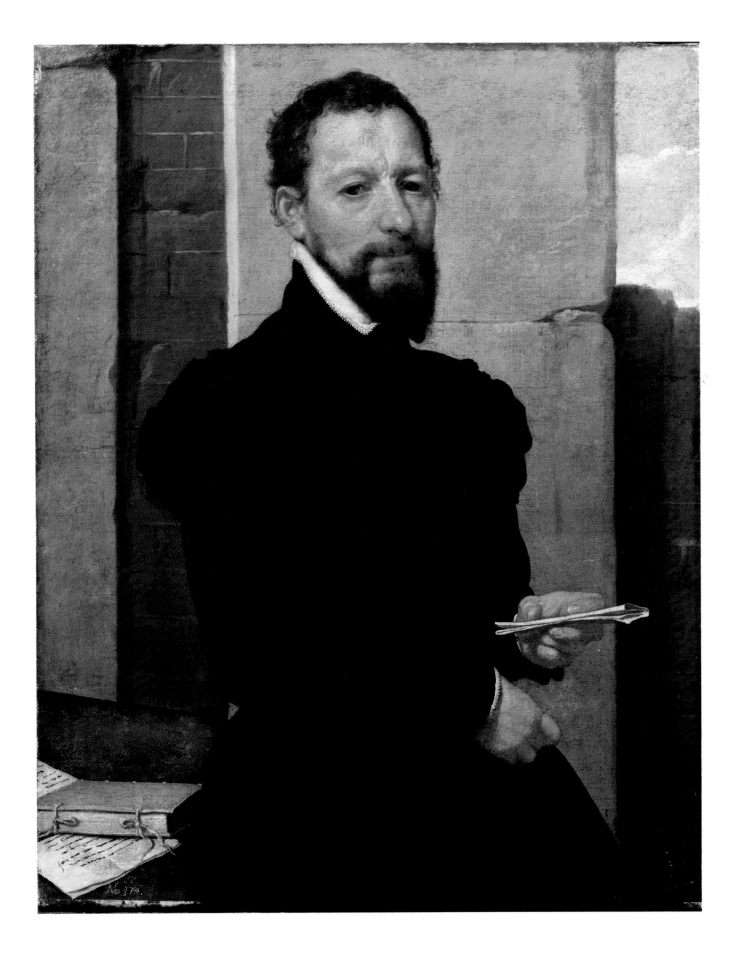

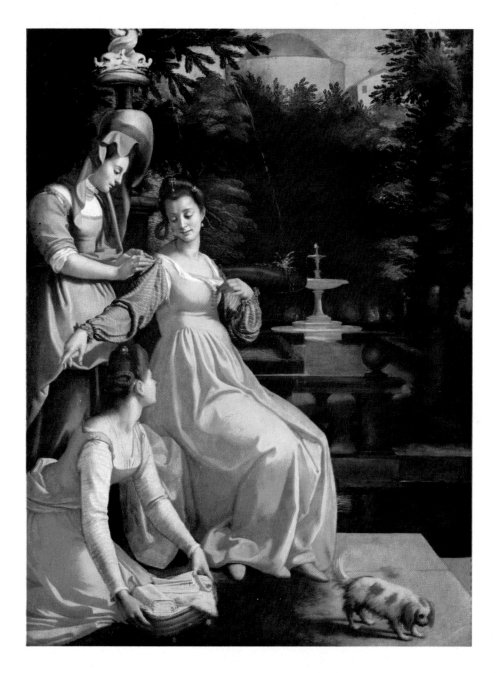

JACOPO DA EMPOLI
(JACOPO CHIMENTI)
Florence 1554 — Florence 1640
Susanna and the Elders (1600)
On canvas; 7'6 1/4" × 5'7 3/4".
Inscribed: "JACOPO EMPOLI. F. 1600."
Mentioned in the inventory of the castle of
Ambras in 1719.

JACOPO DA EMPOLI. *Susanna and the Elders.*

It is not so much a poverty of imagination as it was a particular expressive vocation that led the artist, who was formed in the circle of Andrea del Sarto, to associate himself with the rigorous form and the intellectualized hedonism of a trend deriving from Bronzino. In this representation of Susanna and her maids, seen against the background of a luxurious suburban villa, Empoli achieves results similar to those of certain refined Netherlandish Mannerists around 1600. This is seen not only in the extenuated elegance of the proportions and the perfectly turned forms — caressed by an abstract light recalling the two *Still Lifes* in the Pitti — but also in the unusual conception of the work. The beautiful Susanna, aided by her maids, has begun to undress, while the two old men spy on her from the trees.

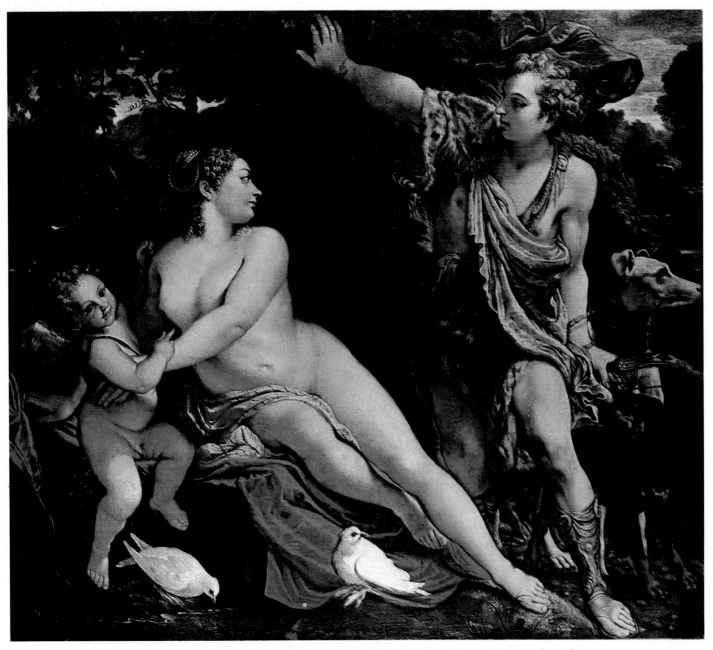

ANNIBALE CARRACCI. *Adonis Discovering Venus.*

While Venus is playing with her little son she wounds herself on an arrow, which arouses in her the desire for love. Following Ovid's account, Annibale illustrates the moment in which the handsome hunter surprises the goddess and gazes at her in admiration; she is already responding to his look, as if fascinated. The term "illustration" is in fact suitable for this elegant and pleasing work, which was executed a little before the artist's departure for Rome in 1595. Here the subtleties of the school of Parma — and not only those deriving from Correggio — are combined with the Venetian tradition, particularly through Paolo Veronese, to nourish compositional monumentality and atmospheric breadth. The critic Cavalli, commenting on the artist's intention, wrote that he appears "undecided between a purifying ideal or a sincere and open naturalness."

ANNIBALE CARRACCI
Bologna 1560 — Rome 1609
Adonis Discovering Venus (circa 1595)
On canvas; 7'1 1/2″ × 8'3/4″.

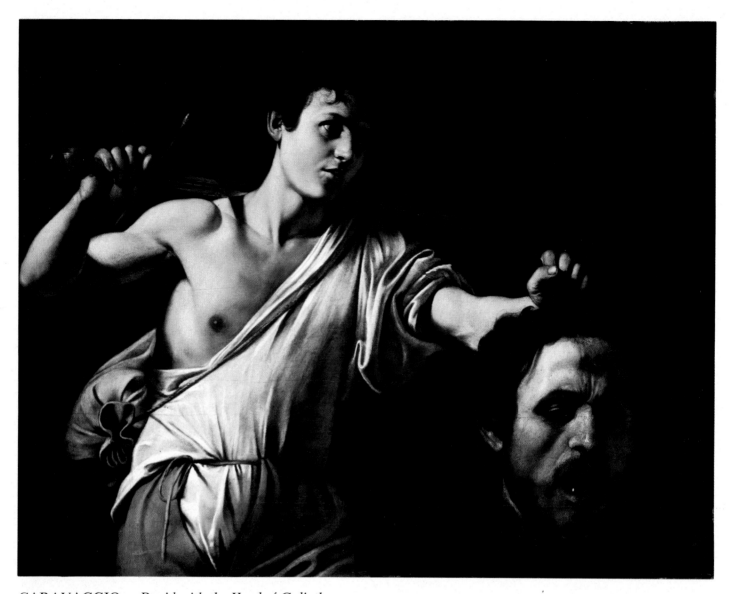

CARAVAGGIO. *David with the Head of Goliath.*

This Old Testament subject was apparently intriguing to Caravaggio, who created three versions of it. There is the youthful work in the Prado, showing David as a shepherd boy. Then there is the highly dramatic picture in the Borghese Gallery at Rome, executed around 1605. Finally we have this more serene and original interpretation, which was painted perhaps before the artist's flight from Rome. David here is not in fact the hero, and Goliath is not a potential executioner but a victim who does not inspire horror. The youth comes toward the spectator, with the sword balanced across his shoulders, holding up with difficulty the heavy trophy. His luminous face seems to be expecting approval for the job he has done. The forms stand out firmly, luminously but with a certain softness, against the black ground.

CARAVAGGIO. *Madonna of the Rosary.*

If the *David* could have been a private effort on the part of the artist, this canvas certainly was commissioned, by a patron variously identified as the Duke of Modena, Don Marzio Colonna or an unknown foreigner. In style

CARAVAGGIO
(MICHELANGELO MERISI)
Caravaggio (Lombardy) 1573 —
Porto Ercole 1610
David with the Head of Goliath (circa 1606)
On poplar-wood panel; 35 1/2″ × 45 1/2″. Cited in the Prague inventory of 1718 as "school of Caravaggio." The work was executed on top of a painting of *Mars and Venus* by a late Roman Mannerist.

CARAVAGGIO
Madonna of the Rosary (circa 1606)
On canvas; 11′11 1/4″ × 8′2″.
For some art historians this is the altarpiece painted in Rome for the Duke of Modena, which was almost finished in 1605. It was seen in Naples by Frans Pourbus the Younger, as he relates in a letter to the Marquis of Mantua in 1607. It was mentioned in the will drawn up by Louys Finson in Amsterdam in 1617. Donated to the Dominican church in Antwerp by the painters Rubens, Jan Bruegel and van Balen.

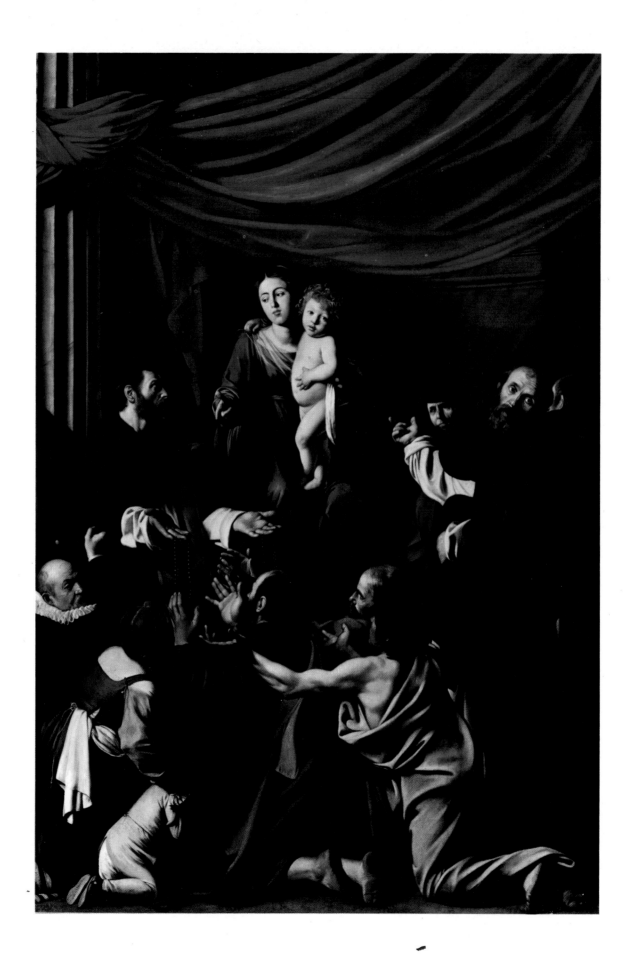

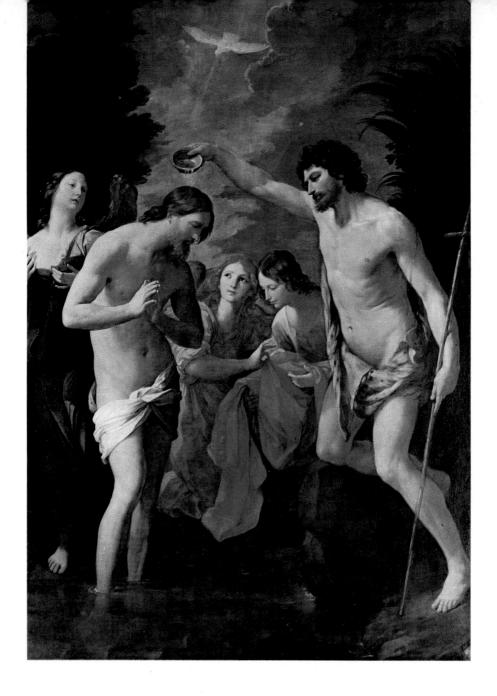

it corresponds to Caravaggio's work at the beginning of his first stay in Naples. The Dominicans, in their austere, heavy robes, distribute rosaries to the poor at the door of the church. The red curtain in front of the door has been raised and fastened to one side, and in the composition balances the light and dark areas of the picture. In the midst of this scene appears the Virgin, represented in everyday human form — but the crowd of the poor does not see her. A wave of pathos and feeling seems to break against the monumental figure of the Dominican with the rosaries, to whom the Virgin turns. The light gives stylistic consistency to these poor imploring creatures. They are not humble and humiliated poor but plain people nobly robed in rough, compactly colored, felt-like garments.

GUIDO RENI. *Baptism of Christ.*

Modern art criticism has discovered in this *Baptism* an important stage in Reni's stylistic development, from his Bolognese formation to the classi-

GUIDO RENI
Bologna 1575 — Bologna 1642
Baptism of Christ (circa 1623)
On canvas; 8'7 3/4" × 6'1 1/4".
Probably the painting ordered by the silversmith Jacobs and shipped to Flanders in 1623. Subsequently in the Duke of Buckingham's collection (sold at auction in 1648). The catalogue of the collection shows that the painting was 23 1/2" wider at the time, and this is confirmed by the copy at Corsham Court, belonging to Lord Methuen.

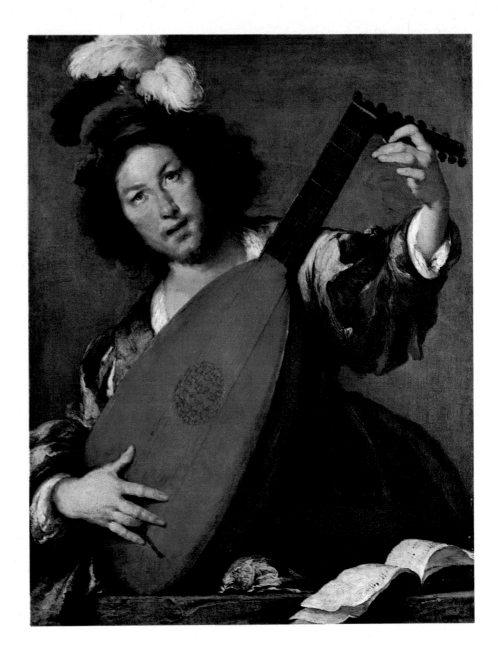

cizing influences of his stays in Rome. The color, in fact, tends toward a silvery tone, and the supple undulations that define the bodies already have the purity of skillfully assimilated means. In this solemn evocation of a rite, the figures are angelic creatures personifying a yearning toward ideal perfection, which in Reni becomes poetry through the melancholy strain suggested by the unattainable. Measured composition, fine play of light and color, and the emotion suggested by the angels' anxious and heart-felt expressions, make up the subtle fascination of this painting.

BERNARDO STROZZI. *Lute Player.*

Bernardo Strozzi arrived in Venice in 1630, having already been formed in the school of Genoa, a cultural crucible in which the Milanese painters of the 17th century predominated but one in which influences from the Sienese Mannerists and from Barocci were also evident. Strozzi had already produced work of the highest quality, in which form — with its European

BERNARDO STROZZI
Genoa 1581 — Venice 1644
Lute Player (circa 1635)
On canvas; 36 1/4″ × 30″.
Mentioned ·as in the Archduke Leopold
William's collection, and as by "a Capuchin
father."

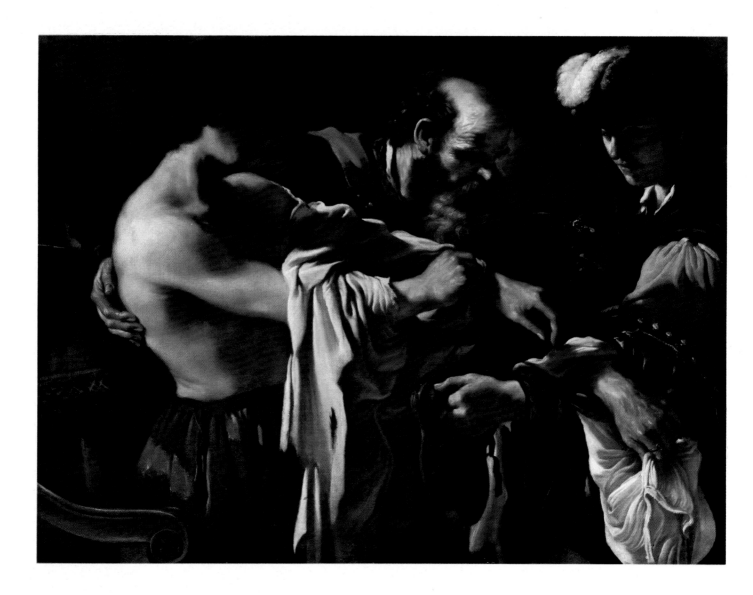

overtones of Rubens and Van Dyck — is more and more exalted by sumptuous color. Venice for him was thus a natural choice as a land of adoption. The tondo composition for the ceiling of the Marciana (1635) is not far from this happy painting of a lute player. In addition to the refinement of some of the non-Venetian color harmonies, what is striking in this work is the breadth of form and the atmospheric feeling, which Strozzi achieves through his knowledge of Veronese's work.

GUERCINO. *The Return of the Prodigal Son.*
The painting was executed along with other works for the Neapolitan Cardinal Serra. This fact helps to establish the stylistic development of Guercino, who was active as an independent master from 1613. The Cardinal was Papal Legate to Ferrara, and it was in that year that the painter went to the same city. It is the period when Guercino, with some effort, inserts his monumental forms into the surface of the painting, yet avoids a feeling of awkwardness by the use of mobile touches of light throughout the color.

GUERCINO
(GIOVANNI FRANCESCO BARBIERI)
Cento (Ferrara) 1591 — Bologna 1666
The Return of the Prodigal Son (1619)
On canvas; 42″ × 56 1/2″.
One of three paintings executed in 1619 for Jacopo Serra, the Cardinal Legate. Cited in the inventory of 1720 (Storffer).

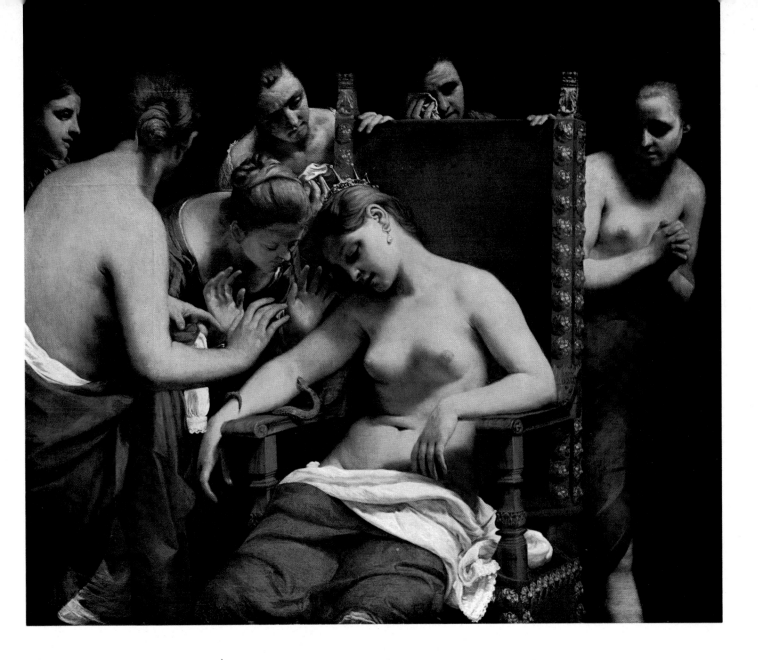

These seem to become part of the plastic structure in the figure on the right, of a young man in a hat. Standing apart from the rest of the picture, he immediately evokes the name of Caravaggio, though not because of iconographic resemblances. In Guercino's precociously Baroque explosion of form (*Erminia and Tancredi,* Doria-Pamphili Gallery, Rome) around 1619–20, there is an awareness of strict Caravaggesque standards of form.

GUIDO CAGNACCI. *The Death of Cleopatra.*

Cagnacci was called to the court of Vienna by the Emperor Leopold I in 1657–58. His fame was based less on his religious pictures than on his canvases of beautiful nudes for private galleries, whose owners a century later would have moral scruples about them. The path to Vienna was probably smoothed by the artist's prior sojourn in Venice. Certainly the present canvas is a work of Cagnacci's late maturity. What does it represent in the uneven and rather adventurous development of his style? On the whole the painter seems to return to the vibrant but contained dramatic effects of his

GUIDO CAGNACCI (or CANLASSI)
San Arcangelo di Romagna 1601 —
Vienna 1681
The Death of Cleopatra (circa 1660)
On canvas; 55″ × 62 3/4″.
Mentioned as being in the
Archduke Leopold William's collection.

87

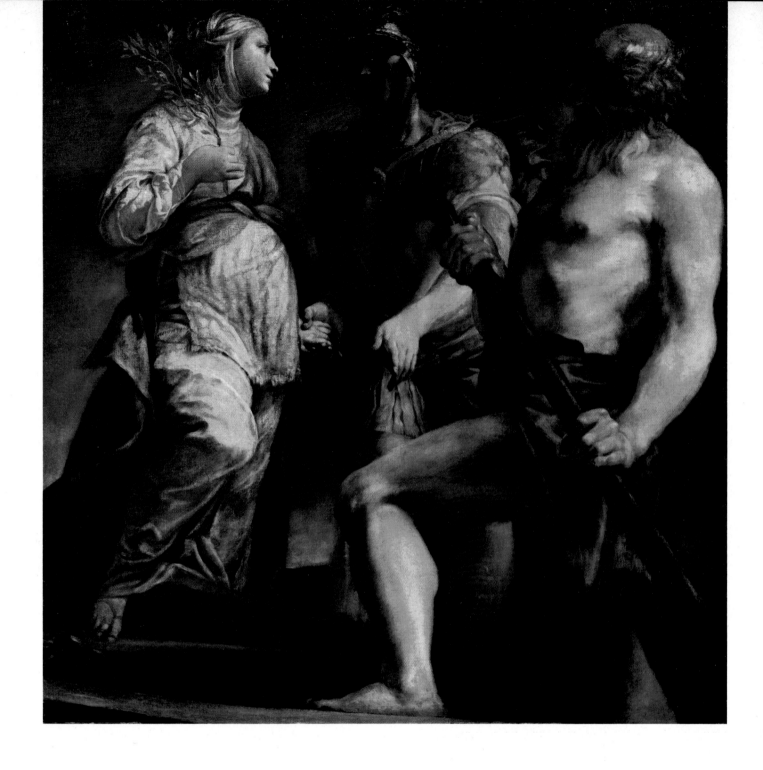

beginnings, which culminated in the *Madonna* in Rimini, a work that shows distant echoes of Caravaggism. The Venetian experience (starting around 1650), however, had not been in vain, and it is the quality of the color that gives the half-nude, grieving creatures their close, tepid, padded feeling. There is a striking absence of the compositional rhythm. As in the artist's theatrical fantasy in Forlì, there is a succession of casual, and thus realist, episodes. Note the repetition of sorrowing faces and the glimpse of the weeping woman behind the chair. Subtlety marks the description of the dying woman: sensuality is transmuted into melancholy.

GIUSEPPE MARIA CRESPI
(LO SPAGNOLO)
Bologna 1665 — Bologna 1747
Aeneas with the Sybil and Charon (1700–1705)
On canvas; 50 3/4″ × 50″.
The companion piece to the *Centaur Chiron and Achilles* which was painted around 1700 for Prince Eugene of Savoy. This work is considered to have been executed a few years later.

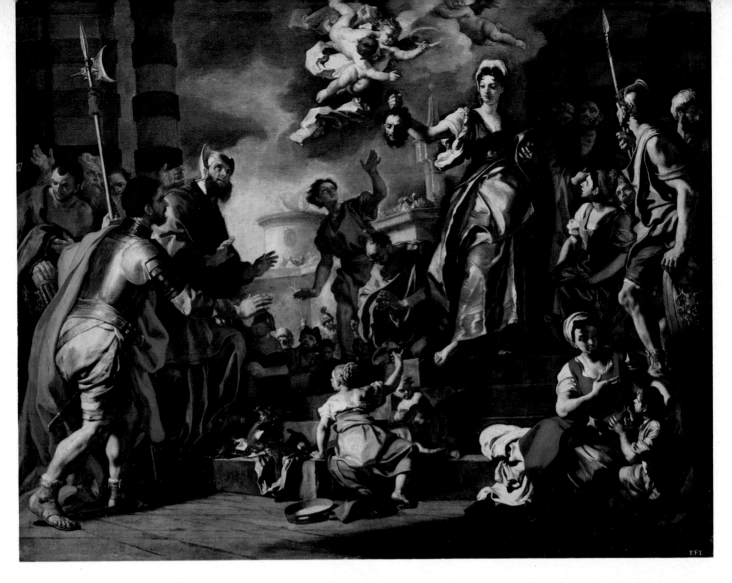

GIUSEPPE MARIA CRESPI. *Aeneas with the Sybil and Charon.*
Perhaps a more typical example of Crespi's painting would be one of his
scenes from daily life, like the crowded, lovingly rendered *Fair at Poggio
a Caiano* (Uffizi, Florence) or the little *Scullery Maid* (Contini Collec-
tion, Florence). In those works modest interiors are described with the af-
fectionate, painstaking care of a 17th-century Dutch painter. But in this
painting, which was certainly executed on commission fairly early in the
artist's career, we already find the qualities peculiar to Crespi. His taste de-
rives from the most painterly elements of the Bolognese school in the 17th
century (Ludovico Carracci, Guercino), and what they brought him of
Venetian influence is reinforced at the end of the century during his own
sojourns in Venice. He made something new out of this Baroque heritage,
enlivening it with a completely 18th-century sprightliness. Only in an Arca-
dian translator of Vergil's *Aeneid* might we find the literary equivalent of
the Sybil's azure and silver grace, which is expressed here in brushwork that
tumultuously builds up the plastic form.

FRANCESCO SOLIMENA. *Judith with the Head of Holofernes.*
The name of Francesco Solimena is linked to the history of the Art History
Museum. Its founder, Charles VI (1685–1740), started the grandiose col-
lection by bringing to Vienna from Prague Ferdinand III's palace picture

FRANCESCO SOLIMENA
Nocera (near Naples) 1657 — Barra (near
Naples) 1747
Judith with the Head of Holofernes (1728–
33)
On canvas; 41 1/4″ × 51 1/4″.
Painted for Count Alois Thomas Raimund
Harrach, Viceroy of Naples. Donated by
the Harrach family in 1935.

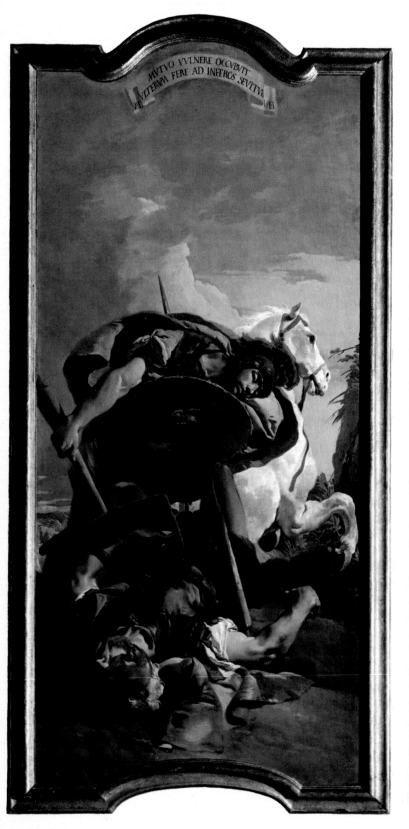
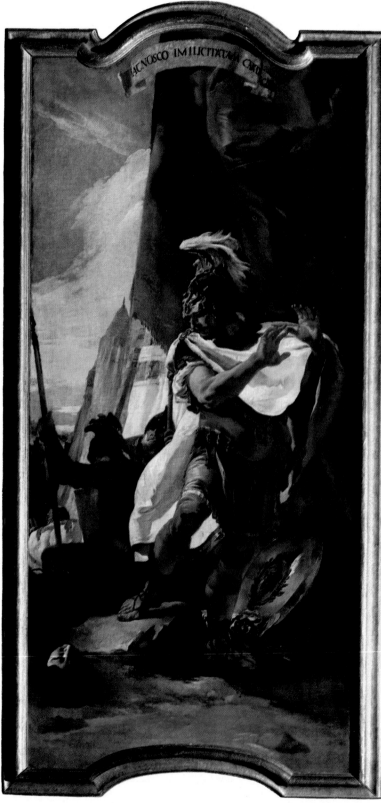

gallery, which had previously absorbed Archduke Leopold William's imposing collection. In 1728, Charles VI commissioned Solimena to paint the commemorative picture of the completed installation. A few years later he executed this *Judith,* a replica of the canvas that the artist had painted twenty years earlier for the Durazzo family in Genoa (now at Cornigliano, Villa Bombrini). A stylistic comparison of the two versions rules out any other explanation of their relationship. The painting in Genoa shows a return to 17th-century Neapolitan taste in the dense texture of the pigment — besides the high contrast of light and shade derived from Preti — which is typical of the first decade of the 18th century. In the present work, there is a calmer spirit and a true 18th-century lightness. Solimena is starting on the purist phase of his career, preceding his last period, which is again tenebrous and dramatic. In setting forth his theme of Judith showing the head of Holofernes to the people of Bethulia, the artist shows the somewhat theatrical bravura that marks the large ceilings he did for various Neapolitan churches. There is also, however, a measured spaciousness that will lead Solimena to devote himself also to landscape.

GIOVANNI BATTISTA TIEPOLO.
The Death of Consul Lucius Junius Brutus and *Hannibal Recognizing the Head of Hasdrubal.*

Giovanni Battista Tiepolo was a precocious and highly gifted artist. When he was little more than twenty years old he was already receiving important public commissions, and his drawings were sought after by engravers. He also had the good fortune to live in a world that was well supplied with rich patrons. In the years between 1725 and 1730 he was the protégé of the noble Dolfin family, and he divided his time between decorating their palace at San Pantalon (Venice) and the palace of the Archbishopric of Udine, for the Patriarch Dionisio was a member of the family. There is no direct documentation, but it is almost certain that the frescoes in Udine were begun in 1726. The two cycles are different in medium but the parallels in subject and form suggest that they were done at about the same time. Perhaps the precedence goes to the canvases with the Roman subjects at San Pantalon, of which these two in the Art History Museum are examples. Whereas the fresco technique obliged the artist to work in broader, simplified areas, in oil he could maintain the Baroque patterns that are at the root of his style, emphasizing the contrasts of light and shade and dramatizing the psychological motivations. The subjects of the San Pantalon canvases, suggested perhaps by some erudite habitué of the palace, were congenial to the dramatic imagination of the young Tiepolo: battles and triumphs, and heroes who were merciful to others and cruel to themselves. The two tall canvases have an admirable concision. Less theatrical than the others, they show the plastic force that characterized the painter from the beginning, and that later allowed him to create the most aerial of creatures suspended among the luminous clouds of his Olympuses. The fatal duel at left — *Death of the Consul Lucius Junius Brutus* — is the perfect complement to the second scene, which depicts the horror and grief of Hannibal on seeing his brother's head which the victorious Romans have thrown into his encampment.

GIOVANNI BATTISTA TIEPOLO
Venice 1696 — Madrid 1770
The Death of the Consul Lucius Junius Brutus and *Hannibal Recognizing the Head of Hasdrubal* (1725–30)
On canvas; 12′6 3/4″ × 5′11 1/2″ each.
Two of the ten canvases that decorated the salon of the Palazzo Dolfin in Venice. Taken to Vienna in 1870, they were part of the Miller von Aichholz collection. Five subsequently went to the Palovtseff collection in St. Petersburg, and to the Hermitage in 1934. Of the other five, which had gone to the Castiglioni collection in Vienna, two entered the Art History Museum in 1930 and the others went to America.

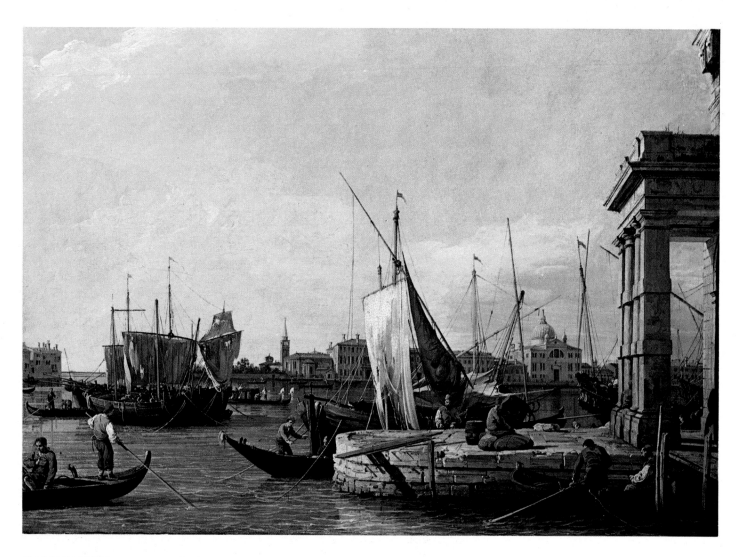

CANALETTO. *View of the Custom House Landing at Venice (La Punta della Dogana).*

Zampetti in 1968 reconstructed the series of views by Canaletto acquired in 1740 by Prince Joseph Wenceslaus Liechtenstein. This included not only the two now in the Art History Museum (*Riva degli Schiavoni* and *La Punta della Dogana*) but also the *Riva delle Prigioni* in the Toledo Museum of Art, the *Basin of St. Mark's Seen from the Piazzetta,* the *Dogana* and the *Riva delle Zattere* in the Crespi collection, Milan, and three other views in private American collections representing the *Entrance to the Grand Canal,* the *Piazzetta of St. Mark's* and the *Quay with the Palazzo Ducale.* These eight, medium-sized views were executed shortly before the year in which they were sold to the Prince. Phenomenal in color and rendering, they record the familiar landmarks and picturesque angles of the Venetian scene. This view is one of the most beautiful of the series and conveys the vitality of the canal teeming with boats carrying little figures, between the foreground of the Punta della Dogana and the background of the Riva della Giudecca. The silvery clouds torn by the breeze accentuate the poetic truth of Canaletto's clear, detached rendering of light, which always has the quality of a particular season.

CANALETTO
(ANTONIO CANAL)
Venice 1697 — Venice 1768
View of the Custom House Landing at Venice (La Punta della Dogana) (1738–40)
Oil on canvas; 18″ × 25″.
Formerly in the Manfrin collection in Venice, then in several private collections in Vienna. At the museum since 1918.

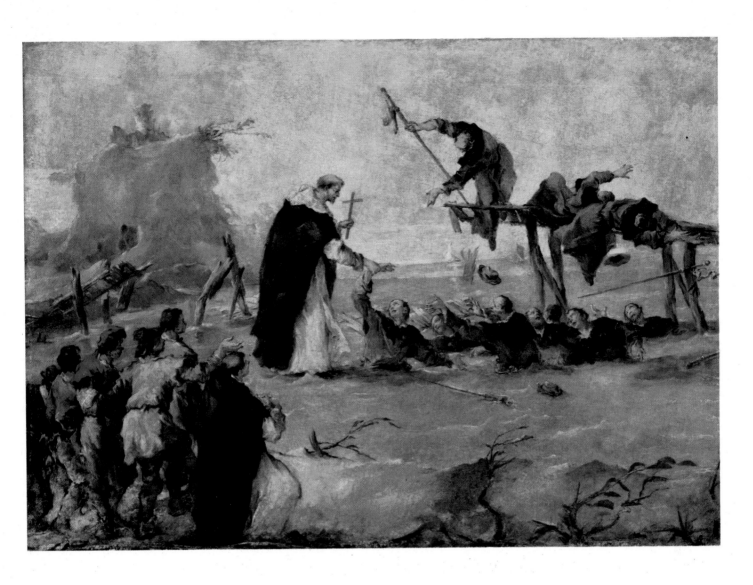

FRANCESCO GUARDI. *A Miracle of St. Hyacinth.*

According to documents published by Gallo in 1953, the chapel of S. Domenico in the church of S. Pietro Martire at Murano was decorated with several paintings in 1763. At the time of the suppression of the religious orders, these were listed as *Miracles of St. Dominic* by Guardi. The canvas in fact shows St. Hyacinth saving some monks who have fallen off a bridge destroyed by the Dnieper in flood. Unquestionably it is the work of Francesco Guardi, rather than his brother Antonio who died in 1760. The painting testifies to the fact that Francesco continued to practice as a figure painter even after the death of Antonio, despite his preference for view painting. The spirit that animates this composition — unfortunately badly preserved — is an evanescent atmosphere enveloping both figures and scene. It is the same as in the *Tobias* series in the church of the Angelo Raffaele, Venice, which was painted some ten years earlier. For some years Francesco Guardi had been transforming his figures into impressionistic little notations appearing incidentally in his views, and here — even where he returned to figure painting as such — he rendered his personages in a more nervous and expressionistic technique.

FRANCESCO GUARDI
Venice 1712 — Venice 1793
A Miracle of St. Hyacinth (1763)
On canvas (obviously cut down);
48″ × 67 3/4″.
Executed around 1763 for the church of S. Pietro Martire at Murano. In the 19th century it entered the Andrassy collection in Budapest. Acquired by the Art History Museum in 1931.

93

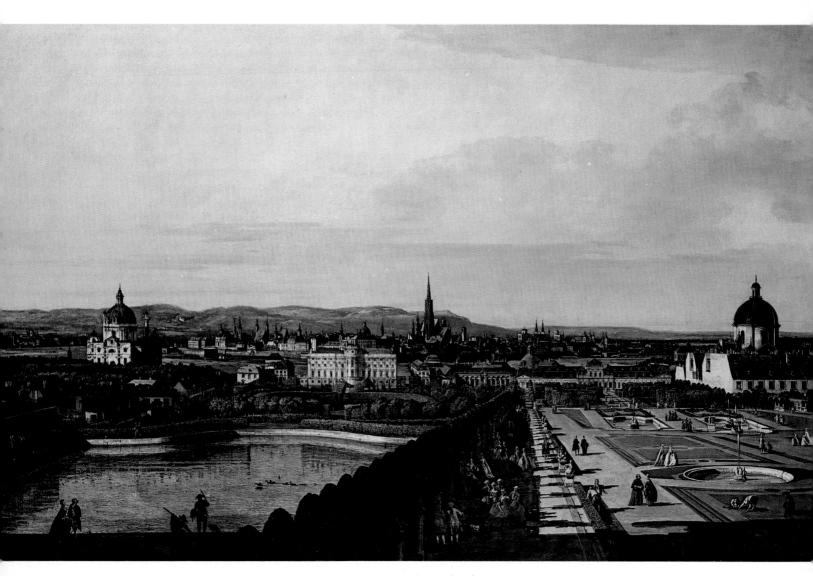

BERNARDO BELLOTTO. *View of Vienna from the Belvedere.*

During his stay in Vienna (1759–60), Bellotto was commissioned by the imperial house to paint a series of thirteen views. One of these was the present painting, of the city seen from a balcony on the northwest side of the Upper Palace of the Belvedere. Vienna basks in the warm light of dusk, against the backdrop of the Vienna Woods. There is a skillful variation of areas of color, alternating in a succession of façades, roofs and bell towers, braked at the sides by the domes of the Karls-Kirche and of the Salesian Nunnery. An interesting invention of Bellotto's is the downward sloping foreground, with its two very different picturesque motifs. On the left is the Schwarzenberg garden and — separated from it by an almost perpendicular hedge — on the right, the parterre of the Belvedere garden peopled with lively little figures. Bellotto has taken a panoramic view and reworked it according to his fantasy. As always in his paintings, the minute observation of detail is incidental to a powerful, embracing structure, which transfigures reality and creates a feeling of magic. This view is a faithful document of a particular scene and a moment in society, but at the same time it is enriched by the bemused, almost melancholy presence of its author.

94

BERNARDO BELLOTTO
Venice 1721 — Warsaw 1780
View of Vienna from the Belvedere (1759–60)
Oil on canvas; 4'5 3/4" × 6'11 3/4".
Executed for the Empress Maria Theresa.

FLANDERS

ANONYMOUS NETHERLANDISH ARTIST. *Portrait of the Jester Gonnella.*

This exquisite portrait, which documents the spread of Jan van Eyck's art to southern Europe, presents a fascinating problem in attribution. The inventory, compiled in 1659, of the Archduke Leopold William's picture gallery states that the curious subject is the "Jester Jonellae" and that the picture is an "original by Giovanni Bellini painted in the manner of Albrecht Dürer." Begeer's research (1952) demonstrated that the painting in fact represents the Jester Gonnella, who lived at the court of Niccolò III d'Este (1393–1441) in Ferrara. It is accordingly almost certain that the picture now in Vienna was formerly in Ferrara. It is obvious that there is a close connection with the style of Jan van Eyck, but the work cannot be attributed to the hand of the great master himself. The author is an artist who painted in the manner of van Eyck, but we cannot at all be sure that he was Flemish. Baldass suggested a painter from southern France. In any case, it seems certain that the picture should be ascribed to a southern follower of Jan van Eyck (circa 1440).

JAN VAN EYCK. *Portrait of Cardinal Albergati.*

"Portrait of the Cardinal of Santa Croce" is the description of this painting in Archduke Leopold William's inventory of 1659. Working from this designation, Weale identified the subject as the Italian cardinal, Niccolò Albergati, whose titular church was Santa Croce in Gerusalemme at Rome. Albergati was in Bruges in 1431, and on that occasion he must have sat for van Eyck, who made a fine drawing of him — now in Dresden — noting on it the colors to be used in the finished oil painting. Compared to the drawing, the painting has less immediacy, but it is still a masterful work and a good example of Jan van Eyck's art, whose revolutionary impact was also felt in the field of portraiture. The painter went beyond the aristocratic, two-dimensional profile portrait proper to the Gothic tradition, creating imposingly corporeal figures that stand out from neutral grounds and are occasionally shown looking at the spectator. With his meticulous and limpid objectivity, expressed in a refined technique of multiple glazes, Jan van Eyck aims to seize the essence of each of his subjects, and his art becomes poetry through the quality and purity of his pictorial means.

ROGIER VAN DER WEYDEN. *Madonna and Child.* p. 98

Jan van Eyck set the example in the Netherlands and Western Europe for humanistic painting characterized by a luminous and refined naturalism. Rogier van der Weyden's work, however, is dominated by the problems of line and psychological expression. Although his images have a corporeal appearance derived from strong modeling, their movements seem unstable and precarious, as if they were not entirely subject to the force of gravity. This *Madonna and Child*, a very small panel, is one of the most original and powerful creations of the Flemish master. The two figures are animated by a great tension, which is particularly evident in the abrupt movement of Mary's head, in her nervous, tapering hands and in the awkward position of the infant Jesus. The painting is a youthful work, datable around 1435.

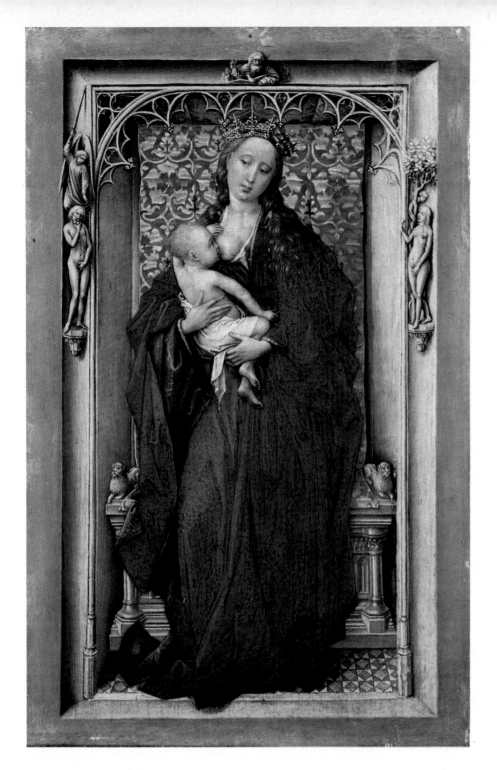

ROGIER VAN DER WEYDEN
Tournai circa 1398 — Brussels 1464
When he worked with Robert Campin at
Tournai he was known as "Roger de la Pas-
ture." From 1435 he was in Brussels, his
name taking the Flemish form of "Rogier
van der Weyden." In 1449–50 he was in
Italy (Ferrara, Rome).
Madonna and Child
Oil on panel; 7 1/4″ × 4 3/4″.
The left-hand panel of a diptych, which has
a *St. Catherine* on the other wing. The
diptych is mentioned, without the name of
the author, in the inventory of 1772. The
attribution to van der Weyden was estab-
lished by G. F. Waagen.

ROGIER VAN DER WEYDEN. *Crucifixion.*

This picture of Mary embracing the cross and weeping is part of the central
panel of a triptych representing the *Crucifixion,* which is one of the most
significant of Rogier van der Weyden's paintings. The Flemish artist, who
painted a number of panels showing the *Pietà,* the *Crucifixion* and the *De-
scent from the Cross,* interprets these dramatic subjects in highly expres-
sive fashion. Here he has not hesitated to represent the Mother of Jesus as
a rather ugly woman. Contorted by grief, her mouth and chin are bitterly
contracted, and tears pour down her cheeks. The generous kerchief with
its pleated edge isolates and brings out the whiteness of Mary's face.

98

ROGIER VAN DER WEYDEN
Crucifixion (detail)
Triptych. Oil on panel.
Center: 37 3/4″ × 27 1/4″; wings:
37 3/4″ ×10 1/2″.
The central panel, of which we reproduce
only a detail, represents Christ on the cross,
with Mary and John and two donors. The
left wing shows Mary Magdalene; the right,
St. Veronica. The work is listed, without the
author's name, in the Archduke Leopold
William's inventory of 1659. G. F. Waagen
established the attribution to Rogier van
der Weyden. Dated around 1440–45.

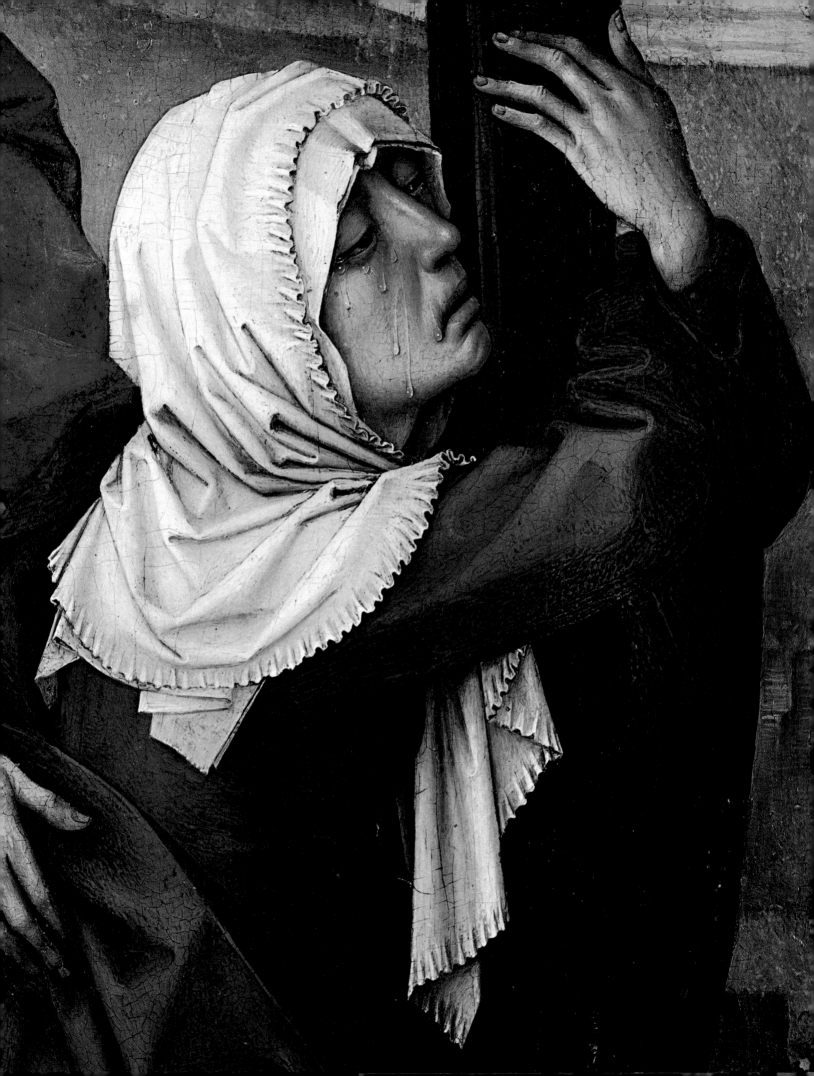

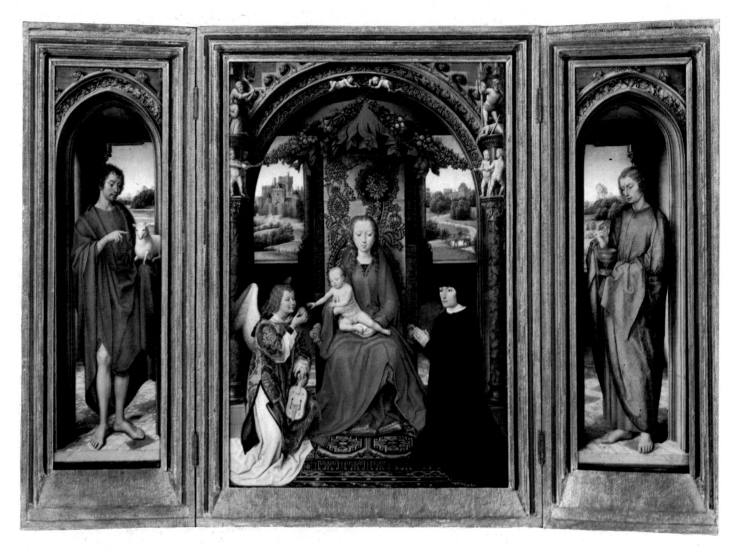

HANS MEMLING. *Triptych.*

The central panel of the triptych represents the Madonna and Child enthroned, an angel and a kneeling donor; the left wing, St. John the Baptist; the right, St. John the Evangelist. On the backs of the wings, visible when the triptych is closed, are Adam and Eve (reproduced on page 101). Hans Memling was a pupil of Rogier van der Weyden, but he was less dramatic in effect and sweetened the austerity and pathos of his master's art. Memling's style is aristocratic, with blandly sentimental elements. A subtle, elegiac mood pervades his best works. In this triptych the Madonna is affably pensive and hieratic, with neither the naturalism of Jan van Eyck nor the humanity of van der Weyden. The dream-like atmosphere of enchantment is reinforced by the landscape behind Mary. A suavely idyllic scene, it shows Memling's pleasure in painting such delightful details as that of the horseman coming out of the castle (on the left) and that of the little figure crossing a wooden bridge (right). The frame ornamented with cupids holding swags indicates that the picture is one of Memling's relatively late works (around 1485). This ornamental motif is certainly Italian, probably Lombard, in origin; and tells us that southern art was already having an influence on Netherlandish painting.

HANS MEMLING
Seligenstadt circa 1435–40 — Bruges 1494
Around 1460, he made a presumed sojourn at Cologne. Worked with Rogier van der Weyden at Brussels from 1460 to 1464. Active in Brussels from 1465.
Triptych. Central panel: *Madonna and Child Enthroned with Angel and Donor.* Left wing: *St. John the Baptist.* Right wing: *St. John the Evangelist.*
Oil on panel. Central panel:
27 1/4" × 18 1/2". Each wing: 25" × 7 1/4".
Listed in the inventory (1659) of the Archduke Leopold William's gallery as the work of Jan van Eyck. Formerly the two wings had been detached, cut down below, and put together to form a single composition. In 1931 the Art History Museum restored the triptych to its original arrangement. In the central panel the little sculptural figures painted above represent the *Sacrifice of Isaac* (left) and the *Beheading of St. Catherine* (right).

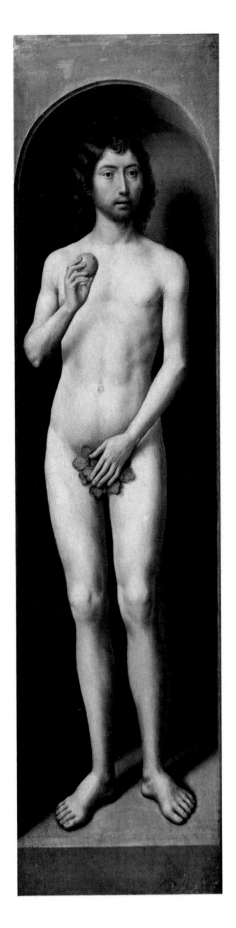

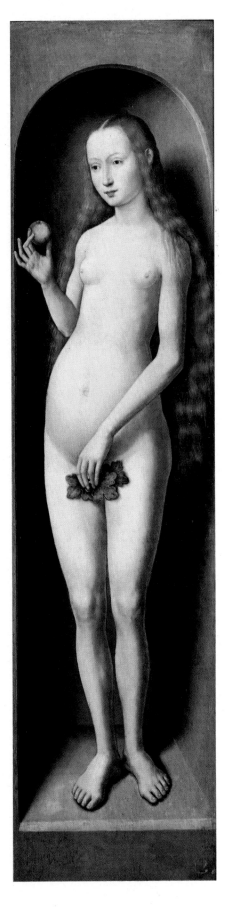

HANS MEMLING
Adam and *Eve*
The outer faces of the wings of the triptych reproduced on the preceding page.

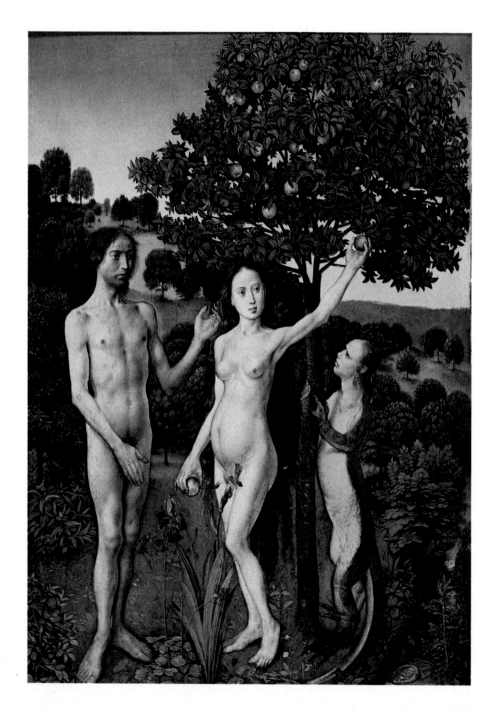

HUGO VAN DER GOES. *Original Sin.*

This work forms a diptych with the *Lamentation for the Dead Christ,* shown
on the next page, with which it has a thematic connection. According to
Catholic theology, in fact, Adam and Eve's sin estranged humanity from
God, and it was only through Christ's sacrifice that a reconciliation was
effected. In van der Goes' panel, the two figures of the progenitors are not
very prepossessing and their gestures are awkward, as if the painter had
sought to emphasize their miserable carnality. The devil is depicted as an
upright standing lizard with a naturalistic human head.

HUGO VAN DER GOES
Ghent circa 1440 — Roode Klooster 1482
Became a master in 1467 at Ghent, where
he worked until 1475. He then entered the
monastery of Roode Klooster, near Brussels.
Original Sin
Oil on panel; 13 1/4″ × 9″.
Left wing of a diptych whose other wing
shows the *Lamentation for the Dead Christ,*
which is reproduced on the following page.
The reverse of *Original Sin,* on which is
painted a *St. Genevieve,* was detached from
the front and is also in the museum. The
diptych is listed in the 1659 inventory of
the Archduke Leopold William. C. Justi and
L. Scheibler are responsible for the attri-
bution to van der Goes. It is a youthful
work, datable around 1470.

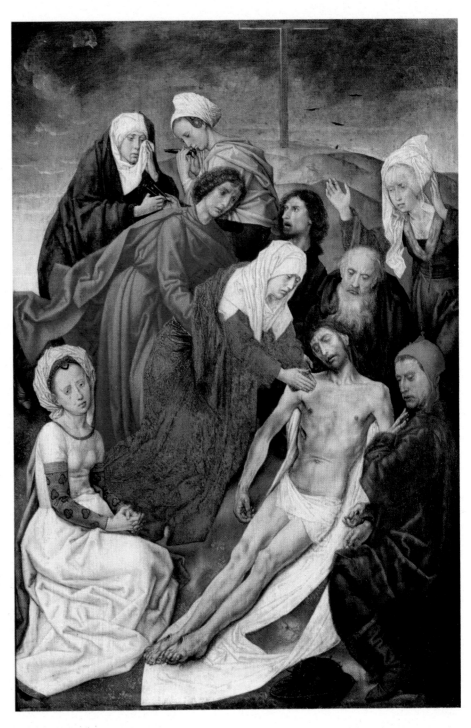

HUGO VAN DER GOES. *Lamentation for the Dead Christ.*
With *Original Sin,* reproduced on the preceding page, it forms a diptych.
Hugo van der Goes' powerful art is in marked contrast with that of his
contemporary, Hans Memling. Van der Goes does not seek to organize a
pleasing synthesis of the results achieved by the founders of Netherlandish
painting. He is animated by a new disquietude which prefigures to some
extent the new departures of the following century. The painter's originality
in composition is seen in this picture, where the figures press together to
form a strong diagonal movement.

HUGO VAN DER GOES
Lamentation for the Dead Christ
Oil on panel; 13 1/4″ × 9″.
The right-hand wing of a diptych whose
other panel shows *Original Sin,* reproduced
on the preceding page. On the reverse there
are vestiges of a coat of arms.

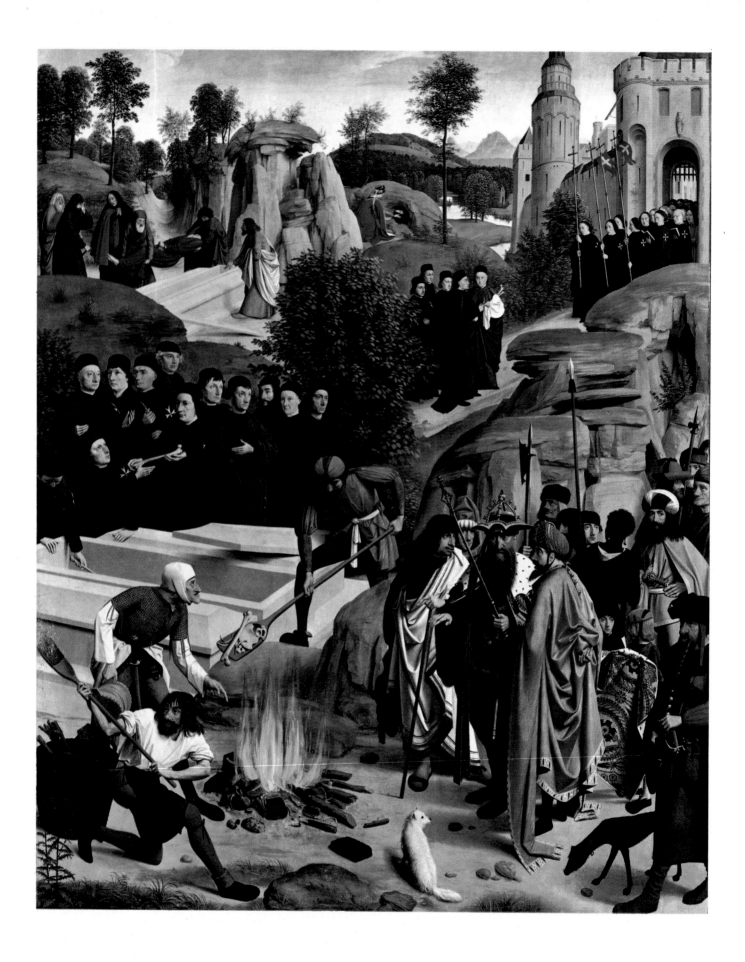

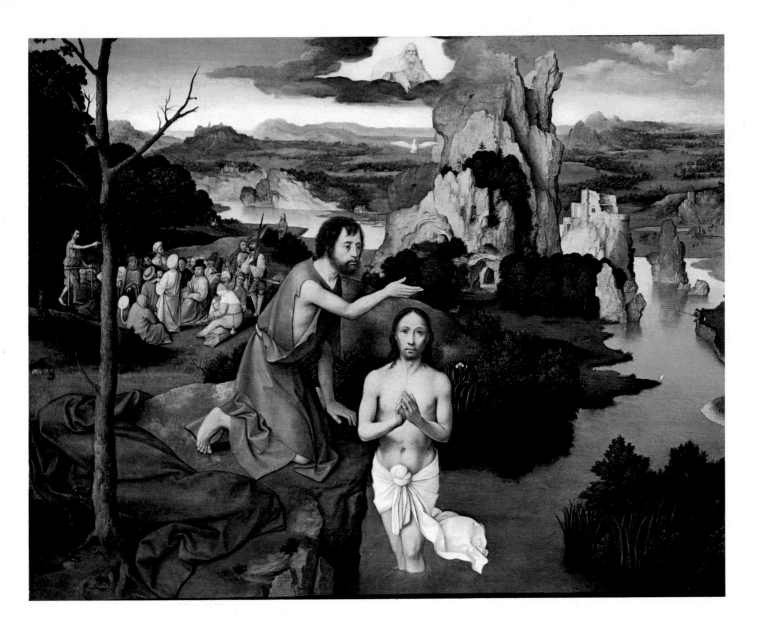

JOACHIM PATINIR
Dinant (?) circa 1480 — Antwerp 1524
In 1515 he became a master at Antwerp.
Baptism of Christ
Oil on panel; 23 1/2″ × 30 1/4″.
Signed: OPUS IOACHIM PATINIER.
In Leopold William's inventory of 1659.

GEERTGEN TOT SINT JANS
Leyden circa 1460 — Haarlem circa 1490
Probably at Bruges as an apprentice in
1475–76. Active in Haarlem.
The Bones of St. John the Baptist
Oil on panel; 67 3/4″ × 54 3/4″.
Outer face of the right wing of a triptych.
The inner face, showing a *Pietà*, which was
detached from its reverse, is also in the Art
History Museum. In Leopold William's in-
ventory of 1659.

GEERTGEN TOT SINT JANS. *The Bones of St. John the Baptist.*
The story of the bones of St. John the Baptist is recounted in five episodes.
Above we see two scenes: the burial of the decapitated body of the Baptist
and the separate burial of the saint's head by Herod's wife. In the fore-
ground the Emperor Julian the Apostate attends the cremation of the saint's
bones, which he had commanded. In the left middle ground the Knights of
Malta are shown finding some of the bones which had miraculously escaped
the flames, and finally the bones at top right are consigned to the convent
of Saint-Jean d'Arc in 1252. Geertgen was the first genius of the Dutch
School, and his art is outstanding in clean-cut form and clarity of space.
The twelve splendid figures of the Knights of Malta (of Haarlem, who were
great patrons of Geertgen) perhaps mark the beginning of a typical Dutch
specialization: the group portrait.

JAN VAN SCOREL
Schoort (near Alkmaar) 1495 —
Utrecht 1562
Pupil of Cornelis Buys at Alkmaar, of Cor-
nelisz Willemsz at Haarlem, and of Jacob
Cornelisz van Oostsanen at Amsterdam.
Between 1519 and 1524 he visited Ger-
many, Carinthia, Venice, Palestine and
Rome. From 1524 he was active in Utrecht,
except for a stay in Haarlem in 1527.
Head of a Young Girl (fragment)
Oil on panel; 11 1/4″ × 9″.
G. Ring is responsible for the attribution.

JAN VAN SCOREL
Presentation in the Temple
Oil on panel; 44 3/4″ × 33 1/2″.
The work is mentioned in Van Mander's
Schilderboek (1604) as Glück discovered
(*Der Cicerone,* II, 1910). Acquired by
the museum in 1910.

JOACHIM PATINIR. *Baptism of Christ.* p. 105

Of Walloon origin, Patinir settled in Antwerp in 1515 or a little earlier,
and died there in 1524. He thus lived in a great port city at a time when
the desire for discovery and the spirit of adventure drove men to explore
distant lands, and he was the first Netherlandish artist to specialize in land-
scape painting. It is obvious that he did not see nature with an Impression-
ist's eye, but conceived it in its abstract totality, beyond any geographic
references or preoccupation with realism. Patinir's landscapes have a cos-
mographic character. Yet he liked to give accurate pictorial descriptions of
the various natural features he observed: rocks, rivers, woods and seas.
The whole nevertheless is enlivened by an exquisite poetic feeling, con-
veyed by the purity of the forms, which are painted with a miniaturist's
subtlety that is worthy of Jan van Eyck. In his cosmographies, Patinir does
not know how to, nor does not care to, divorce himself from traditional
religious themes. However, the figures representing the sacred subjects are
generally quite small, so that the landscape plays the main role. This is true
of the present painting, which is one of the few works signed by Patinir.
The figures of Christ and John the Baptist are stiff and conventional. Al-
though less rich in motifs than the artist's masterpieces at the Prado (see
Prado/Madrid, page 127), the landscape has a particular unity and co-
herency due to a knowledgeable modulation of the color. Patinir had many
followers, and Bruegel himself found in him a valuable source of ideas.

JAN VAN SCOREL. *Head of a Young Girl.*

This is one of the least known works by Scorel, to whom it has been cor-
rectly attributed only recently by Grete Ring. When he returned from his
travels in the south, Scorel inaugurated a new era in Dutch painting, to
which he introduced Italian intellectual concerns with respect to form as
well as composition. This picture — a fragment of a larger work — shows
that in portraits as in other subjects the painter goes beyond the natural
data to subordinate them to an ideal of geometric form.

JAN VAN SCOREL. *Presentation in the Temple.*

The scene takes place in the interior of a classical temple, inspired (ac-
cording to Jantzen) by Bramante's project for St. Peter's, Rome. The ma-
jestic architecture also recalls that of Raphael's famous fresco, the *School
of Athens.* During Scorel's stay in Rome, from 1522 to 1524, Pope Hadrian
VI, his fellow countryman, appointed him curator of the antiquities in the
Belvedere. Scorel's Roman experience gave his art a strong stamp of classi-
cism, but did not make him into a complete Romanist, for his previous stud-
ies in Germany and Venice had profoundly influenced his style. In this
work an interest in Mantegna is evident, while the full-bodied, warm color
shows an extensive knowledge of Venetian tonal painting (Scorel had stayed
in Venice in 1521). The artist's rigorously "formal" mentality is apparent
also in his reduction of the sacred personages to dehumanized bodies.

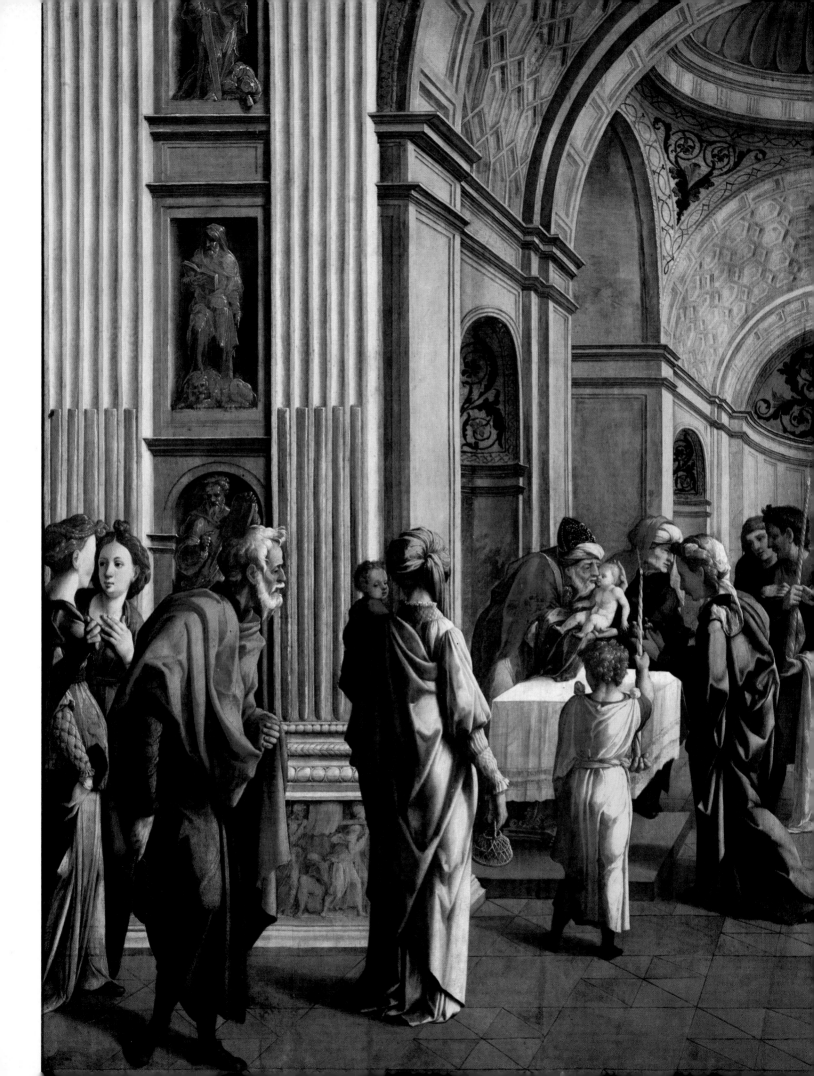

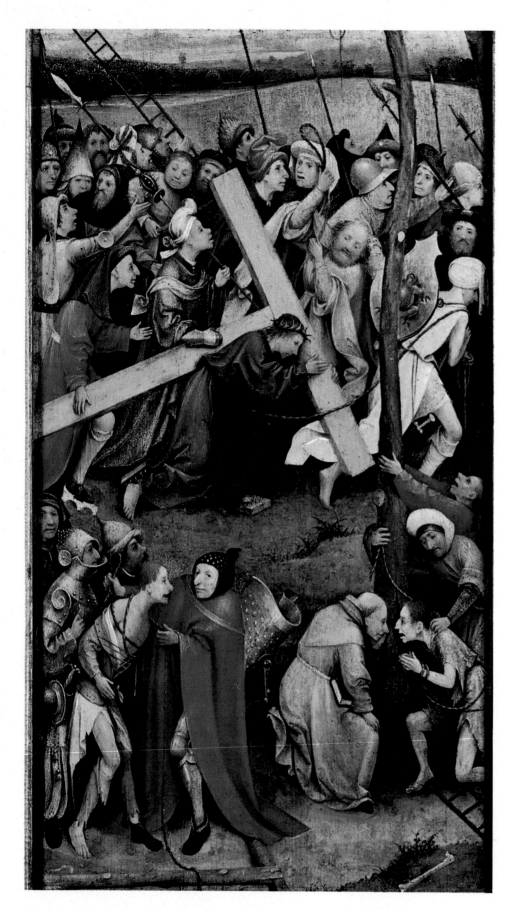

HIERONYMUS BOSCH
's-Hertogenbosch circa 1450 —
's-Hertogenbosch 1516
Active from around 1475. His presence in
's-Hertogenbosch is documented from 1488.
The Procession to Calvary
Oil on panel; 22 1/2" × 12 1/2".
Left-hand wing of a triptych which had a
central panel showing the *Crucifixion* (now
lost). On the reverse in a tondo there is a
painting of a nude child. Bax does not see
this as the Infant Jesus, but as an allegory
of the ignorance and stupidity of mankind
related to the "dishonor of Golgotha." A
youthful work of Bosch, the panel has been
cut down above and below. Acquired in
1923.

MICHIEL COXCIE
Mechelen 1499 — Mechelen 1592
Pupil of Bernard van Orley at Brussels.
From 1531 to 1534 he was in Rome, where
he knew Vasari. Active subsequently at
Brussels and Mechelen.
Original Sin
Oil on panel; 7'11 1/4" × 2'9 3/4".
The panel was formerly a wing of a trip-
tych. The other wing, showing the *Expul-
sion from the Garden of Eden,* is also in the
museum. Both panels have geometric orna-
mentation on their reverses. Both are listed
in the Archduke Leopold William's inven-
tory of 1659.

HIERONYMUS BOSCH. *The Procession to Calvary.*

The work of the Brabant master Hieronymus Bosch represents the peak of Netherlandish art around 1500. Living in an isolated town and without any apparent links with tradition, Bosch was decidedly a revolutionary artist. The present painting shows him in his least esoteric aspect, as it lacks the typical deformations and the profusion of symbols that make so many of his other works difficult to interpret. Yet, as always, the composition is unmistakably original. The procession is represented in two zones, one above the other, with Christ above and the two thieves below. On the right there is the curious episode of one of the thieves being confessed by a friar. The figures are thin and nervous, and are depicted with mocking irony. But what gives every painting by Bosch its miraculous quality is the extraordinary color sense, expressed in soft, warm, luminous hues.

MICHIEL COXCIE. *Original Sin.*

The history of art still owes a debt to Michiel Coxcie, for he has long been the object of undeserved blame. What the critics have not liked is the fact that Coxcie, unlike Scorel, wanted "to play the Italian" though conserving a decidedly Flemish technique. This gave his work a cold and pedantic tone which did not arouse much enthusiasm. Yet Coxcie is an interesting personality who achieved on occasion a notable purity of style, especially in his few portraits. The artist had been in Rome between 1531 and 1534, and there — perhaps the first among the Netherlanders to do so — he became accomplished in fresco painting. After his return home, his gifts as a patient artisan earned him well-paid commissions from King Philip II to copy Rogier van der Weyden's *Deposition* as well as the entire *Ghent Altarpiece* by the brothers van Eyck.

PIETER BRUEGEL. *The Tower of Babel.* pp. 110–11

Carel van Mander, the biographer of the old Netherlandish painters, mentions that Bruegel painted two pictures of this subject, which at the time (1604) were in the possession of the Emperor Rudolph II. One of the two is the present composition; the other, which is smaller, is in the Boymans-van Beuningen Museum, Rotterdam. The artist conceived this masterpiece as an allegory of human pride and frailty. The mass of the grandiose construction seems to crush the city at its feet but also conveys a sense of uneasiness in its incompleteness and precariousness. In the design of his tower (which was inspired by the ruins of the Colosseum), Bruegel shows a particular interest in building techniques. This is an instance of the painter's insatiable curiosity for all sides of human life, considered however as phenomena of the vaster life of the universe. Bruegel fuses the minutiae of the details with the extraordinary vastness of the vision, and the lucidity with which the far-reaching depths of the landscape are rendered gives the spectator a feeling of awe.

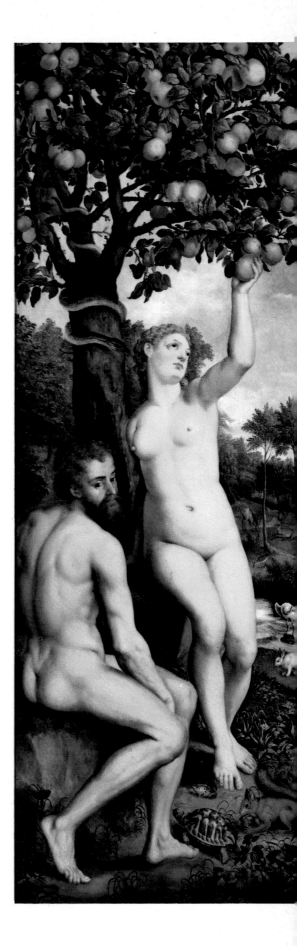

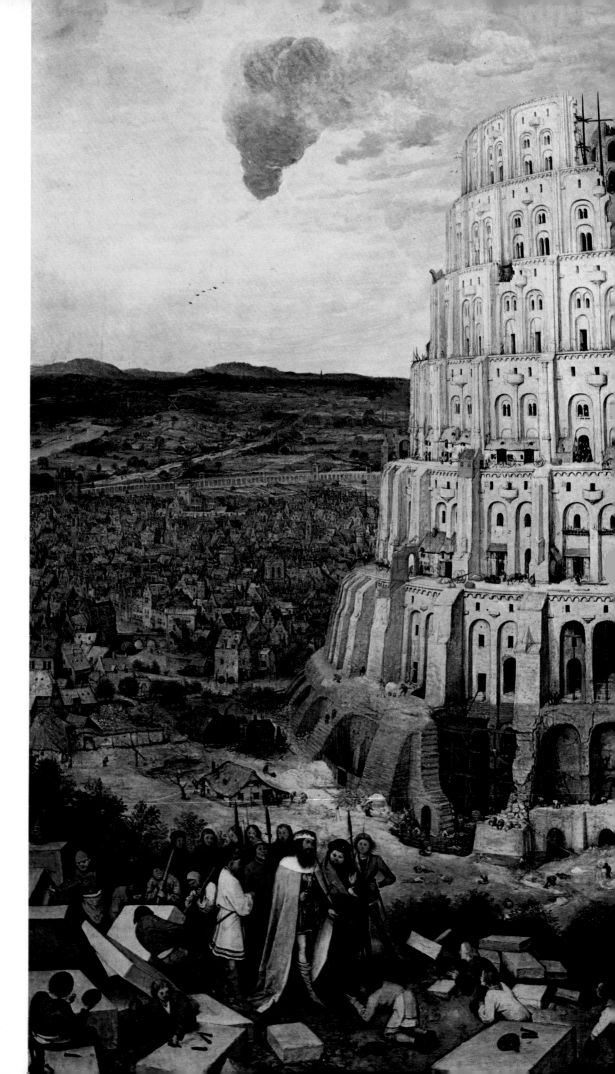

PIETER BRUEGEL
Breda circa 1525 —
Brussels 1569
He worked with Pieter Coecke van Aelst at Antwerp, where he is registered as a master in 1552. From 1552 to 1554 he traveled in Italy (Rome, Naples). Subsequently he was active in Antwerp. In 1563 he moved to Brussels.
The Tower of Babel
Oil on panel; 44 3/4″ × 61″.
Signed and dated:
"BRUEGEL MCCCCCLXIII."
Formerly in the possession of Rudolph II. Mentioned in Leopold William's inventory of 1659. During his youthful sojourn in Rome, Bruegel had already painted a little *Tower of Babel* on ivory (mentioned in Giulio Clovio's inventory, 1577).

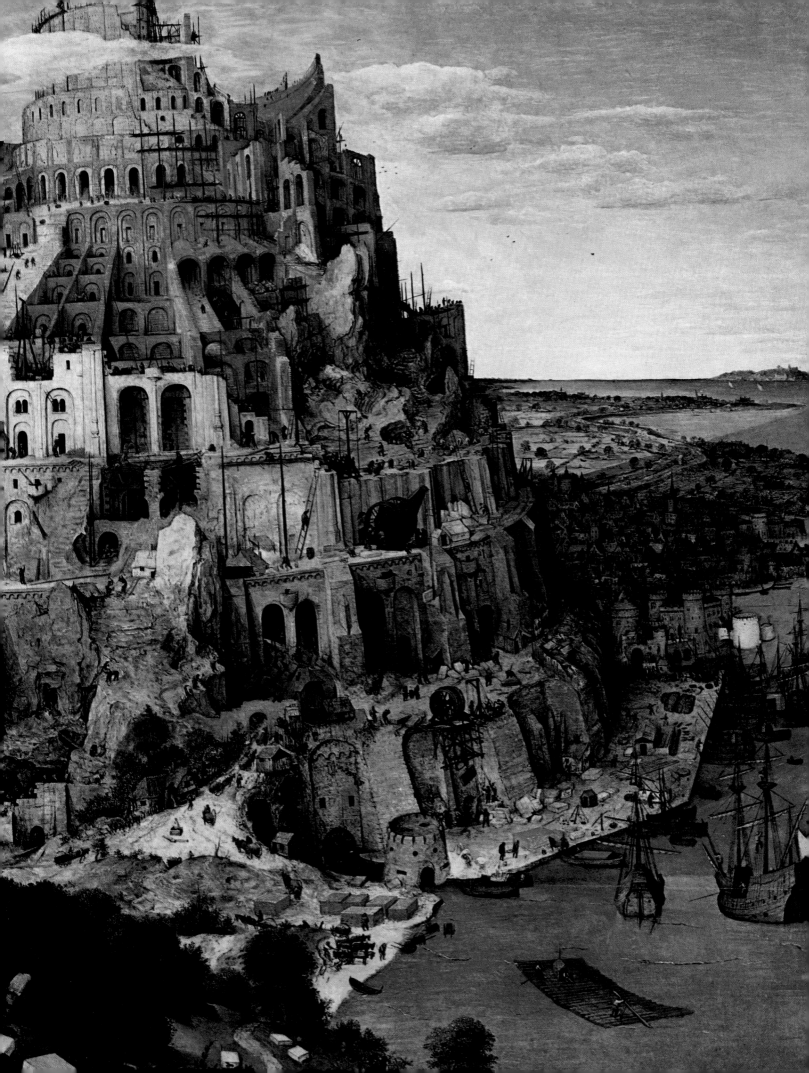

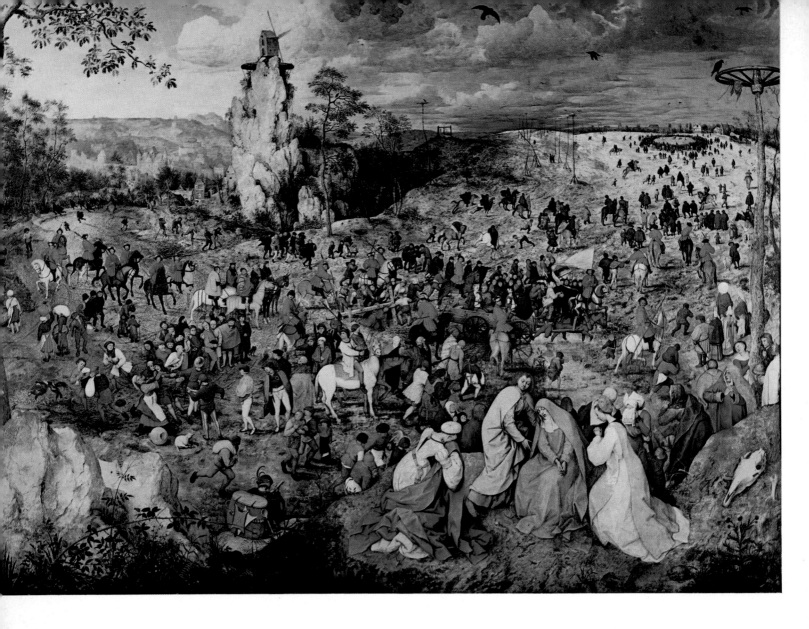

PIETER BRUEGEL. *The Procession to Calvary*.

Framed between a tree on the left and a pole surmounted by a wheel, this
landscape is also vast and grandiose. In the sunlit, hilly scene a multitude
of people on foot and horseback is moving toward the place of execution,
where a crowd has already formed a large circle. The figure of Christ fallen
under the cross has been placed at the center of the picture (where the two
diagonals of the composition meet) but is lost in the crowd, which is com-
pletely insensitive to the drama and interested only in enjoying a spectacle.
The two thieves are in a cart a little ahead of Christ. On the left a man and
his wife are resisting some soldiers: the man is Simon of Cyrene who has
been asked to help Christ carry the cross. Throughout the breadth of the
picture numerous soldiers dressed in red make vivid patches of color, which
also give the scene a festive air. Isolated from all the rest are the large fig-
ures of Mary, John and the Holy Women, at lower right. They contrast
markedly with the other figures in their size, their "ancient" dress and their
idealized and suffering faces.

PIETER BRUEGEL
The Procession to Calvary
Oil on panel; 48 3/4" × 67".
Signed and dated: "BRVEGEL MDLXIIII."
Almost certainly identifiable with the *Pro-
cession to Calvary* mentioned by van Man-
der as belonging to Rudolph II (1604). Two
preparatory drawings for separate figures
are in the Boymans-Van Beuningen Mu-
seum at Rotterdam.

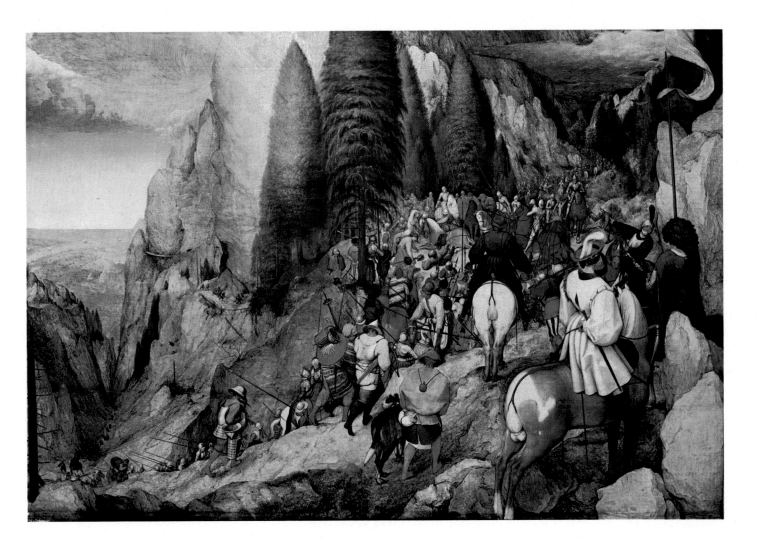

PIETER BRUEGEL
The Conversion of Saul
Oil on panel; 42 1/2″ × 61 1/2″.
Signed and dated: "BRVEGEL
MDLXVII."
Acquired in 1594 by Archduke Ernest, Re-
gent of the Netherlands; subsequently in the
possession of Rudolph II (van Mander,
1604). According to Stridbeck, the picture
is to be interpreted as an allegory, symboliz-
ing the laborious path of virtue, which is in-
dispensable for the salvation of man.

PIETER BRUEGEL. *The Conversion of Saul.*
The artist's open-minded and independent attitude toward the cultural dog-
mas of his time was made very clear during his travels in Italy (he was in
Rome in 1553–54). Far from considering that Raphael and Michelangelo
had discovered "absolute beauty," Bruegel did not do a single drawing
from the works of these masters, nor did he spend any time copying the
statues and monuments of antiquity. What interested Bruegel greatly was
natural scenery and particularly the Alpine landscapes, which he drew with
tireless enthusiasm. The Italian painters who influenced him most were not
the prestigious masters of the 16th century but those of the 15th, especially
the artists who emphasized perspective. In the present work the effects of
the Italian journey are still evident. The scene has been laid in an Alpine
landscape, and some of the figures — in particular the large horseman
dressed in yellow — recall the purity of line and the geometric form of
15th-century Italian painting. Like Christ in the preceding work, the main
figure of this composition, Saul, is relegated to the background. He is shown
at the center of the clump of trees, the figure in blue, at the moment he has
fallen from his horse, blinded by the heavenly vision.

113

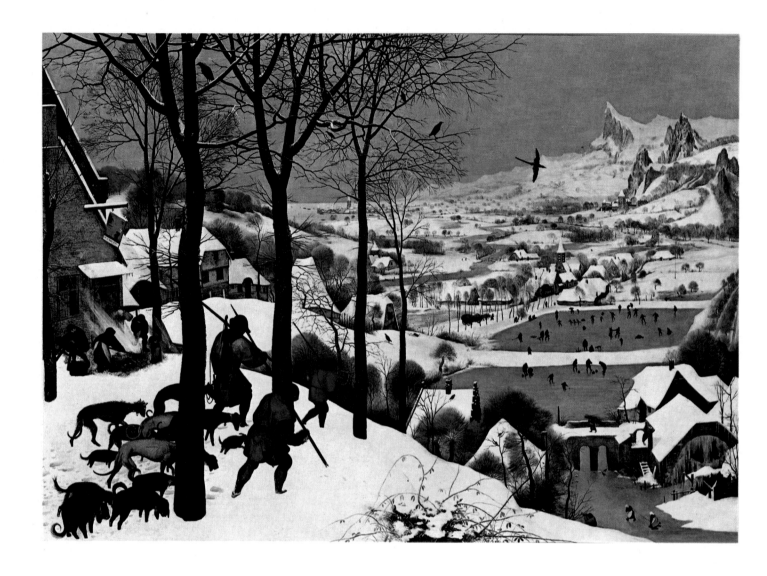

PIETER BRUEGEL. *Hunters in the Snow.*
This work belongs to a series representing the months of the year, which also includes the *Dark Day* and the *Return of the Herd* (reproduced on page 117), both in Vienna; the *Hay Harvest* in Prague; the *Harvesters* at the Metropolitan Museum in New York; and the *May Pole,* a lost work of which only copies by Bruegel's son, Pieter the Younger, exist. Bruegel thus painted only six of the months of the year, but possibly he intended to do all twelve. *Hunters in the Snow* very likely stands for December. In this connection, a miniature in the Grimani Breviary — an early 16th-century manuscript in the Biblioteca Marciana at Venice — illustrates December with the same motif of the quartered hog that we see in Bruegel's panel (left). The artist has masterfully rendered the atmosphere of cold and silence that hangs over a snow-clad landscape. In the background rise the mountains of the south, depicted with a feeling for nature that was not to be found in the old Patinir. The white of the snow and the green of the sky and the ice are matchlessly effective.

PIETER BRUEGEL
Hunters in the Snow
Oil on panel; 46″ × 63 3/4″.
Signed and dated: "BRVEGEL MDLXV."
In 1566 the collector Nicolaas Jonghelinck of Antwerp owned sixteen paintings by Bruegel, including a series of the months of the year. These works became the property of the city of Antwerp, which in 1594 donated six of the paintings to the Archduke Ernest, Governor of the Southern Netherlands. Five panels showing the months have been preserved; the sixth has been lost. *Hunters in the Snow* illustrates either the month of December or January.

Right: detail.

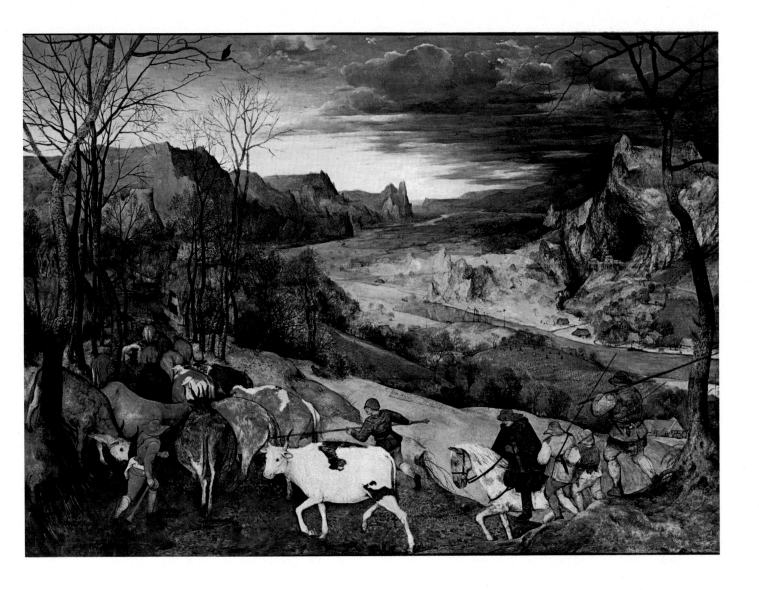

PIETER BRUEGEL
The Return of the Herd
Oil on panel; 46" × 62 1/2".
Signed and dated: "BRVEGEL MDLXV"
One of the six months painted by Bruegel
which belonged in 1566 to the Antwerp col-
lector Nicolaas Jonghelinck (see description
of the preceding work).

Left: actual size detail.

PIETER BRUEGEL. *The Return of the Herd.*
Like *Hunters in the Snow* (reproduced on page 114), it is one of Bruegel's
six representations of the months of the year. Authorities disagree on
whether this panel represents October or November. In the *Hunters in the
Snow* Bruegel emphasized the diagonal that starts from lower left. Here the
herdsmen and the cattle form a broad curve, which is stopped by the clumps
of trees on the left and the single tree on the right. The color is thin and
earthy, and suggests that the picture was not completely finished.

PIETER BRUEGEL. *Peasant Wedding.* *pp. 118–19*
The guests are seated at a long table, which the painter has shown obliquely.
The bride is readily identifiable: she is the young peasant girl against the
green backdrop, with the foolish expression on her face and her hands
folded in her lap. The groom may be the young glutton off to her right
who has most of his spoon in his mouth. It was because of works of this

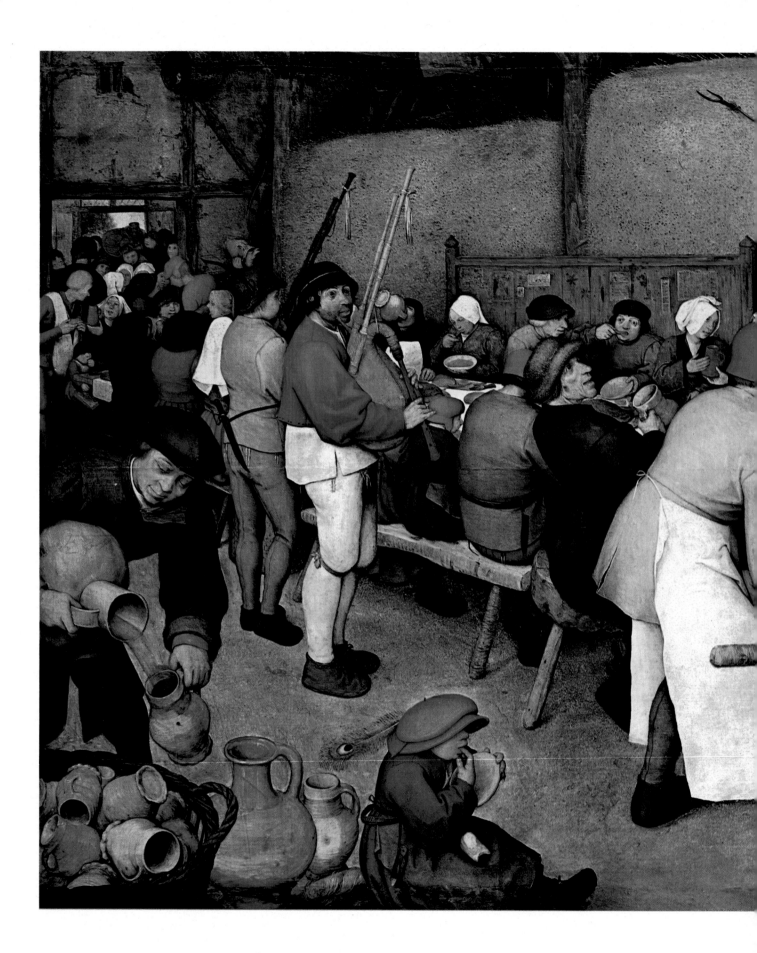

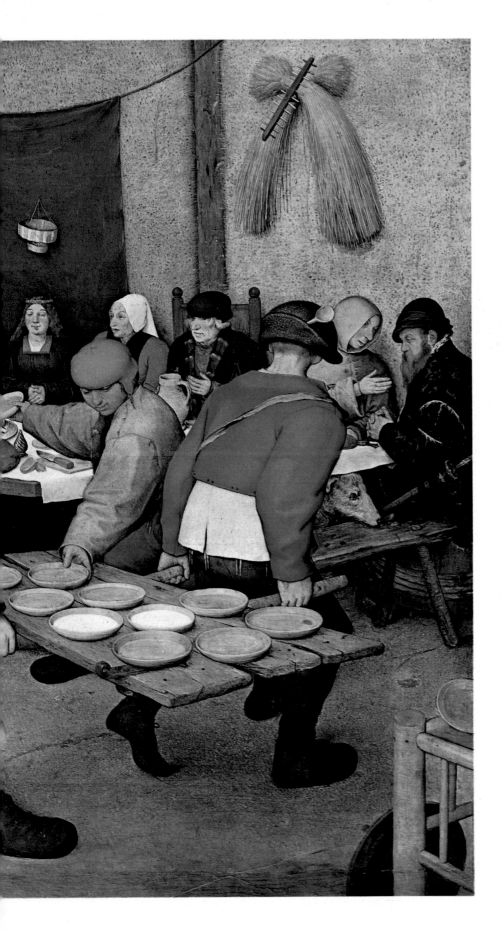

PIETER BRUEGEL
Peasant Wedding
Oil on panel: 44 3/4″ × 64 1/4″.
The lower part, where Bruegel's signature probably appeared, was cut down. Subsequently, however, it was enlarged by 2 1/4″ (which makes it the same size as *Peasant Dance*). Acquired in 1594 by Archduke Ernest. It is listed in Leopold William's inventory of 1659.

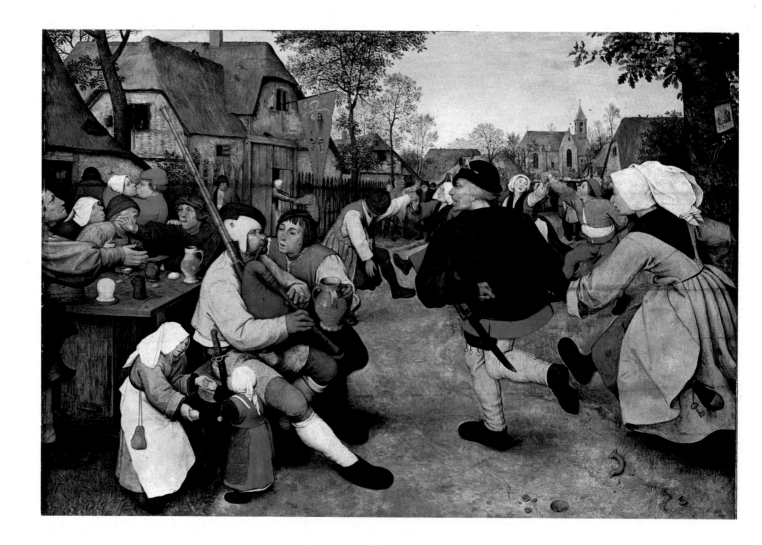

kind that the artist received the nickname of "Peasant Bruegel." Indeed, rustic life fascinated the painter, for he took it to be one of the most spontaneous manifestations of nature and thus a highly important subject for study. Bruegel is anything but facetious; his is the rigorous eye of an objective observer. Some writers maintain that in his scenes of peasant merriment Bruegel aims to moralize on human dissoluteness.

PIETER BRUEGEL. *Peasant Dance.*
As this work is almost exactly the same size as the *Peasant Wedding* reproduced on the preceding page, the two panels seem to be companion pieces. Here is the climax of a village *kermess,* or festival. On the left we see some drunken topers sitting at a table; behind them, a couple kissing. The bagpiper is piping meanwhile, and two couples dance to his music. A dandified oldster, pulling a young peasant woman, runs up to join the dance. In the left foreground two little girls (also shown in the detail, page 121) are imitating their dancing elders. The whole village, from the nearer houses among the trees to the distant little church, participates in the festival.

120

PIETER BRUEGEL
Peasant Dance
Oil on panel; 44 3/4" × 64 1/2".
Signed: "BRVEGEL."
Mentioned in Inventory "G"
(circa 1615).

Right:
Detail showing two dancing children.

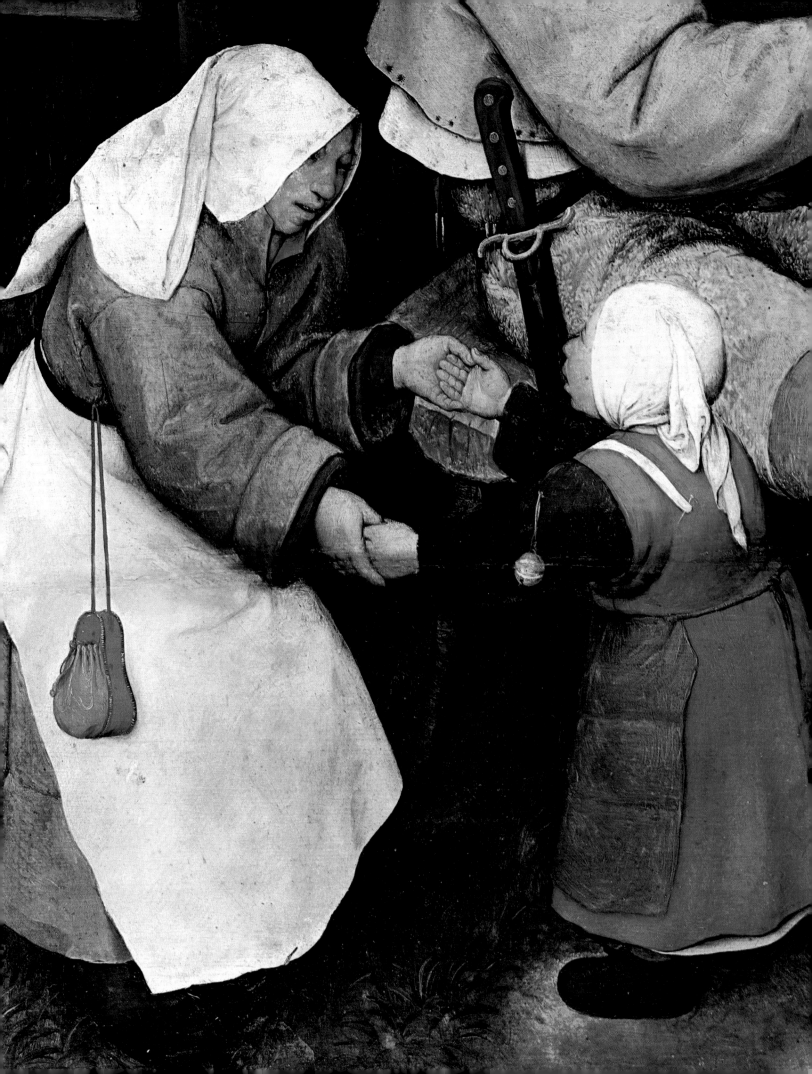

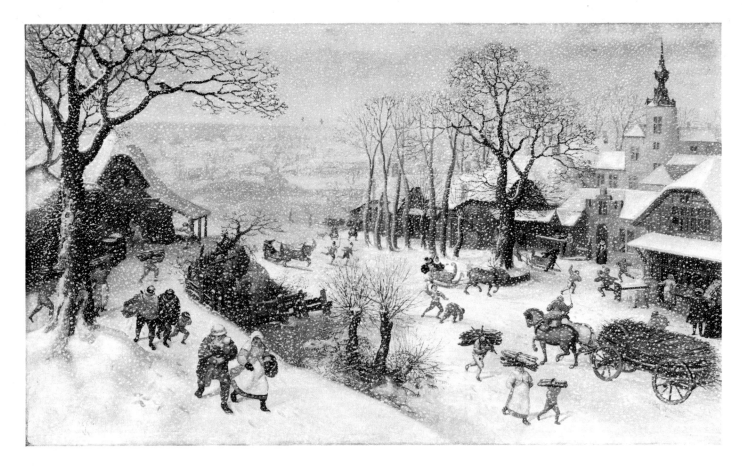

LUCAS VAN VALCKENBORCH. *Winter.*

This is one of four large canvases representing *The Seasons,* all of which are in the Art History Museum. The attractive landscape painting of Valckenborch, one of the artists in Bruegel's circle, is narrative and idyllic in tone. A comparison of his "busy" landscape with Bruegel's *Hunters in the Snow* (p. 114) shows profound differences in conception and style between the two works. Bruegel's landscape is seen from a distance, and provides an immense view that may be explored indefinitely; Valckenborch's is a close view, containing a limited number of compositional elements, most of which are anecdotal in character. In short, Valckenborch transposes Bruegel's rigorous art to a more prosaic plane, yet his painting is fascinating in its candor and freshness.

ANTHONIS MOR. *Portrait of Granvella.*　　　　　　　　*p. 124*

Antoine Perrenot de Granvella (1517–86) was a prominent personality in the political history of the Low Countries. Bishop of the Flemish city of Arras, Minister of State under Charles V and Philip II, he then served for five years as minister of Margaret of Parma, natural daughter of Charles V and governor of the Low Countries (1559–64). Anthonis Mor was one of the greatest portraitists in Europe in the 16th century, and the dignity and distinction with which he invested his subjects made him a favorite painter in the courts of Europe. In composition, *Portrait of Granvella* seems to be based on Titian, from whom Mor differs however in the smoothness of the modeling and the careful execution of the details.

LUCAS VAN VALCKENBORCH
Louvain circa 1530 — Frankfurt-am-Main 1597
Active in Mechelen until 1566, and subsequently at Liège and Aachen. Around 1575 he was at Antwerp, where he entered the service of Archduke (later Emperor) Matthew, whom he followed to Linz in Austria. From 1593 he was in Frankfurt-am-Main.
Winter
Oil on canvas; 46″ × 78″.
Monogrammed and dated 1586.
One of a series of four seasons — all in the museum — which are the same size but of different dates (1585 for *Summer* and *Autumn,* 1587 for *Spring*). The series is mentioned in Mechel's inventory of 1783.

Right: actual size detail.

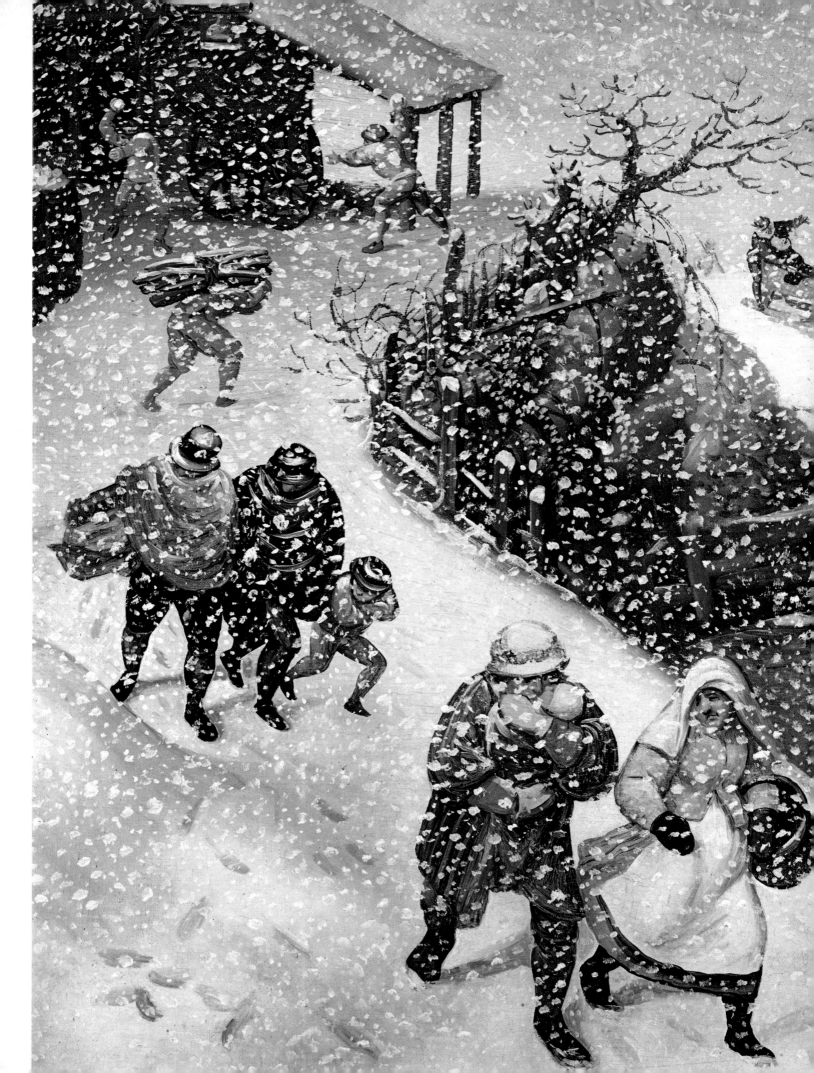

BARTHOLOMEUS SPRANGER. *Venus and Adonis.*
The Art History Museum is rich in paintings by the great Mannerist, Bartholomeus Spranger, who was active at the court of the Austrian Emperor, Rudolph II, at Prague. Very early in his career Spranger left his native Antwerp, where he could not find a teacher who satisfied him, and traveled via Paris and Parma to Rome. He stayed in Rome for ten years, from 1566 to 1575. In that city he mastered the "Italian Manner" with such felicity as to amaze his Roman colleagues and arouse the envy of one old chauvinist, Giorgio Vasari. Summoned to Prague by Rudolph II, Spranger executed a magnificent series of canvases, whose mythological and erotic themes were progressively suggested to him by the Emperor himself. They are extremely elegant works, loaded with a somewhat morbid sensuality. At Prague Spranger influenced Heintz (see page 33), but the impact of his art was felt all over Europe, especially in the Dutch centers.

124

ANTHONIS MOR
(SIR ANTHONY MORE or
ANTONIO MORO)
Utrecht circa 1520 — Antwerp 1576
Pupil of Jan van Scorel at Utrecht; master at Antwerp in 1547. He was in Rome in 1550–51. Active at the courts of Portugal (1552), England (1554) and Spain (1559). He often returned to his native Utrecht. His last years were spent at Antwerp.
Portrait of Granvella
Oil on panel; 42″ × 32 1/4″.
Signed and dated: *"Antonius mor faciebat 1549."* In Mechel's inventory of 1783.

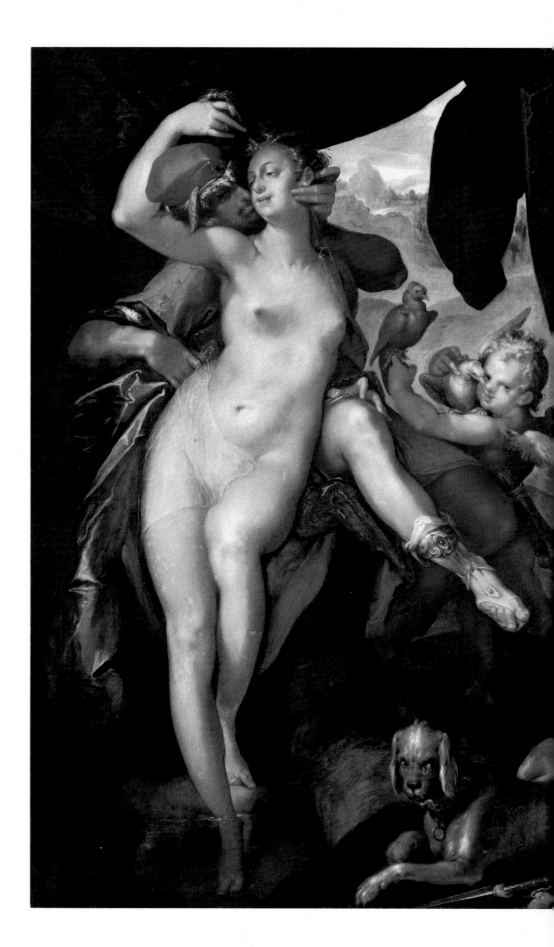

BARTHOLOMEUS SPRANGER
Antwerp 1546 — Prague 1611
Pupil of Jan Mandijn, Frans Mostaert (d.
1560) and Cornelis van Dalem, at Ant-
werp. In 1565 he left for Italy and so-
journed in Paris, Lyons, Milan, Parma and
for a long time in Rome (1566–75). In
1575 he went to Vienna, and from 1584 he
was active in Prague.
Venus and Adonis
Oil on canvas; 64 1/4″ × 41″.
It has been on exhibition since 1915. The
work was executed at the end of the 16th
century, and its color nuances reveal a close
study of Johann van Aachen, court painter
of Rudolph II from 1592.

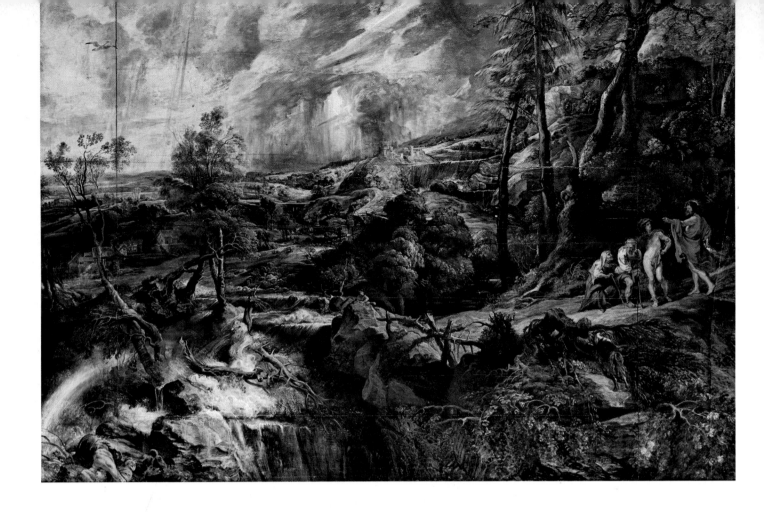

PETER PAUL RUBENS. *Stormy Landscape.*

It has been said that the most extraordinary 17th-century landscapes were painted by artists who did not specialize in the genre (Rubens, Rembrandt, Poussin), and this statement has a kernel of truth. Rubens' all show a Baroque agitation. In *Stormy Landscape* the unleashing of the elements touches on paroxysm. One seems to hear — in the vast landscape on which the storm has burst — the rustling of the trees lashed by the wind. In the lower left we see a woman and an infant who have been overcome by the waves, while a little above them a man clings desperately to a tree. But the tempest is abating, and though the sky is still uncertain and threatening, the colors of the rainbow have appeared below. Titian's influence is fundamental in this landscape, and in others by Rubens, but the Flemish master's powerful naturalism and titanic qualities have radically transformed any elements deriving from the 16th-century tradition. The figures on the right represent Jupiter and Mercury with Philemon and Baucis. According to the myth recounted in Ovid's *Metamorphoses,* Philemon and Baucis gave hospitality to the two gods who had come to them under the guise of pilgrims. The goodness of the old couple was rewarded. When a tempest burst on them, their cabin was undamaged, and transformed into a temple in which Philemon and Baucis lived happily as priests. Although he was fascinated by classical fables, Rubens in this case was not concerned with Ovid's story. Here the mythological figures are used to give a literary patina to a grandiose and wildly disordered landscape.

PETER PAUL RUBENS
Siegen (Westphalia) 1577 — Antwerp 1640
Pupil of Tobias Verhaecht, Adam van Noort and Octavius van Veen at Antwerp, where he became a master in 1598. In 1600–08 in Italy and Spain. From 1609 he was established in Antwerp but traveled to Holland, Paris, London, Madrid (1628), etc.
Stormy Landscape
Oil on panel; 4'9 3/4" × 6'10 1/4".
According to Glück it was executed around 1624. The panel is mentioned in the inventory drawn up after the death of Rubens (1640), and subsequently in Leopold William's inventory of 1659. A smaller version, perhaps by Lucas van Uden, is in the Johnson Collection, Philadelphia.

Right: detail.

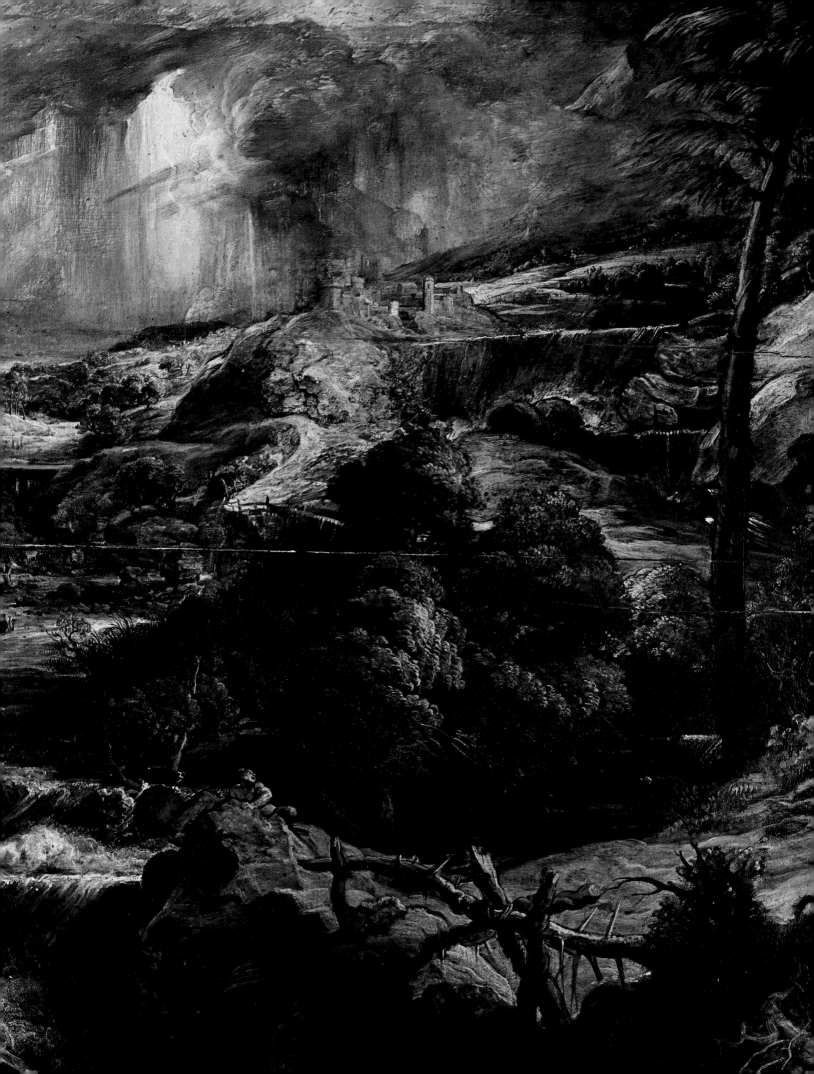

PETER PAUL RUBENS. *Park of a Castle.*

Throughout his career Rubens placed his art at the service of the prevailing political and religious powers, whose vanity and thirst for dominance he knew how to satisfy with his grandiose painting. From time to time, however, the artist felt the need to retire into himself and to forget for a moment his arduous role as official mythographer to the great of the world. Thus every now and then he created intimate, simple and lyrical works, and the present painting is certainly one of these. The landscape, seen with a serenely realistic eye, is painted in mixed pastel tones, while more substantial color is used in the elegant foreground figures, which are executed with great freedom and dash. Although the personages shown appear to be intent on amorous play, the milky sky veiling the sun strikes a dominant elegiac note. Works like this, in which Rubens' Baroque impetuosity is fined down and poeticized, profoundly influenced such painters of the following century as Watteau and Fragonard.

PETER PAUL RUBENS. *Cimone and Efigenia.*

Boccaccio tells the story of these lovers in the *Decameron.* Cimone, the son of a Cypriot nobleman, refused the education suitable to his rank and did not learn to read or write; he lived away from his father's palace and worked as a peasant. On a hot midday Cimone saw Efigenia sleeping in the shade

PETER PAUL RUBENS
Park of a Castle
Oil on panel; 20 3/4″ × 38 1/4″.
In Mechel's inventory of 1783. An engraving by Schelde à Bolswert and a variant in the Dulière collection, Brussels, give more space to the sky. According to Glück it is datable around 1632; for Raczynski it was executed between 1635 and 1638.

of some trees with other maidens and a little page. Cimone fell in love with Efigenia and resolved to change his life so that he might ask for her hand. In a short time he acquired a proper education, and after some adventures he succeeded in marrying the girl. Rubens' painting, in which the feminine forms are so monumental and opulent as to be almost provocative, recalls the mythological compositions of Frans Floris and his school. In this large canvas, the fruits and animals were painted by Frans Snyders, while the landscape was added by Jan Wildens.

PETER PAUL RUBENS. *The Four Quarters of the Globe.* *p. 130*
Four female personifications, each accompanied by a river god, represent the four continents. At the upper left are Europe and the Danube; below, Africa with the Nile. On the right in front are Asia and the Ganges; behind, America and the Amazon. It is a work of Rubens' most "classical" period, that is, the middle of the second decade of the 17th century. The strong relief of the figures recalls ancient sculpture, while the drawing calls up Michelangelo's art in its organic feeling for the contours of the human

PETER PAUL RUBENS
Cimone and Efigenia
Oil on canvas; 6′9 3/4″ × 9′3″. (Cut down all around, especially on the left).
Originally it belonged to the Duke of Buckingham, and was sold at auction in 1648. Subsequently it appeared in Storffer's inventory (II, 1733). According to the Art History Museum catalogue it was executed around 1617.

129

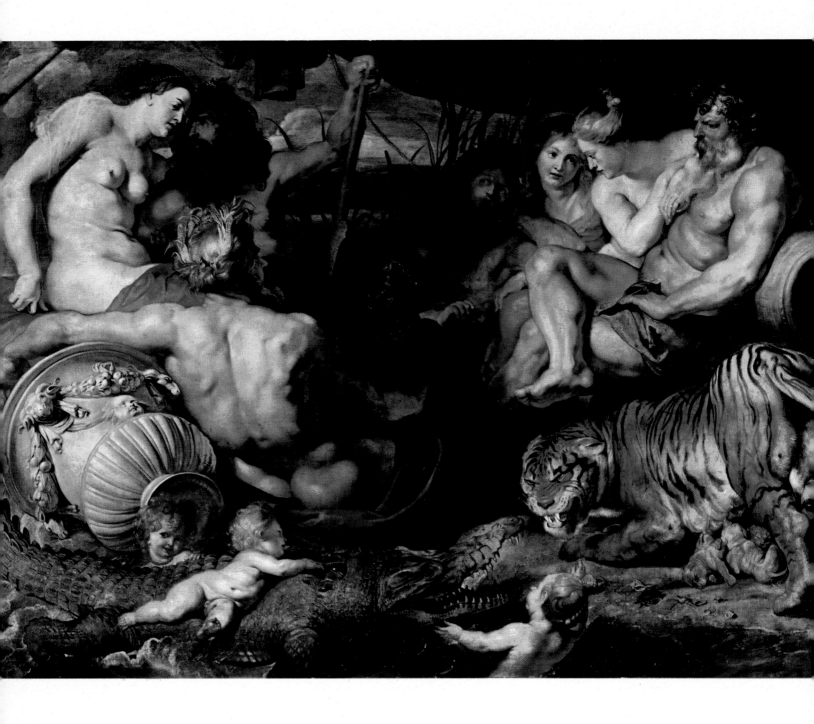

body. The high, full-bodied color, though, is in the Venetian tradition. Rubens' brilliance lies in having summed up all these diverse elements in paintings whose vitality and sensual fire are unflagging. In harmony of composition and form the present picture is entirely worthy of the golden age of Italian painting. The crocodile and the tigress with her cubs, which are painted with amazing virtuosity, are probably based on life studies.

PETER PAUL RUBENS. *Angelica and the Hermit.*
The eighth canto of Ariosto's *Orlando Furioso* tells that a hermit-magician fell in love with Angelica and transported her to a desert island. This little

PETER PAUL RUBENS
The Four Quarters of the Globe
Oil on canvas; 6'10 1/4" × 9'3 3/4" (Cut down all around).
Perhaps a companion piece to the *Neptune and Amphitrite* in Berlin (7'6 1/2" × 10').
Dated by Glück around 1612–14, by Oldenbourg around 1615–16. Mentioned in the Prague inventory of 1718.

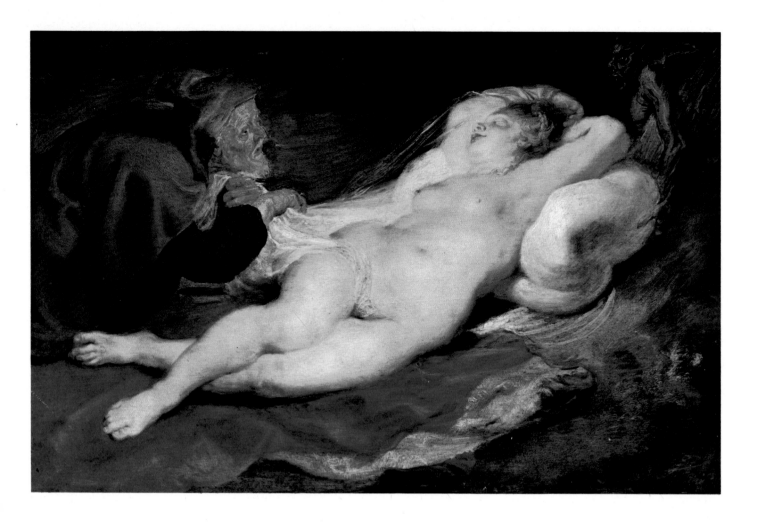

PETER PAUL RUBENS
Angelica and the Hermit
Oil on panel; 17″ × 26″.
Perhaps the same painting that was listed among Rubens' possessions at his death in 1640. Mentioned in the Prague inventory of 1718. Dated around 1625–28 by Raczynski, around 1630–31 by Seilern, around 1635 by Parker and by Popham. A very similar sketch is in Count Seilern's collection in London.

picture, painted on panel, is one of Rubens' most refined late works. What a contrast it shows to the great canvases of his earlier period, which were animated by an ideal of monumentality and turgid volume. In his advanced age the painter developed a particular taste for fineness in the brushwork and intimacy in narrative tone. There is no doubt that the basis of this new phase was the prodigious example of Rembrandt, who had established himself from around 1630 on as the greatest painter of the Dutch School. Rubens, who was always ready to learn from the achievements of the most modern painters, must have been impressed by the subtle fabric, as gossamer as a cobweb, of Rembrandt's youthful works. In *Angelica and the Hermit* the old man's face is close to the art of the Dutch painter. Rembrandt on his part was not indifferent to the manifold aspects of Rubens' painting. In some of his pictures that show a Baroque charge (for example, the *Blinded Samson* in Frankfurt, 1636) he seems to be competing with the powerful creations of the older Brabantine artist. Although many aspects of their art seem antithetical, the two great 17th century Netherlandish painters knew each other's work and influenced each other.

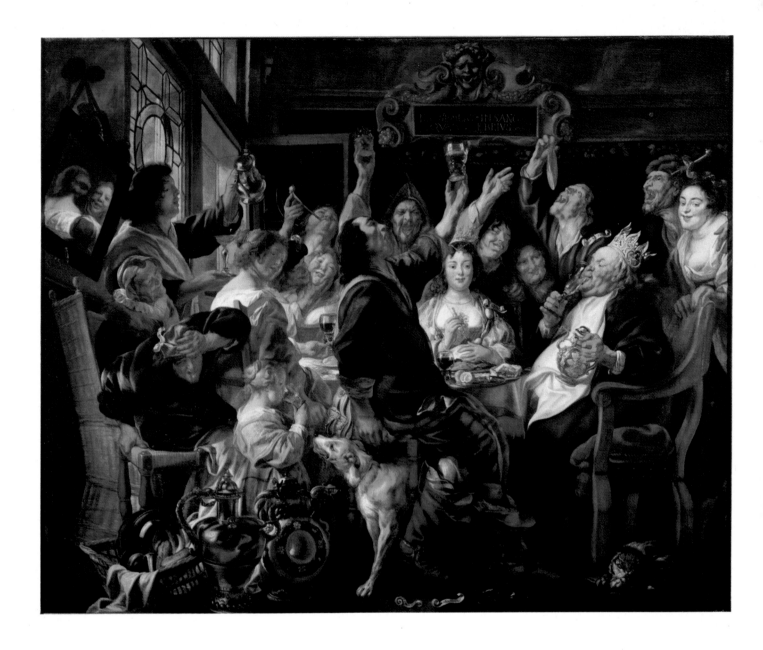

JACOB JORDAENS. *Bean-Feast.*

It was a widespread custom to serve a cake containing a single bean at Twelfth Night banquets; the guest whose slice of cake included the bean became the king of the feast. In Jordaens' picture, a Latin inscription on the paper on the wall warns that: "No one is more like a madman than a drunk." The turbulent celebration is thus seen moralistically (and perhaps following Bruegel) as a deplorable excess. It should be remembered in this connection that Jordaens was one of the few Calvinists in Antwerp at that time, as the city had been obliged to return to Catholicism after the Spanish victory of 1585. The painting is one of the most brilliant masterpieces by Jordaens, who with Rubens and van Dyck makes up the trio of great Brabantine painters of the 17th century. Although he never went to Italy, Jordaens' work is related to that of Caravaggio. The quality of his color as a structural element is extraordinary.

132

JACOB JORDAENS
Antwerp 1593 — Antwerp 1678
Pupil of Adam van Noort in 1607. He became a master in 1615 at Amsterdam, where he was subsequently active.
Bean-Feast
Oil on canvas; 7'11 1/4" × 9'10".
As it is in Archduke Leopold William's inventory of 1659, the picture must have been painted before then. According to Rooses it was done a little before 1656. Similar compositions are in the museums of Kassel, Braunschweig and Brussels. A preliminary sketch for the child in the foreground is in the Braunschweig Museum.

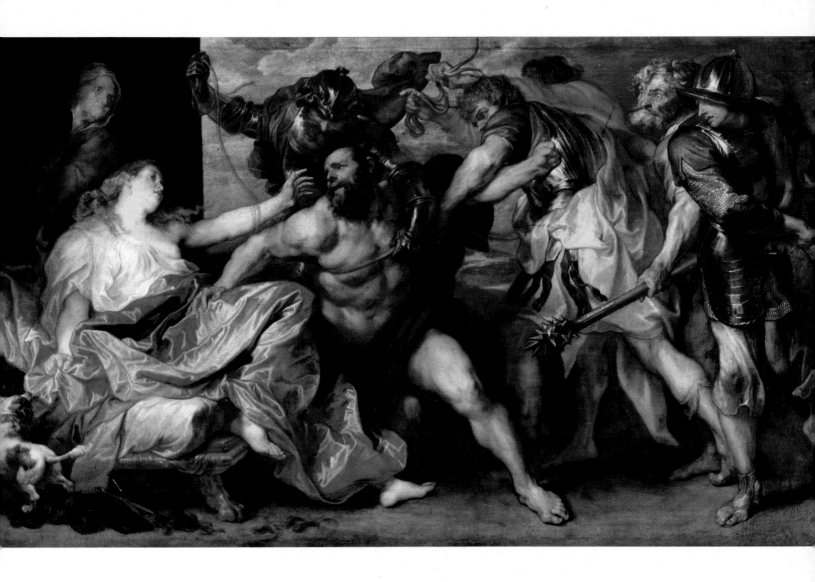

ANTHONY VAN DYCK
Antwerp 1599 — London 1641
In 1609 he was working with Hendrick van
Balen at Antwerp. He became a master at
Antwerp in 1618. In 1620 he was in Lon-
don; from 1621 to 1627 in Italy (Genoa,
Venice, Florence, Rome, Palermo, etc.);
from 1627 to 1632 in Antwerp; in 1632 at
The Hague; from 1632 to 1640 in London;
in 1641 in Paris.
Samson and Delilah
Oil on canvas; 4'9 1/2" × 8'4".
In Leopold William's inventory of 1659.
Two preparatory drawings for details of the
picture are in the Lugt collection in Paris.
A painting of the same subject is in the
Dulwich College Picture Gallery. According
to Glück the work was executed during
the artist's second period in Antwerp (1627-
32).

ANTHONY VAN DYCK. *Samson and Delilah.*

It was mainly his seven-year stay in Italy (1621–27) that detached van
Dyck from the orbit of Rubens, who in previous years in Antwerp had
been his ideal master. "It is surprising," Justus Müller Hofstede has written,
"with what interest, the moment he came down to Italy, van Dyck concen-
trated on Venetian art and the examples of Titian, Veronese and Tintoretto.
His palette became darker and richer in nuances; his brushwork more
measured and sensitive, his manner of laying in colors — now of greater
delicacy — more fluid and careful. Under the influence of the measured
and intimate work of Titian, the drama and fierceness of his youthful pe-
riod in Antwerp are transformed, one might say, into an art expressive of
the feelings." The large canvas representing *Samson and Delilah* is dated to
the period immediately following the artist's return from Italy. Although
there is a sketch by Rubens (Chicago) which seems to have given van
Dyck the idea for the composition, the soft modeling of the figures and the
elegiac mood of the painting are typical of the younger artist's work. Ti-
tianesque suggestions are evident in the broadly draped figure of Delilah.

133

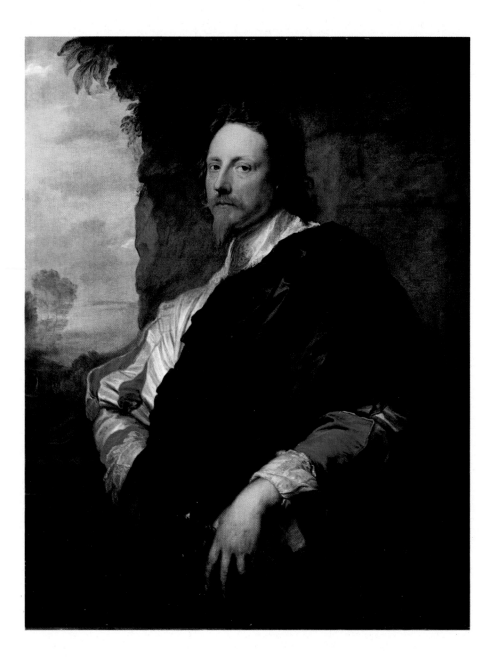

ANTHONY VAN DYCK. *Portrait of Nicholas Lanier.*
After a first stay in London in 1620–21, van Dyck returned to England in 1632 and remained there almost without interruption until his death. It is likely that this portrait was executed during the early months of van Dyck's second sojourn in England. Lanier (1588–1665) lived in London as court musician to Charles I; his position was subsequently confirmed by Charles II. Lanier was also an engraver and an amateur painter, and because of this bent he was repeatedly commanded to buy art works for the royal palaces. In his portrait, van Dyck sees the musician above all as a courtier, giving him a solemn and dignified stance. Essentially van Dyck was the portraitist of the aristocracy, but it has been correctly observed that his subjects are shown with psychological insight, and reveal a nobility that is not merely an external gloss.

134

ANTHONY VAN DYCK
Portrait of Nicholas Lanier
Oil on canvas; 44" × 34".
It is listed in Storffer's inventory (I, 1720).
The subject has been identified from an engraved portrait of Lanier by L. Vorsterman.
A preliminary drawing is in the National Gallery at Edinburgh. Dating is uncertain.

HOLLAND

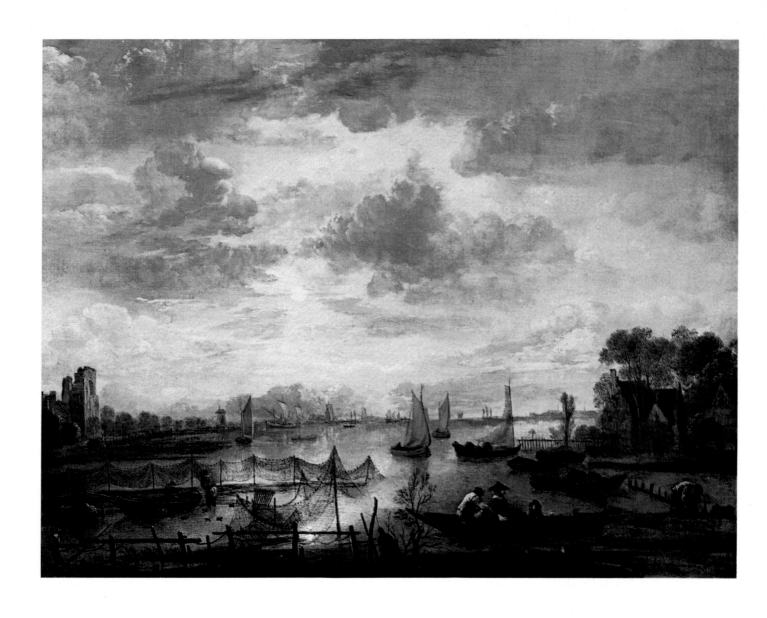

AERT VAN DER NEER. *River Scene with Fishermen.*

Aert van der Neer's formation clearly reflects the proximity of artists like Avercamp, Camphuysen, van Goyen and Salomon van Ruysdael. This plurality of interests is particularly evident in his continual references to the various genres that are typical of these masters. He also had a genre that was exclusively his own: moonlit landscapes. This choice supplies the clue to an understanding of the artist's style. In all of his pictures, and especially in the works of his late maturity like this one, the emphasis on a particular "atmosphere" is a constant element. He follows the traditional compositional means of measuring off the space, often with great emphasis, and at the same time he sets the tone of the scene by his particular combinations of light effects and objective observation.

AERT VAN DER NEER
Amsterdam circa 1603–4 —
Amsterdam 1677
River Scene with Fishermen
Oil on canvas; 26 1/4″ × 34″.
Monogrammed.
From the Louis Viardot and the Péreire collections in Paris. Acquired by the museum in 1924.

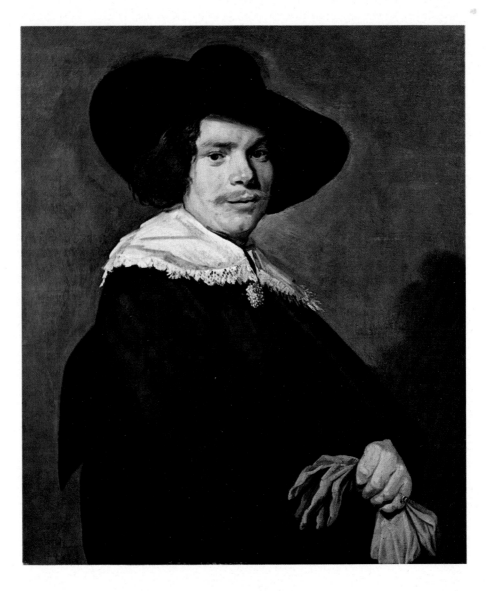

FRANS HALS. *Portrait of a Young Man.*
In composition and details, as well as in the range of colors, this work is typical of the artist's mature style. The dynamic structure, balanced by rapid and brilliant color harmonies, of his earlier work gave way around 1635–47 to more measured and contained rhythms. The painting is no longer in clear tones with rapid turns of the brush, but shows deeper harmonies in which the light areas of the faces, hands and collars stand out. A more reflective study of feeling is seen in the expressions of the subjects.

FRANS HALS. *Portrait of a Man.* *p. 138*
Some scholars consider this to be a self-portrait. The unlikelihood of the hypothesis is apparent when the work is compared with two paintings that more probably are self-portraits: the one in the group portrait of the *Civic Guard of St. George* in Haarlem, and the other at the Clowes Foundation in Indianapolis. The pose is conventional and is seen, with slight variations, in dozens of Hals' portraits. But the strong characterization of the face and the set of the head and hat against the variations of the ground have an

FRANS HALS
Antwerp 1580 — Haarlem 1666
Portrait of a Young Man
Oil on canvas; 31″ × 26 1/4″.
Formerly cut down to an oval, the canvas was restored to its original shape in 1935. Hals authorities date this portrait in the period of the artist's full maturity, between 1639 and 1650.

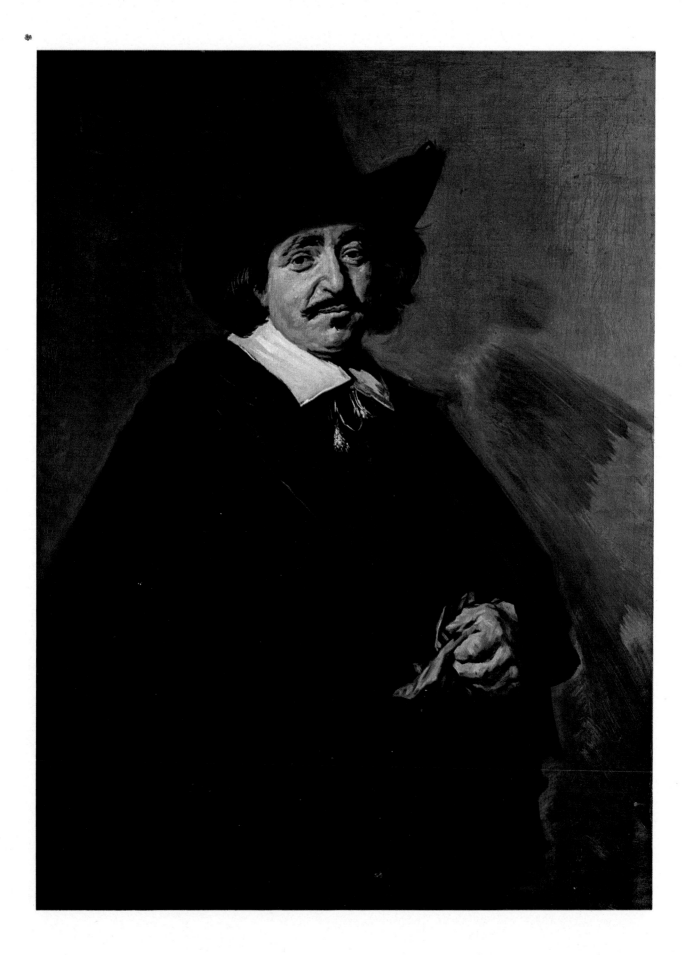

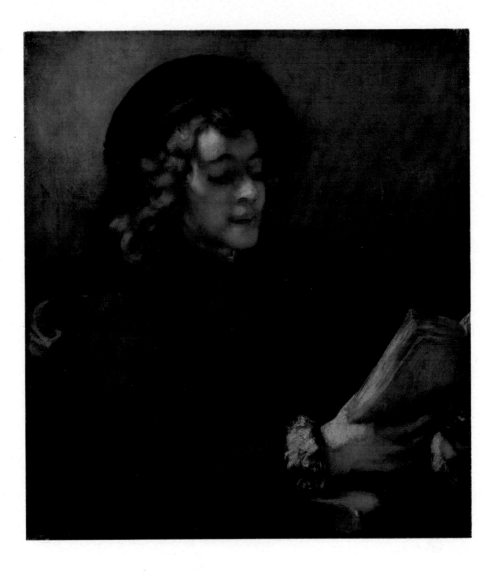

unmistakably individual stamp. This portrait is part of the great human gallery that the master left us. His ability to explore the feelings of his subjects was perhaps unequaled even by Rembrandt.

REMBRANDT VAN RIJN. *Portrait of Titus.*
Titus was the only one of Rembrandt's four children by his wife Saskia to survive infancy. Much loved by his father, Titus stood by him devotedly in his misfortune, when he lost the favor of his rich patrons in Amsterdam and had to give up his house and a good part of his possessions. The premature death of Titus in 1668 was Rembrandt's last great sorrow; beset by loneliness and old before his time, he died a year later. In the full maturity of Rembrandt's style, as in this portrait, the light becomes a vehicle for physical and psychological description. Following the convention in portraiture, the light lingers on the face and hands. But here this convention is transformed by the current of feeling that runs between the figure and the book. The expression of the boy's face and the pose show that he is somewhat amused by his attentive reading.

139

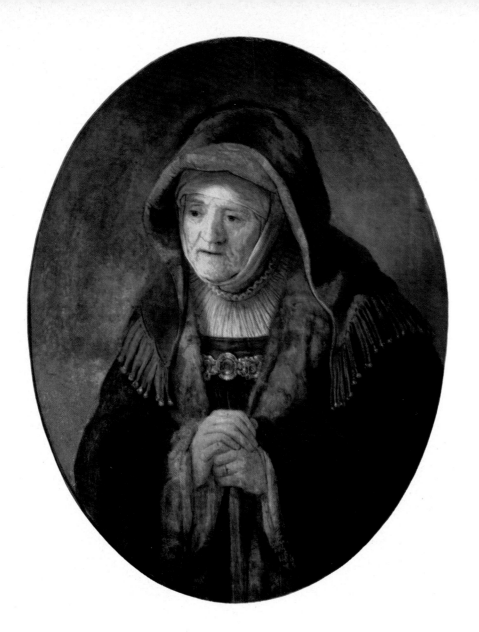

REMBRANDT VAN RIJN
Rembrandt's Mother
Oil on panel; 31 1/4″ × 24 1/4″.
Signed and dated: "Rembrandt 1639."
The original rectangular shape was
reduced to an oval in the
18th century.

REMBRANDT VAN RIJN. *Rembrandt's Mother.*

A marked senility, exaggerated even for the advanced age of the woman, is
revealed by the luminous reflections created by the thick and clotted brush-
work. The figure is encased in the heavy contours of her clothes. Her hands,
deformed by age, are placed in front, in the middle, and give the pose
cadence. Enclosed by the band that goes under her jaw, her face is enlivened
by an intensely absorbed expression, of the sort to be found only in por-
traits of the master's late maturity. These family portraits and the splendid
series of self-portraits recount a history of feelings and sufferings connected
with private events but rendered universal by Rembrandt's genius. As in the
Portrait of Titus (see *Rijksmuseum/Amsterdam,* page 79), which was also
executed a few years before the death of the beloved subject, there is a
presentiment of mortality.

REMBRANDT VAN RIJN. *Self-Portrait.*

The bigness and monumentality of the structure, the breadth and scansion of
the forms, emphasize the emotional impact of the tight-lipped mouth and
the suffering gaze of the subject. Executed when the artist's fortunes were on

REMBRANDT VAN RIJN
Self-Portrait (detail)
Oil on panel; 26″ × 20 3/4″.
Signed and dated: "Rembrandt f. 1655."
It belonged to the following collections:
Lord Carysfort, London; Samuel Rogers,
London; Evans-Lombe, Paris; Ch.
Sedelmeyer, Paris; Mendelssohn, Berlin.
It came to the museum in 1942.

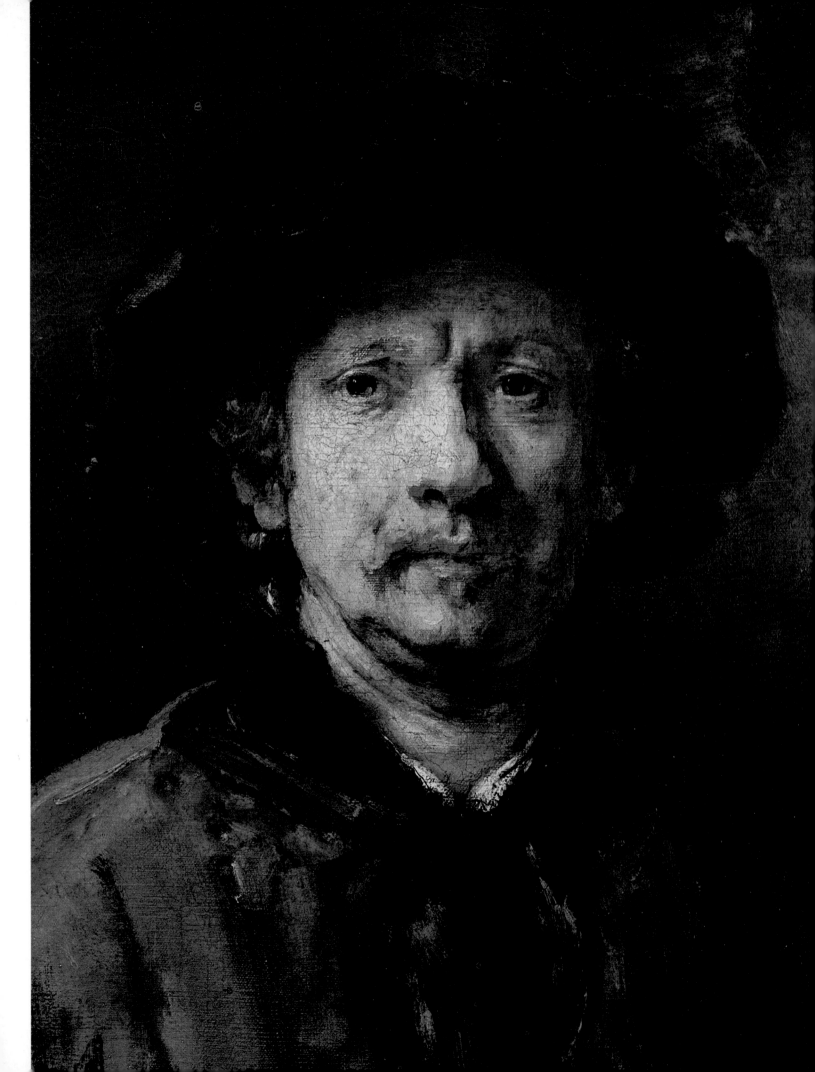

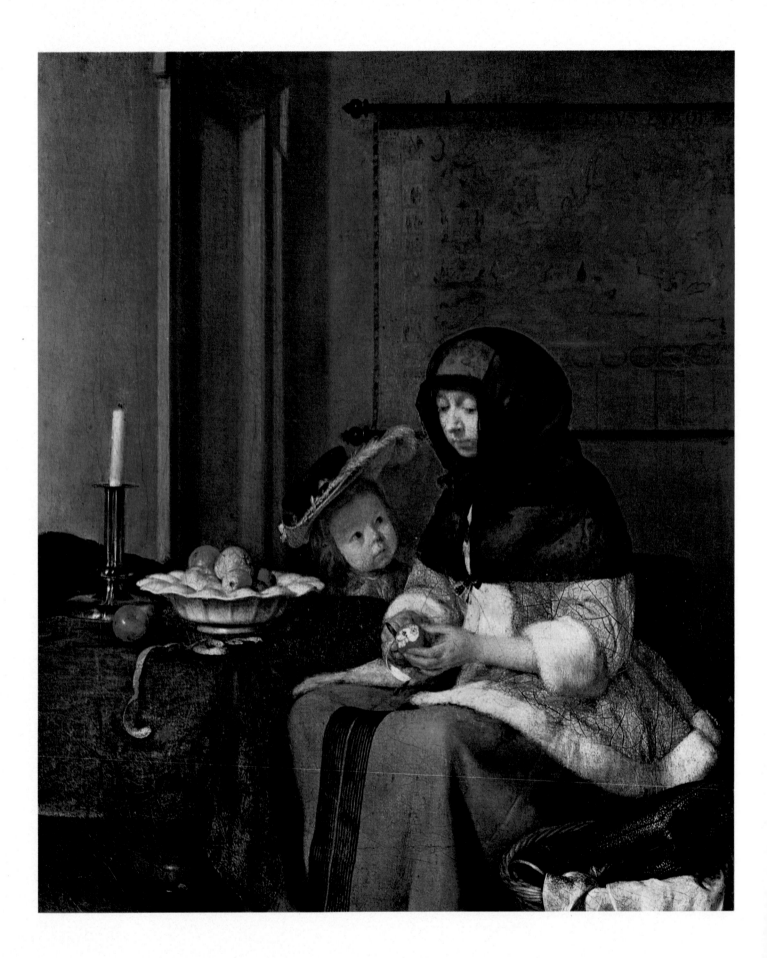

GERARD TER BORCH
Zwolle 1617 — Deventer 1681
Woman Peeling an Apple
Oil on canvas mounted on panel;
14 1/4" × 12.".
There are numerous copies and replicas,
signed and dated 1651 or 1661.

the decline, it is the first of the self-portraits Rembrandt painted in his maturity, in which disquietude affects his intensely virile physiognomy. Previously they were always full of a great vitality, sometimes willful or ironically amazed, sometimes serene in the awareness of his own genius. This work accordingly marks a watershed in the detailed autobiography made up by the self-portraits. It starts the dramatic turn that will closely follow the sad story of the sorrows and loneliness of the old master. A higher, ethical serenity remains the constant in these works, up to the painful irony of *Portrait of the Artist as Democritus* in Cologne.

GERARD TER BORCH. *Woman Peeling an Apple.*

The pupil of his father while he lived in Zwolle, then of Pieter Molijn in Haarlem, Ter Borch was a cultivated artist and a highly successful portraitist. The fame of his works is attested by the number of copies and replicas of some of the best-known paintings, like the *Company in an Interior* (formerly called the *Paternal Admonition;* see *Rijksmuseum/Amsterdam,* page 90), and the present panel. Aside from external evidence for dating, which is provided by the copies, this painting is typical of the master's mature style. The prominence in the foreground of the figures, and their relationship to the still life on the left may recall Vermeer's similar compositions executed during the same period. But Ter Borch's work has an abstract aristocratic — almost archaic — quality. Although lighted in a caressing way, the figures and the objects have an almost ritual development as they follow the obvious structural lines of the composition. The child's face is vividly, almost unexpectedly, inserted into the picture, but this effect is tempered by the shadow from her hat, as if to keep it from emphasizing the narrative side of the picture and thus affecting its function as the center and regulator of the entire composition.

JAN STEEN. *The World Upside Down.* pp. 144–45

The work is also often called *Wantonness,* which is taken from the admonition to beware of that condition, in the Dutch inscription on the little panel at lower right. In truth, however, the more commonly adopted title is more in keeping with the artist's human approach, for even in dealing with themes like this Jan Steen avoided any moralizing stance. In *The World Upside Down,* everything around the two drunken lovers is confused, indeed topsy-turvy: the dog is eating on the table; a florid infant in a highchair is playing with money; a little girl is stealing something out of the larder. So it goes, up to the absurdity of the duck on the doctor's back, the monkey playing with the weights of the clock, and the basket with a crutch, a sword and other odds and ends hanging from the ceiling. Everything is going its own way, but the merry artist of Leyden is not a Brouwer nor even a van Ostade. His approach is always full of human sympathy and cheerful participation. The tightly organized composition is developed in a series of wide-angle episodes departing from the marked central axis. This structure permits a rhythmic, cadenced narration, in which each person and object, even the most absurd, is good-humoredly studied and described. The ability to characterize and then to suggest the universal from the characteristic is

one of the most original aspects of Steen's creativity. His scenes of family life and his festive interiors form a gallery of human types that will not be equaled in penetration and understanding until Dickens produces his novels.

JACOB VAN RUISDAEL. *The Great Forest.* p. 146

The problem of dating for the great number of works by Ruisdael is especially complicated with respect to the painter's activity after 1657, when he settled in Amsterdam. This large landscape is dated by Bode and Rosenberg between 1655 and 1660, or in the stylistically most complex period of the master's early maturity, when his attitude toward the landscape tradition of the preceding generations became definitive. That is, when he went beyond the last residues of Mannerist stylization, though retaining the traditional divisions of space, and created intensely emotional works of art. The dramatic dialectics of the relationship between the artist and his subject is not to be found elsewhere, apart from Rembrandt's masterpieces. It is not seen even in the outstanding works of artists like Salomon van Ruysdael, the artist's uncle, whose works were fundamental to Jacob's formation

JAN STEEN
Leyden 1626 — Leyden 1679
The World Upside Down
Oil on canvas; 41 1/4″ × 57″.
Signed and dated: "JS 16 . . ."
From Count Karl von Lothringen's collection in Brussels.

Right:
Detail showing the child at the table.

144

and influenced his choice of composition and subject. In this sense there is justification for the theory of scholars who have seen Jacob as the fore-runner of the Romantic relationship between artist and nature, which was expressed in the 19th century by the Barbizon School painters.

JAN VERMEER. *The Artist and His Studio.*
The iconographic problem of this work is complicated. Formerly the model on the left was taken to represent Fame. More recently, she has been iden-tified as Clio, the muse of history, who is holding a book by Herodotus or

JACOB VAN RUISDAEL
Haarlem 1628 or 1629 —
Amsterdam (?) 1682
The Great Forest
Oil on canvas; 55" × 70 3/4".
Signed: "J. v. Ruisdael."
It was in the von Artaria collection in Mannheim, from which it was acquired by the museum in 1806.

JAN VERMEER
Delft 1632 — Delft 1675
The Artist and His Studio
Oil on panel; 47 1/4″ × 39 1/4″.
Signed on the lower edge of the map: "I
Ver-Meer."
At the end of the 18th century the painting
belonged to Baron van Swieten, Ambassador
of Austria in Brussels, Paris and finally Berlin. In 1813 it entered the Czernin collection in Vienna, and before the Second World
War it was placed on loan in the museum.
Confiscated by Hitler in 1942, it was returned to the museum in 1945. Some scholars identify this work with the *Portrait of
Vermeer in a Room with Various Accessories,* which the painter's widow gave his
mother as surety for a debt, and which was
sold at auction in 1696 at Amsterdam. The
identification is, however, tenuous. This
celebrated masterpiece poses many problems. First among them is the date, and art
historians dispute as to whether the model
was the elder or the younger daughter of the
artist, who was married in 1653. Apart from
this debate, the dates proposed for the work
range from 1660 to 1672. The painting belongs to Vermeer's fully developed, final
period.

On page 148:
Detail showing the model.

Thucydides and is looking at the symbols of the other muses on the table.
The musical score symbolizes Euterpe, the muse of music; the plaster mask,
Thalia, muse of comedy; the book, Polyhymnia, muse of sacred song. If,
however, the mask is interpreted as symbolizing sculpture, and the open
notebook as showing an architectural plan, the picture may be intended as
a contest of the arts, in which painting — represented by the painter at his
easel — triumphs. Other problems are the identity of the painter — is this
figure a self-portrait or not? — and the reason for his antiquated dress. The
iconographic complexities, however, should not distract the observer from
an appreciation of this masterpiece. In his fully mature style, Vermeer has
moved the axis of the composition well to the right. The source of light is
isolated on the left, and the curtain in the left foreground has its own prominent reflection. Vermeer has tightened his structural patterns, and his descriptive precision becomes absolute and abstract.

147

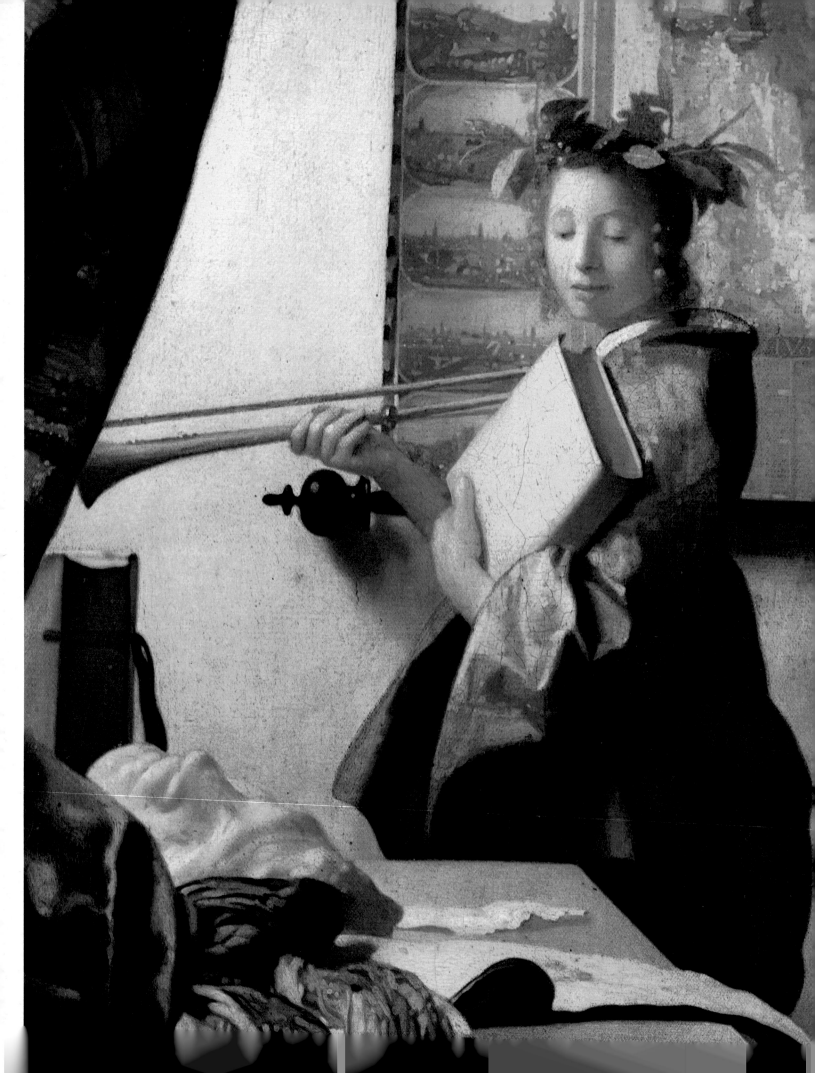

SPAIN

FRANCE

SWITZERLAND

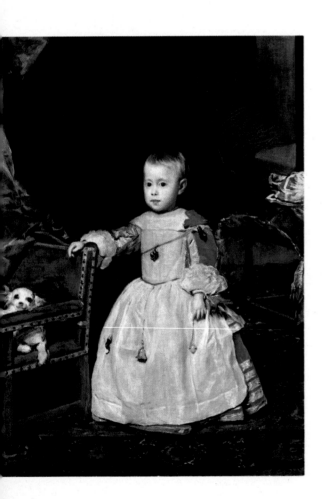

DIEGO VELÁZQUEZ DA SILVA. *Prince Philip Prosper.*

Philip Prosper, son of Philip IV and Mariana of Austria, was born in 1657 and died in 1661. His portrait, which was executed to make a pair with that of his sister Margareta, is one of Velázquez's last and finest works. In the vast space indicated by the shadows and the fall of the curtain, the series of objects and the foreground figure are rapidly picked out by the clear light. As in all of the artist's great portraits, the background and lateral epi-sodes serve as the wings of an extensive scene in which the figure provides the final means of measuring the distances. A peak of virtuosity is reached in the great variety of color relationships. In other "official" portraits, the features and expressions are rendered so as to convey an atmosphere of heraldic pomp. Here, however, the detailing of the infant's toys attached to his dress and the lightly characterized physiognomy carry much more feel-ing, and relate the picture to the afternoon splendor of *Las Meninas* at the Prado (see *Prado/Madrid,* page 89).

DIEGO VELÁZQUEZ DA SILVA. *Infanta Margareta at the Age of Three.* p. 152

In all likelihood this is the first of Velázquez's portraits of the Infanta and the first of the three owned by the Art History Museum, which show the little princess at the ages of three, five and eight. The plump childish face has not yet hardened into the ugly lines hereditary in the imperial family, and the little girl strongly resembles her brother, Philip Prosper, whose por-trait Velázquez was to paint five years later. As in that masterpiece, the figure, shown in the identical pose, is related to the objects around it in an amiable counterpoint. Here it is principally with the vase of flowers — two roses, an iris and some cornflowers. In contrast to the quietly shadowed tones of the background, there is the portentous theme of the black and red carpet, which is then attenuated in the red and gray of the dress. The fluid brushwork, now continuous and now broken, alternates the colors in in-creasing contrast. The palette is dark in the background, but as the brush lays in the embroidery of the dress it becomes light. In the bodice there is a diminishing effect as the gray harmonizes with the background.

DIEGO VELÁZQUEZ DA SILVA. *Infanta Margareta at the Age of Eight.* p. 153

The Infanta, with all the attributes of her station, is seen posing for the offi-cial portrait to be sent to her uncle, the Emperor Leopold I, whose wife she was to become seven years later — at the same age at which her mother, Mariana of Austria, had married her own uncle, Philip IV. With a similar work in the Prado, it is the most splendid portrait that Velázquez painted of the royal little girl. Where the first is a continual series of variations of reds and muted greens, here the variations play on deep blues and dark greens. The overture in the symphonic color scheme is provided by the banding on

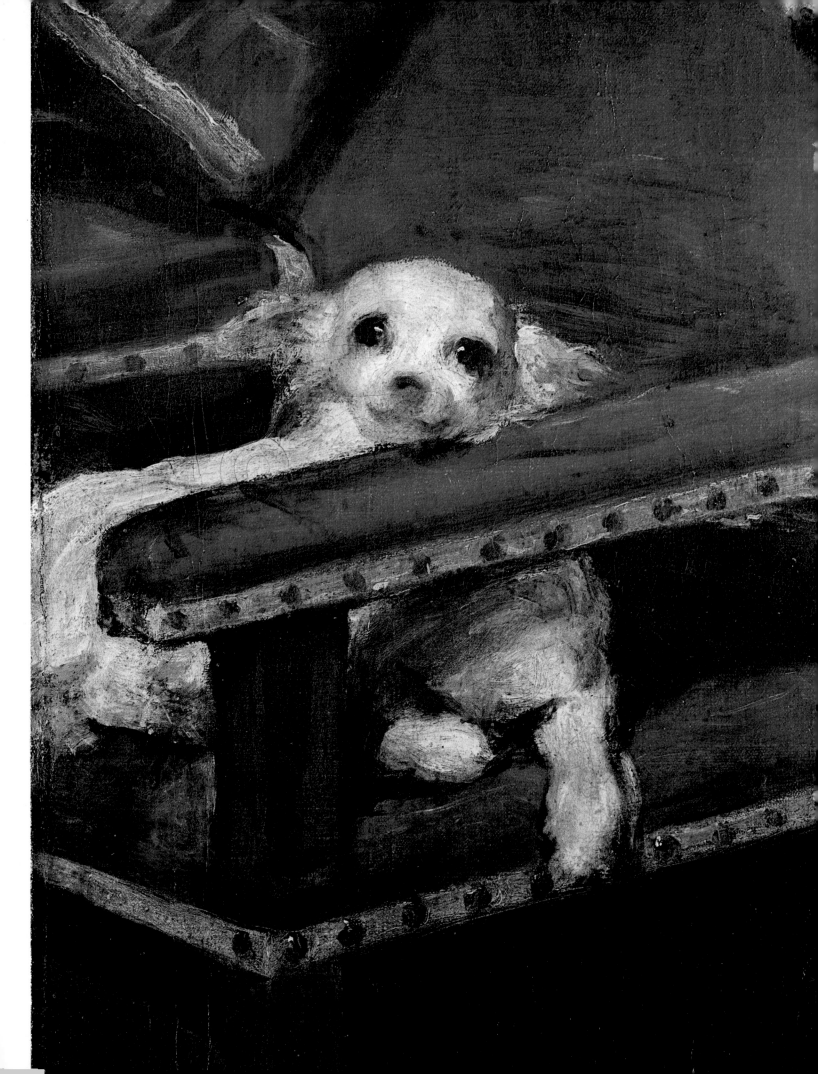

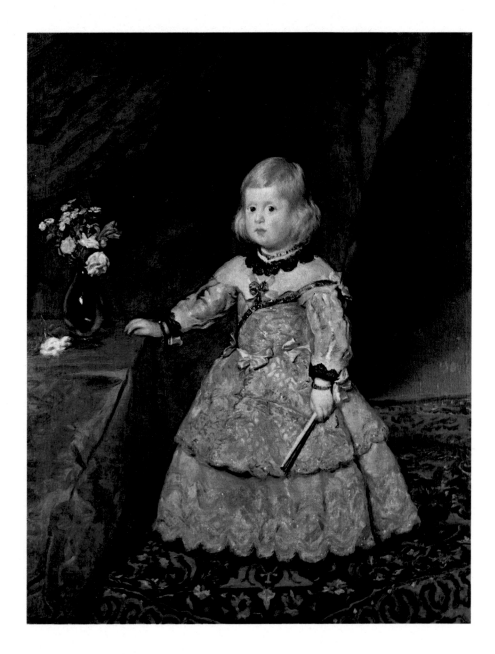

DIEGO VELÁZQUEZ DA SILVA
Infanta Margareta at the Age of Three
Oil on canvas; 50 1/4″ × 39 1/4″.
It was probably sent as a present by Philip
IV to the court of Vienna. From 1816 it
was listed in the catalogue of the imperial
gallery. Executed around 1654. A copy,
probably by Mazo, who was Velázquez' son-
in-law, is owned by the duchess of Alba,
Madrid.

the dress, and the composition is then built up on a series of angular returns,
with the figure standing apart from its surroundings.

JUAN BAUTISTA MARTINEZ DEL MAZO. *The Artist's Family.*

p. 154

Mazo (who was Velázquez's son-in-law) has included, in this complex fam-
ily portrait, Francisca de la Vega, his second wife, the children of his first
and second marriages and other members of the family. Velázquez himself
is shown in a picture in the background, painting a portrait of the Infanta
Margareta. In the center there is a portrait of Philip IV which is very similar
to the one in the Art History Museum. It is obvious that Mazo used his fa-
ther-in-law's *Las Meninas* as a model in painting this splendid group (see
Prado/Madrid, page 89). A device that comes from Dutch art — the inclu-

DIEGO VELÁZQUEZ DA SILVA
Infanta Margareta at the Age of Eight
Oil on canvas; 50″ × 42 1/4″.
It followed the vicissitudes of the *Portrait of
Philip Prosper* to the castle of Graz. For rea-
sons still unknown it then disappeared and
was found again in the museum's reserves
in 1923, having been cut down to an oval
(probably in the 18th century). In 1953 it
was restored to its original form. There is a
variant in the Budapest Museum, probably
executed by Mazo.

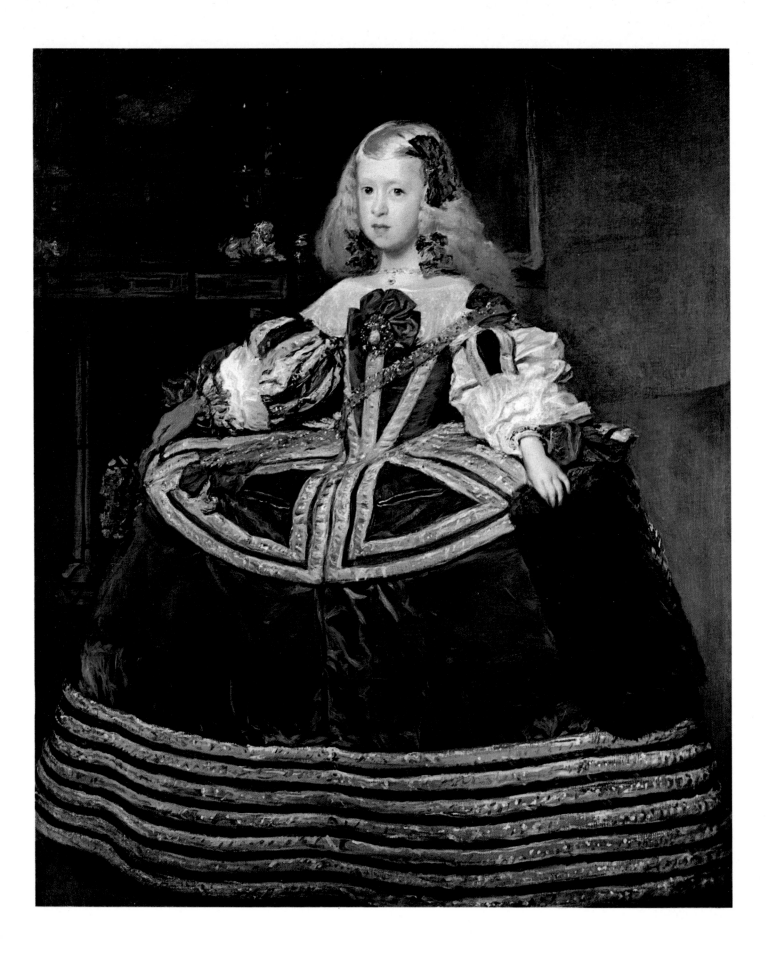

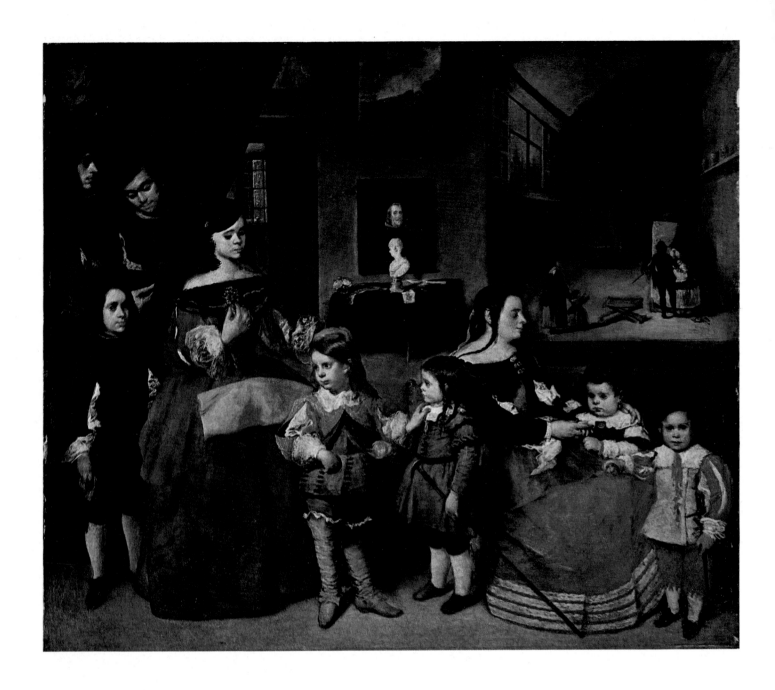

sion of some related event as if viewed in a picture or through a window — is seen in the "picture" represented on the right. This recalls Velázquez's procedure in *Christ in the House of Martha* in the National Gallery of London. But these stylistic and iconographic ties do not prevent Mazo, who was Velázquez's most devoted pupil, from achieving his own originality. Although it does not have the flashing synthesis of Velázquez, and is recounted in conventional terms, his domestic narrative affords an honest and affectionate study of people and things.

NICOLAS POUSSIN. *The Conquest of Jerusalem.*
This is one of the works executed during the most problematic decade of
Poussin's activity, 1631–41. Having given up the official commissions for

JUAN BAUTISTA MARTINEZ
DEL MAZO
Beteta (Cuenca) 1612 — Madrid 1667
The Artist's Family
Oil on canvas; 58 1/4″ × 68 3/4″.
Acquired in Italy in 1800.

154

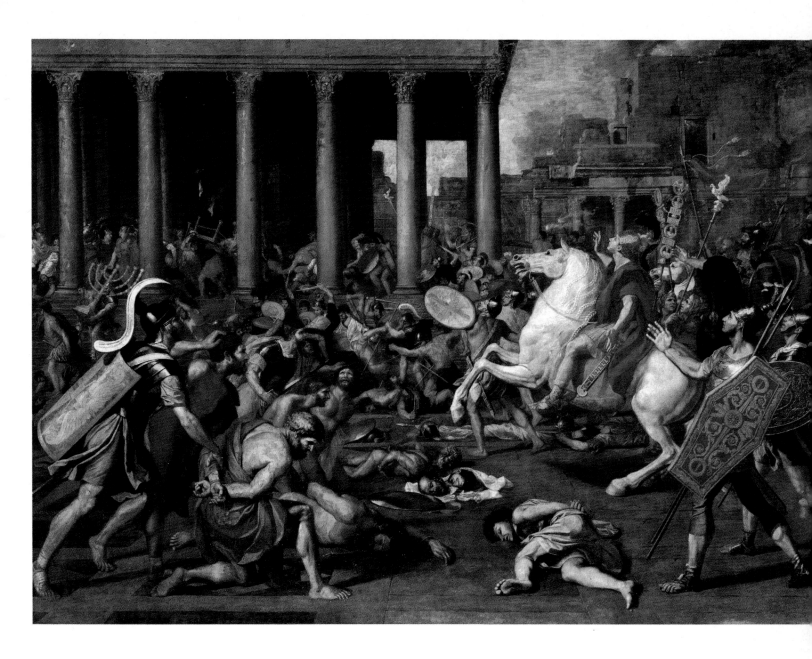

NICOLAS POUSSIN
Les Andelis 1594 — Rome 1665
The Conquest of Jerusalem
Oil on canvas; 4′9 3/4″ × 6′6 1/4″.
Signed: "NI POUSIN FEC."
Commissioned by Cardinal Francesco Bar-
berini, who gave it to Prince Eggenberg,
Imperial Ambassador at the court of Pope
Urban VIII, probably as a present to the
Emperor. It is listed in the catalogue of the
imperial collections published in 1718, after
which it belonged to Prince Kaunitz. Since
1956 it has been at the museum. According
to Bellori, Poussin executed an earlier ver-
sion, all trace of which has disappeared. As
Eggenberg was ambassador in Rome during
1638–39, the painting must have been done
at that time, and stylistic evidence bears this
out.

big Baroque compositions, for which his "rival" Pietro da Cortona was
often preferred, Poussin devoted himself during these years to the study
of theory and compositional schemes, executing small pictures for the most
part and being drawn more to landscape. Scholars have sought to identify
several "modes" in this phase of Poussin's work, in which the study of the
"ancients" and of Raphael are constants. *The Conquest of Jerusalem,* in
this view, is the greatest example of the artist's "archaeological mode." The
perspective framework provides the structure for the exact reconstruction
of ancient architecture. The space created and measured by these buildings
in the background provides a broad foreground in which the tumultuous
scene is scanned and ordered by the rhythms of the composition.

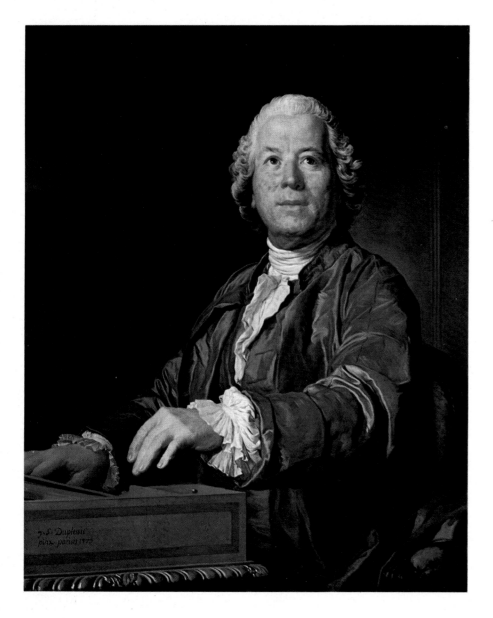

JOSÈPHE SIFRÈDE DUPLESSIS
Carpentras 1725 — Versailles 1802
Portrait of Gluck
Oil on canvas; 39 1/4″ × 31 1/2″.
Signed and dated: "*J. S. Duplessis pinxit parisis* 1775."
It has belonged to the museum since 1824. There is a smaller replica in a private collection in Vienna, and a study for the head in a private collection in France. Exhibited at the Salon of 1775.

JOSÈPHE SIFRÈDE DUPLESSIS. *Portrait of Gluck.*
Court portraitist Duplessis had studied in Rome with Subleyras, from whom he had acquired his vein of elegant classicism. He painted this portrait of the great German opera composer in 1774, when Gluck came to Paris at the insistence of Marie Antoinette, his former singing pupil. Gluck had a sensational success in France, routing the powerful "Italianist" faction with the première of his *Iphigénie*. The official pose, suggesting "inspiration," does not take away from the clear characterization of the subject and the elegantly adjusted movement of the composition.

CAMILLE COROT. *Portrait of Mme. Legois.*
This masterpiece is a striking example of the poetic effect Corot achieved through tonal harmonies. Madame Legois sat for the artist in a classical portrait pose. Her face is frontal, slightly tilted and off axis, while her bust and lap turn progressively toward the left. Her hands and gradually curved

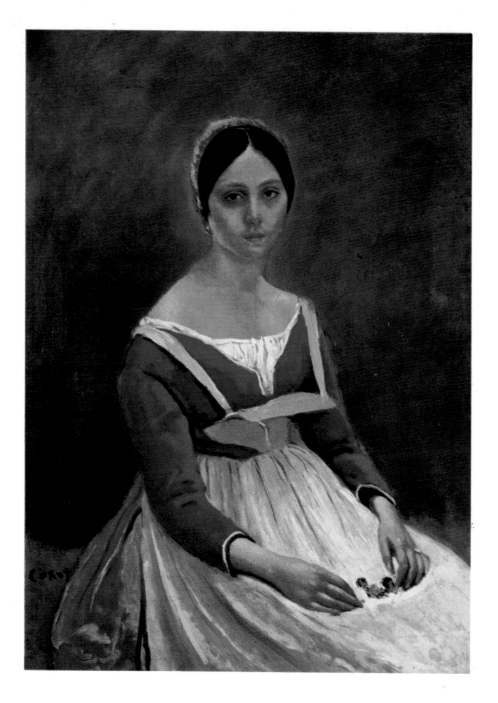

CAMILLE COROT
Paris 1796 — Paris 1875
Portrait of Mme. Legois (1838)
Oil on canvas; 20 3/4″ × 15 3/4″.
Signed on the left: "COROT."
In the sale of Corot's works held in Paris
the year of his death. It belonged to the
N. A. Hazard collection in Orrouy. In 1935
it was acquired from the Paris art dealer,
Barbazanges, with the financial aid of the
Society of Friends of the Museum. Number
381 in Robaut's catalogue raisonée.

arms "collect" the movement of the composition. In this slow, subtle and sensitive movement the tonal harmony is woven out of the pink-white and red of the dress and the headdress, and the whites, pinks and gray-greens of the skin, the apron and the ground. The flowers that have dropped listlessly from the figure's hand into her lap are also part of this spectrum, in which the shadows and the darkness of the eyes and the hair are the only contrasting elements. Rather than individual description or psychological characterization, the aim here is pure contemplation, with the shadowy intensity of the gaze tempered by the calibrated relationship of color and volume. The abstract classical face is underscored by symmetrical repetitions along the axis of the figure, such as the bodice line echoing the lines of the hair.

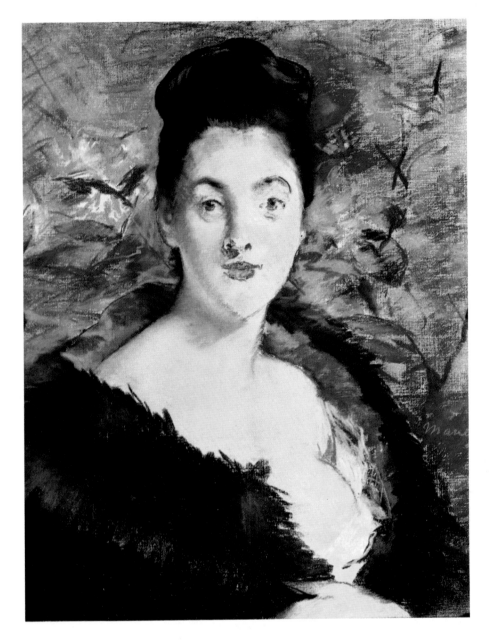

EDOUARD MANET
Paris 1832 — Paris 1883
Lady with a Fur
Pastel on canvas; 21 1/2″ × 17 3/4″.
Signed: "MANET."
Executed around 1880.
It was in the Pellerin collection in Paris and the Mendelssohn collection in Berlin. Acquired in 1942 from O. Schatzker, Vienna.

EDOUARD MANET. *Lady with a Fur.*

In 1879, Manet, already weakened by the disease that was to lead to his death, started work in the seclusion of his studio in the rue d'Amsterdam on a series of paintings that would include some of his finest achievements. His subjects were bouquets of flowers or women with neutral or landscape backgrounds. He worked in pastel, an unusual technique for Manet, but one that he used with mastery. Often he portrayed women he knew, splendid feminine figures set in deliberately conventional poses and enlivened with brilliant light effects. Fresh and sensitive in touch, these pictures testify to the artist's belief in the renewal of life as he approached death. Pastel was the ideal medium for his purposes, with its precision and graininess, its transparency and its ability to indicate reflections.

AUGUSTE RENOIR
Limoges 1841 — Cagnes 1919
After the Bath (1876)
Oil on canvas; 36 1/2″ × 28 3/4″.
Signed on the right: "Renoir."
Acquired in 1910 from H. O. Miethke.

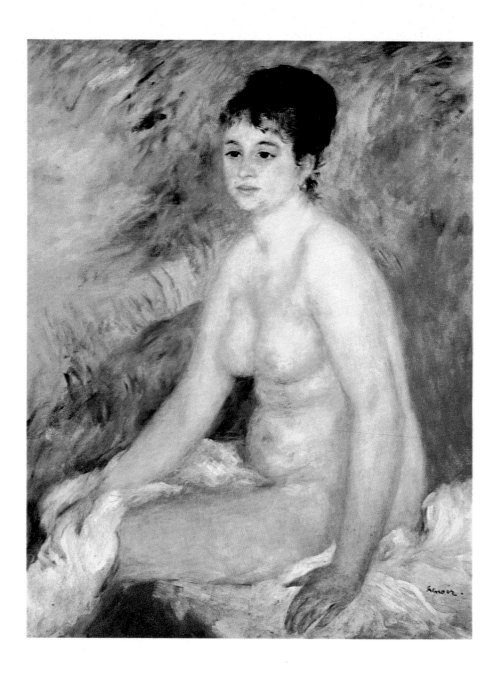

AUGUSTE RENOIR. *After the Bath*.

Among other similarities, the model for this work is the same as in the celebrated *Anne* in Moscow. That painting is fundamental for Renoir's style at a time in which his relationship with the Impressionists' program is most evident (these were the years when Nadar's exhibitions were held at the Hôtel Druot). As in other works of the same period, there is a marked contrast between the modeling of the splendid nude and the vivid, rapidly brushed background, where Renoir seems to have borrowed his technique from Monet. The volume of the figure is thrown into relief. The head has the most definition but the entire figure has an opalescent glow, and with the sensitively indicated landscape conveys an exuberant open-air effect.

159

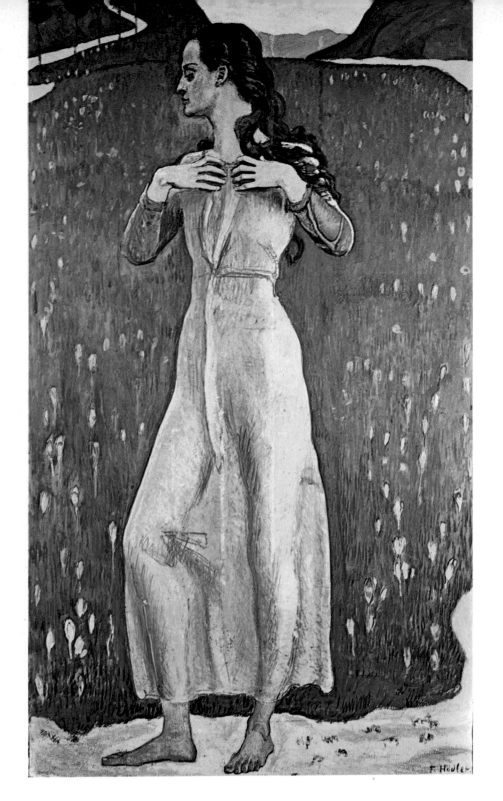

FERDINAND HODLER. *Distress.*

Among the major painters of the Vienna Secession movement, Hodler is distinguished for the monumentality of his ambitions. In some examples this takes the form of a stylization close to the experiments of the Post-Impressionists. The relationship of figure and setting is not expressed by decorative repetition, but is worked out in terms of close geometric modulation. Color becomes an exterior and ornamental element, with symbolic overtones.

FERDINAND HODLER
Bern 1853 — Geneva 1918
Distress (1900)
Oil on canvas; 45 1/4″ × 27 1/2″.
Signed at lower right: "F. Hodler."
Hodler painted several works similar in theme — single figures with variations or groups — in 1894 and 1903. This painting belongs to the period when he was a member of the Vienna Secession movement. Shown in 1903–4 at the Secession exhibition, it was acquired by C. Reininghau and remained in his collection until 1918. From 1929 it was in the Moderne Galerie at the Orangerie of the Belvedere.

HISTORY OF THE MUSEUM
AND ITS BUILDING

THE COLLECTIONS

The character of the Picture Gallery, or Pinacoteca, of the Art History Museum is the result of centuries of growth. The imperial picture collection which it includes is among the oldest in existence. In fact it is due to the great interest that generations of the Habsburg dynasty took in art that a distinguished collection of paintings was already formed by the 16th century. Today the Picture Gallery still reflects the personal taste and sensibilities of the illustrious collectors of the Renaissance and the Baroque ages.

An understanding of the work of art as such and regard for its practical utility are the two interrelated criteria that characterize the beginning of the history of the collection. It is evident that portraits were of particular interest as genealogical documents. It is thus not by chance that the gallery contains a very large number of them, and this group was the nucleus of the imperial collection. Maximilian I (1459–1519) had already shown a predilection for this branch of painting, which was able to give representational form to his imperial ideals. Many of the portraits were originally conceived as expressions of Habsburg policy and dynastic aims. That the Emperor also had taste is made clear in his portrait by Dürer, one of the most notable works in the history of art.

Maximilian's great-grandson, the Archduke Ferdinand (1529–1595), a man of wide artistic interests, also valued portraiture above all. Following Maximilian's taste, he acquired one hundred small portraits of members of the princely dynasties. The series was executed with the clear intention of providing a complete genealogical picture. This magnificent survey was accompanied by a series of portraits of heroes and geniuses, beginning with Dante and Petrarch, which displayed the ideals of Humanism. The Archduke Ferdinand also kept in his castle of Ambras a collection of more than one thousand portraits, many of merely a documentary value. But among them there are a few of notable artistic level, such as the two portraits of Charles IX of France by Clouet and paintings by Holbein and Cranach the Younger.

We have considerable information about the Archduke Ferdinand as a collector, but know little about the taste of his brother, the Emperor Maximilian II (1527–1576). It is not unlikely, however, that it was he who acquired Titian's late work, *Diana and Callisto,* thus being the first in the imperial house to develop a taste for the great masters of the Italian Renaissance.

Rudolph II (1552–1612) was praised by his contemporaries for his veneration of painting, which was greater than that of any of his predecessors. Indeed the quality of the pictures he acquired puts the collections of the previous rulers in the shade. His collection was outstanding not only for its number of works, but also for the fact that he judged each work of art on its own merits. All other considerations were subordinated to esthetic criteria, although he was not indifferent to the subject of a painting. His refined and confident taste was directed principally toward the masterpieces of the most famous artists, both Italian and German. It is difficult today to form an adequate idea of Rudolph's collection, as it was dispersed during the chaos of the Thirty Years' War. The Picture Gallery of the Art History Museum, however, still has a large number of paintings whose merits testify to the Emperor's wisdom.

Rudolph had a taste for the Venetian masters (Titian's *Danae* was one of his acquisitions) and perhaps even more for Correggio and Parmigianino. But un-

questionably his predilection was for the most illustrious of the Germans, Dürer. Five of the pictures in the gallery (among them the *Adoration of the Trinity*) belonged to Rudolph, as did the *Adoration of the Magi* and the large canvases of *Adam* and *Eve,* which are respectively in the Uffizi and the Prado. The painters who worked at the Emperor's court in Prague belonged to the final phase of Mannerism. Hans van Aachen, Bartholomeus Spranger and Joseph Heintz make up the group of "Rudolphian" artists, many of whose works may be seen at the Art History Museum.

Archduke Ernest (1553–1595), brother of the Emperor Rudolph II, was from 1590 to 1595 the governor of the Southern Netherlands, which belonged to the Spanish Crown. During those years he became involved with Flemish painting, and it is to him that the imperial collection owes the acquisition of the most important of the works by Pieter Bruegel. From the Archduke Ernest's time, the history of the gallery was for more than two hundred years largely determined by the Empire's political link with the southern Low Countries. Ernest's successor, his brother Albert VII, was a man of great taste, and his name is indissolubly tied to that of the great Flemish painter, Peter Paul Rubens.

Ernest had collected mainly the works of the past; Albert had favored contemporary artists with his patronage. Both interests were combined in the person of the Archduke Leopold William (1614–1662), who was governor of the Low Countries from 1647 to 1656. He was munificent in buying and commissioning contemporary art, and at the same time he eagerly followed the international old-master market, especially for Renaissance works. For this purpose the Netherlandish towns offered much greater possibilities than the imperial capital, which was not one of the main trade centers. Accordingly it was in the Low Countries around the middle of the 17th century that the imperial picture gallery was born. Like the Archduke's, the collection of the Emperor Ferdinand III (1608–1657) in Prague was acquired in the Low Countries, certainly with the direct assistance of the Archduke. Leopold William was thus the real creator of the Art History Museum's Picture Gallery.

It was Leopold William who collected almost all the 16th-century Venetian paintings that are today among its main attractions: masterpieces by Titian, Giorgione, Lotto, Palma and Veronese. He was responsible as well for the series of great Flemish artists, from Jan van Eyck to the genre painters of the 17th century. When Leopold William resigned as governor in 1656 and returned to Vienna, his collection followed him. The detailed inventory that he had compiled lists 1,400 paintings. He bequeathed all this to his nephew, the Emperor Leopold I (1640–1705), who thus became the owner of both collections acquired in the Low Countries: the imperial pictures in Prague and the Archduke's collection in Vienna.

In the 18th century the Spanish Netherlands continued to be a rich source for the imperial picture gallery, and all the more so when those territories were assigned to Austria by the Treaty of Utrecht. Among the important acquisitions made in the Low Countries during this period were the great altarpieces by Rubens (1776, 1777) and Caravaggio's *Madonna of the Rosary*.
The relations between the imperial house and the princely Italian dynasties did not have as much weight in the history of the gallery as those linking it with 163

the Low Countries. The court of Innsbruck, however, had established close ties to the rulers of Tuscany in the 17th century, which lasted for more than two generations. A collection that was purely Florentine in taste was assembled here. Most of the large group of 17th-century Florentine paintings in the Art History Museum come from this Habsburg-Medicean court, where the outstanding Florentine artists worked, including Lorenzo Lippi, Cecco Bravo and Carlo Doli. One of the masterpieces of the Renaissance, Raphael's *Madonna in the Meadow (Madonna nel Prato)* was acquired by the Archduke Charles Ferdinand (1628–1662).

Italian artists determined the taste of the imperial court from the middle of the 17th to the late 18th century. The decoration of the palaces was in the hands of Italian painters, who had much greater success than their Dutch competitors. Some of the paintings done as decorations were later moved to the imperial picture collection, where they now document the history of Austro-Italian cultural developments. These pictures, by such artists as Maratta, Solimena and Crespi, are of the highest quality. The expansion of Italian art is made even more evident to the visitor by the thirteen large views that Bernardo Bellotto executed for the Empress Maria Theresa (1717–1780) in 1759–60.

The character of the Viennese collection had been established by the time that the Emperor Joseph II (1741–1790) put the art historian Christian von Mechel in charge of the reorganization of the picture gallery in 1780–81. A major move was the transfer of the gallery from the Stallburg, where it had been installed since the time of Leopold William, to the more spacious Belvedere. The gallery was officially opened to the public by imperial decree in 1781, and two years later Mechel published a detailed catalogue, to serve as a guide for visitors. Mechel's catalogue lists 494 Flemish paintings, 316 Italian, 371 German, as against only 86 Dutch, 22 French and 8 Spanish. Most of the portraits had remained in the apartments of the imperial castles, including the series by Velázquez which followed dynastic vicissitudes and passed from the Spanish to the imperial court in the 17th century.

It was certainly part of the didactic aim of the age of Joseph II, in the midst of the Enlightenment, to enlarge as much as possible the historic scope of the collection. But his untimely death, the disruptions of the Napoleonic wars and the resulting financial difficulties that mark the reign of Francis II (1792–1835) prevented the achievement of this program beyond some early notable efforts. An attempt was made to broaden the Dutch collection which was rather sparse, but did include some notable works, such as the Rembrandt portraits. With the acquisition of Ruisdael's *The Great Forest* and the Reith collection, composed mainly of Dutch paintings, a program of acquisitions was laid down that has continued to this century. Considerably aided by the generous bequests of the Baroness Clarice and the Baron Louis de Rothschild, this area is today more than adequately represented.

The age of Joseph II and of Mechel left as a heritage the principle that such a collection is a cultural institution that must be directed by scholars of solid competency. In the course of the 19th century this idea was extended, to the point of considering the gallery as an instrument for the study of art history. With the foundation and construction of the Art History Museum to house all of the im-

perial collections (1891), ample quarters were provided for research. This character of the Picture Gallery still determines the main functions of the museum's staff.

As in previous eras, during the 19th century the Emperor considered it his duty to support contemporary painters through purchases and commissions. Those who benefitted principally were naturally the Emperor's subjects, just as Leopold William — as governor of the Low Countries — had been mainly concerned with Flemish painters. In this way a collection of modern Austrian painting came into being. After the First World War, the exhibition of Austrian Baroque art and the organization of the more recent collections were entrusted to various independent museums: Austrian Baroque and 19th-century paintings were moved to the Upper and Lower Belvedere. Since the Second World War the Belvedere museum has been reserved exclusively for Austrian art. French and German 19th-century paintings were brought back to the Art History Museum, and in exchange the medieval Austrian panels were installed in the Belvedere. The works of German Romanticism, French Realism and Impressionism, and German painting up to Expressionism were installed in the old Stallburg in 1967.

The Picture Gallery is one of nine collections belonging to the Art History Museum. Not all of them are in the main building, which houses the Picture Gallery on the entire first floor and half of the second floor. The sculpture and applied arts section, Greek and Roman antiquities and the Egyptian and Oriental collection are on the mezzanine floor. Collections of medals and coins occupy the other half of the second floor. The treasure room (*Schatzkammer*) and arms and armor and ancient musical instruments are in the Hofburg. The state carriages are housed in the castle of Schönbrunn. The collections in the castle of Ambras, near Innsbruck, also belong to the Art History Museum.

The Picture Gallery includes: 1. the Art Gallery proper (first floor); 2. the Auxiliary Gallery (second floor), which is also open to the public, though mainly reserved for study and research; 3. the New Gallery or Gallery of Modern Art, which includes 19th-century works and is at present installed in the Stallburg; 4. the Portrait Gallery, which is in the process of arrangement and will be installed in the castle of Laxenburg, near Vienna.

The museum has its own laboratory for conserving and restoring pictures, which was established in 1857. Since 1883 the results of scientific research carried out by the staff of the Picture Gallery have been reported in the Art History Museum's annual publication. Furthermore, for several decades there has been an association with the Institute of Art History of the University, by which students may take courses to familiarize themselves with the work being carried out by the museum.

THE BUILDING

A typical public building of the Emperor Francis Joseph's period, the Art History Museum was built on the Ringstrasse, an elegant boulevard laid out on the site of the old city wall in 1857. Planning began in 1862 for two large edifices, the Museum of Natural History and the Museum of Art History, which would house all of the imperial collections. Gottfried Semper and Karl Hasenauer were responsible for the plans, and the cornerstone was laid in 1871. In 1880 the Art History Museum's building was completed, and work was started on its elaborate interior decoration. Installation of the collections began in 1885, but the museum was not officially inaugurated by the Emperor until October 17, 1891.

The two museums, which face each other, are almost the same on the outside. They are like the parts of a grandiose architectural complex, as if to express in visual terms the principle of the unity of all the arts and sciences. The ornate sculptural decoration of the two buildings indicates their contents in symbolic form.

FIRST FLOOR

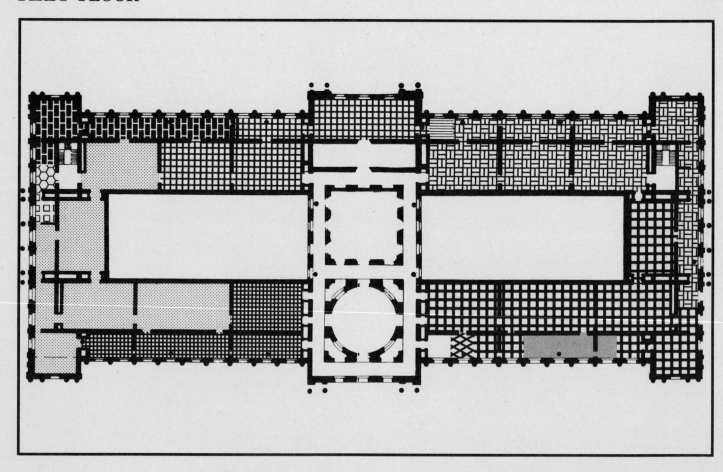

LEGEND

ITALY — 15TH CENTURY

ITALY — 16TH CENTURY

ITALY — 17TH & 18TH CENTURIES

SPAIN

NETHERLANDS — 15TH CENTURY

NETHERLANDS — 16TH CENTURY

FLANDERS — 17TH CENTURY

HOLLAND — 17TH CENTURY

GERMANY — 16TH CENTURY

FRANCE — 16TH CENTURY

ENGLAND — 18TH CENTURY

SECOND FLOOR

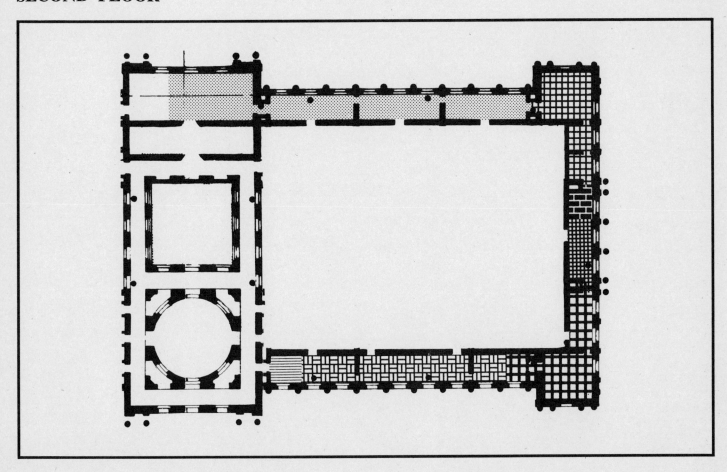

167

SELECTED BIBLIOGRAPHY

BENESCH, OTTO. *German Painting: From Dürer to Holbein.* (World Publishing Co., Geneva, 1966).

BRION, MARCEL. *German Painting.* (Universe Books, New York, 1959).

BURCKHARDT, J. *Recollections of Rubens.* (Phaidon, New York, 1950).

DELEVOY, ROBERT L. *Bruegel.* (Skira, New York).

FLETCHER, JENNIFER. *Peter Paul Rubens.* (Phaidon, London, 1968).

FRIEDLANDER, MAX J. *From Van Eyck to Bruegel.* (Phaidon, London, 1956).

FROMENTIN, EUGENE. *The Masks of Past Time: Dutch and Flemish Painting from Van Eyck to Rembrandt.* tr. by A. Boyle. (Phaidon, London, 1948).

GROSSMANN, F., ed. *Bruegel, the Paintings: Complete Edition.* (Phaidon, London, 1956).

LEVEY, MICHAEL. *Dürer.* (W. W. Norton & Co., New York, 1961).

MORASSI, ANTONIO. *Titian.* (New York Graphic Society, New York, 1964).

ROSENBERG, J. *Rembrandt: Life and Work.* 2nd rev. ed. (Harvard University Press, Cambridge, 1964).

SHIPP, HORACE. *The Flemish Masters.* (Philosophical Library, New York, 1954).

TIETZE, HANS. *Titian.* 2nd rev. ed. (Phaidon, New York, 1950).

WAETZOLDT, WILLIAM. *Dürer and His Times.* (Phaidon, New York, 1950).

For their courtesy in furnishing information of great value for the preparation of this book, we wish to thank Professor Erwin M. Auer, Director of the Art History Museum, Dr. Friderike Klauner and Dr. Günther Heinz.

INDEX OF ILLUSTRATIONS

INDEX OF NAMES

GENERAL INDEX